LIVING
THE
ARTIST'S
LIFE

UPDATED
& REVISED

For Annie

LIVING THE ARIST'S LIFE UPDATED & REVISED

A GUIDE TO GROWING, PERSEVERING AND SUCCEEDING IN THE ART WORLD

Paul Dorrell

HILLSTEAD PUBLISHING

KANSAS CITY, MO

LIbrary of Congress

Dorrell, Paul.
Living the artist's life: updated & revised: a guide to growing, persevering and succeeding in the art world /
Paul Dorrell.-2nd Hillstead paperback ed.
p. cm.
Includes bibliographical references.
Library of Congress Control Number: 2012934901
ISBN 978-0-9853091-0-7

Cover Design: Stephanie Lee
Interior Layout: Susan L. Schurman

Printed in the United States of America
on Recycled Paper

This book is set in Futura and Helvetica Neue typefaces.

PRAISE FOR *LIVING THE ARTIST'S LIFE*
(FIRST EDITION)

Dorrell advises sagely on topics from photographing your work to inspiration, depression, self-doubt, getting commissions, and getting into galleries.—*Ceramics Monthly Magazine*

Dorrell matches his work's ambition with a conversational tone that makes the book succeed as an animated, how-to resource for everyone from starving artists to gallery owners to general free thinkers. —*New Orleans Gambit*

An insightful, honest exploration of what it takes to make it as an artist, in spite of challenging circumstances and psychological hang-ups. —*Professional Artist Magazine*

Dorrell's passion is to help artists thrive in what is often an unsupportive art world. This is a very important book that scores of artists can learn from.—*ArtStreet*, Miami Public Television

The most informative, thought-provoking, and important book about developing an art career that I have ever read.—Doug Baldwin, Professor of Ceramics, Retired, Maryland Institute

Dorrell, who owns the Leopold Gallery, seeks to teach, reassure, enrich and inspire artists of all stripes. His advice ranges from the practical to the cautionary. But mostly he urges artists to realize how important and relevant they are.—*The Kansas City Star*

Dorrell's clearly written book guides the reader through failure and frustration on the road to success. It also includes tips on résumé building, artists' statements, portfolio presentation, press relations, and on how to find supportive dealers.—*The Albuquerque Journal*

Dorrell's reference book provides pragmatic advice for the artist trying to negotiate the ever-changing face of the art world...delivered with wit and charm.—Warren Rosser, WT Kemper, Distinguished Professor of Painting, Chair of Painting Department, Kansas City Art Institute

With compelling prose and rare insight, Dorrell covers practical topics such as photographing one's work inexpensively, getting placed with galleries nationally, and landing commissions. —*The Louisville Courier-Journal*

Dorrell writes in a conversational, easygoing tone. Inspiration, execution, marketing and selling, dealing with successes and failures—numerous aspects of the professional fine art world are thoroughly addressed.—*Saint Louis Post-Dispatch*

If you've decided to follow your dream of becoming an artist, Paul Dorrell has sound advice for you in his memoir/art guide, *Living the Artist's Life*. His book tackles topics as diverse as depression, art fairs, juried shows and getting paid.—*The St. Paul Pioneer Press*

Down-to-Earth, accessible, and infinitely readable, this book is invaluable for anyone who is an artist. Readers will find Dorrell's experience-based advice engaging and enlightening, with important practical information not taught in school.—*Fiberarts Magazine*

Dorrell has a heartfelt generosity of spirit that he extends to others. His book helps the novice traverse the rough terrain of an artist's life, every step of the way.—Edie Pistolesi, Ph.D., Professor of Art, California State University, Northridge

Part memoir and part how-to, Dorrell's book sagely coaches artists on how to be media-savvy, deal with rejection, show publicly and find that one great gallery.—*Houston Press*

Dorrell imparts candid first-hand knowledge about the perils of living off one's passion. His book covers everything from creating portfolios and networking with galleries, to dealing with critics and an artist's inevitable self-doubt, with great insight and generosity. —*The Cincinnati CityBeat*

Dorrell's book is a survival primer that, while predominantly covering the universe of art galleries, paintings and sculpture, also contains plenty of valuable information that aspiring writers, musicians, actors, and filmmakers could utilize.—*The Nashville City Paper*

Dorrell's book covers everything from low-budget travel tips to the defense of copyrights and the preservation of sanity. Information about innumerable subjects is detailed in a simple, conversational, and often amusing tone.—*Des Moines Register*

ACKNOWLEDGMENTS

My wife Annie, for her love and wisdom. Greg Michalson, Sam Anderson and Ted O'Leary, for believing in me. Jim Leedy, Murray Dessner, Edie Pistolesi, Ken Ferguson, Michele Fricke, Warren Rosser, and Ralph White, for their kind support. Gretchen Robinson, for the yoga. All the folks in Connecticut, for those fine years along the Farmington River. Bob Fisher, Dean Mann and Trudy Jacobson, for uncommon generosity. Steve Dickey, for poetry. Cynthia Roederer and Tom Geiger, for the West Bottoms. Bill Kluba, for New York. Dan Akkerman, for altitude sickness. Bowie, for Blackwater. Geo, for the Olympic Range. Buddy Fuoco and Don Smith, for Lake Garda. Stive and Johnny Butler, for Low Chicago. Jeff Boring, for the bikes. My stable of artists, for their talent and loyalty. My clients, for their loyalty and checkbooks. Byron Dickson, Kevin Harden, Renee Jacobs, Mark Litzler, Karen Orosco, Belinda Lower, Jon Jackson, Abby Helin, Betty Hunter and Ed Tranin, for so many cool projects. All the fine people who bought my first book. My sons Denny and Josh, for all that we have given each other. My mother and father, for all that they gave me.

LIVING THE ARTIST'S LIFE
UPDATED & REVISED

FOREWORD

Only about 15% of all artists make a living from their work. I wrote the first edition of *Artist's Life* for the other 85%, as well as those succeeding. Now I've updated it, covering critical subjects that I didn't before and expanding on others. So whether you're an unrecognized master still struggling to make your career click, a recognized master intent on maintaining your success, or are just starting out, I wrote the book for you. I've been in the art business since 1991, and have placed roughly $12 million in work by artists of various regions since then. Consequently, I've learned a great deal about advancing careers.

Why write the book? Because most artists are never fully taught how to effectively navigate the art world, whether they live in LA, the Midwest, New York, Paris, or the Northwest. Well it isn't a mystery. There are proven approaches that work. I've covered them in detail. My point of view, as a successful but untypical gallery owner, may prove informative, though of course you should consult other points of view as well.

Am I only concerned with your prosperity? No, since that's only one part of an artist's life. In fact many artists I know are indifferent to making money. But most, in the end, would like to earn income from their work. I can assist with this, and many related issues.

The memoir section has also been expanded, with me telling more about our crazy journey: my dances with near-bankruptcy, my dances with booze, the years of despair, the years of success, and the challenges of sanely raising a family through all this. I believe you'll find our failures and victories illuminating. I'm pretty candid, since to me anything less would be a disservice to us both.

I hope you enjoy the book.

Paul Dorrell
Kansas City and San Francisco, 2012

CAREER CHECKLIST

Below is a list of basic steps that, from my experience, have helped bring success to a wide range of artists. I cover these issues, and many others, in considerable depth throughout the book. But for now, I want you to have this checklist to go back and review periodically as you develop your career. I wrote it, and the book overall, as something of a road map for realizing your dreams.

1. Is Your Work Ready?: Have you reached some level of mastery yet, and have you had qualified critics honestly assess your work to confirm as much? If so, then it's nearly time to go after the collectors and galleries.

2. Photography: Before presenting to the public, make sure your work is well-photographed, so that it always looks exceptional on websites and printed materials.

3. Resumes, Bios and Artists' Statements: Have you drafted at least one of these so that it reads easily, briefly, and comprehensively? After writing one, or all three, you might have a friend with editing talents help you tighten each document.

4. Your Website: Before you begin holding public exhibitions and submitting to galleries, you must have a website. If you're not sure of how to build one, hire an inexpensive designer who can assist, customizing a template to suit your needs. Just make sure the site is easy to navigate and update, and sophisticated in design.

5. Social Media Site: Because of their popularity, it's essential that you have one of these, and regularly update it to drive traffic to your website. This will help you announce new achievements to friends, acquaintances—and potential collectors.

6. Establishing Goals/Setting Deadlines: We all have goals, but for artists this can be a nebulous area, as it is with most people who are self-employed. I suggest listing the goals you wish to achieve over a ten-year period, assigning a deadline to each. The section I've written on this provides a sample goal sheet.

7. Business Cards and Postcards: It's important that you have at least one of these, if not both. They tell people at a glance that you're a pro, whether you're showing your work in your own studio or are in a gallery.

8. Pricing Your Work: Naturally you should know how to price your art before you begin selling it. I cover how to determine pricing that is fair to both you and collectors.

9. Arranging a Public Exhibition: If you're not in a gallery yet, and haven't had any public exhibitions, then it's time. Refer to this section of the book in arranging it. I list multiple venues where this is not only possible, but welcome.

10. Juried Shows, Art Fairs: Whether you're a conceptual artist, landscape painter, or glass artist, there are venues in your region—and others—where your work will be welcome. I cover the importance of submitting to these in building up your resume, and also explain how to learn about them.

11. Portfolios and Presentation Folders: It's important to have an impressive portfolio to show clients and galleries, and just as important to have an impressive presentation folder that you leave with them. I explain ways to lay out both.

12. Getting into the Galleries: It's easiest to start with a gallery in your region, but once you've achieved some success there, you should seek galleries in other parts of the country as well. This can take time, and often involves a lot of initial rejection. I carefully walk you through that process, and remove much of the mystery from it.

13. Landing a Show: Once you're in a gallery, and prove to them that you can be relied upon to consistently create stunning work, it will be time to request a show. I discuss the particulars of this, and many of the details involved.

14. Press: After a show has been scheduled, you and your gallery should work to land an article that covers it, utilizing both the print and online versions to advantage. There are many steps involved in achieving this; I list those that have worked for us.

15. Corporate Clients: Corporations are the new Medicis, helping to finance the Regional Renaissance in America and many other countries. Increasingly more of them are buying art. Pursue them, or have your galleries do this for you. This doesn't mean you'll be creating corporate art, but rather selling original art to corporations.

16. Networking: Get out and meet people who you can assist, and who can assist you. This includes architects, interior designers, art dealers, assorted professionals, and other artists. If you have time to assist a philanthropic organization, even better. Great things often come from that, though it's a mystery as to why.

17. Commissions: Any time you can land a commission, especially a large one, it's a great thing. Why? It forces you to create work that you otherwise would not, and often will bring you increased recognition. I review all the necessary steps, from learning about commissions, to drafting contracts, to getting media coverage.

18. Finance: As you begin to structure your career, you should seek sound advice on tax write-offs, raising capital through the use of your art, minimizing debt, saving for the future, and related issues. Needless to say, I go through this at some length.

19. Museums: As your career expands, it will be time to approach these institutions. I explain basic ways in which to do it, and where to begin.

20. Grants: I discuss these at length, for those of you who wish to apply.

21. Success: Enjoy this once you've earned it, since it is almost always hard-earned. But please never forget that the next failure, large or small, is often just around the corner. No worries. Take the setbacks with resilience and a sense of humor, and success will prove to be the primary theme of your life.

CHAPTER 1

WHO AM I?

'm a gallery owner and art advisor, as I have been since 1991. Over the years I've been fortunate enough to rack up many accomplishments, which were built on the wreckage of multiple failures. In the business sense, the aesthetic sense, and the giving sense, I suppose I'm considered a success. That's cool, but that state of success was preceded by a lifetime of artistic and financial struggle—bounced checks, creative frustration, black despair, and hundreds of rejections for myself and my artists.

Why rejections for myself? I'm a novelist. Writing is the primary passion of my life—driven, maddening, fulfilling, by turns sane and insane. Just as many of you can't live without painting or sculpting, I can't live without writing. The only reason I got into the art business was to support my family on the road to publication, which says a lot about my initial naiveté in both professions. But I got into this gig to succeed, and so undertook it with the same passion with which I write. I also got into it to make a difference in my part of the world, not just make a buck.

Have our successes come easily? No, for me they took decades of sacrifice, dedication, and very long hours. Was it all worthwhile? In some ways yes, in others no—all achievements have their price. My artists and I have paid that price, just as everyone must—usually throughout our lives.

Why have I written this? To help you succeed as an artist. The definitions of your success—whether aesthetic, rebellious, monetary, or all of these—are up to you. My job is to assure you that you can achieve your goals, and to assist with their realization. This book, based on all my years of experience, can help you do just that. I've been immersed in the arts since the '70s; many of my artists since the '60s. Collectively we've learned a great deal along the way.

Is this book only for artists? No. I've written it for the student and teacher, the writer and reader, the gallery owner and collector, and anyone else who lives within the world of creative drive. Further, the things I'm going to cover are not typically taught on campuses. Why? Because while art professors are greatly skilled at what they do—guiding raw talent toward mastery—most have never run a gallery. Why would they? That isn't their profession, any more than to instruct in painting is mine. But unless you've managed a gallery, with all the risks and challenges that come with one, it's not possible to fully teach about building a career that works. Both points of view, and both realms of experience, are essential.

And by *teach* I don't mean perpetuating shopworn methods that usually lead nowhere. I mean cutting through the bull, being honest about what works and what doesn't, and understanding why the art business, as it has traditionally been structured, is more often a recipe for failure than success.

Over the course of my gallery's existence I've caused roughly $12 million to be invested in the artists of my region, about half of this through projects I've overseen, the other half through gallery sales. Is that big money? When compared to those rare dealers who routinely trade in the millions, no. But for the rest of us who struggle just to pay the rent, this series of feats have far exceeded my initial goals. They've allowed me to live the dream, though during the initial years it seemed more of a nightmare.

Now when a gallery begins to succeed in selling art, does that make it commercial—assuming that the work it carries is not? No more than when an indie film succeeds. You don't compromise on the art; you create a market for it, however edgy it might be. Yet when an artist begins to sell well, their work and the galleries that carry it are often branded this way. This exemplifies a common dilemma in the arts, including music. The majority of all artists want to sell, but once they begin to, they're sometimes ostracized by their peers.

Why? Because certain snobs look down upon the business of selling, as though it degrades the work. What, so it's better to starve? Interestingly, I've noticed that people who have this view often are not artists, which basically makes them armchair quarterbacks, since if you're not on the field, you can't comprehend the risks of the struggle. Van Gogh would have given anything to sell just one painting. Warhol sold very well, and inevitably came under fire for doing so.

Where does this contradictory view come from? I believe it's rooted in the fact that artists never want to see their work associated with a retail business—which they shouldn't. Art creation should take place outside the market, driven exclusively by passion, vision, and a little bit of hell-raising where needed. However once a piece has been delivered to a gallery, it has indeed been delivered to a retail business. Frankenthaler understood this, Magritte understood this, and Picasso understood it best of all.

If a gallery is to be run competently, it must be businesslike. And like any firm, it must have a marketing plan, accurate bookkeeping, public relations skills, sophisticated graphics, annual projections, satisfied creditors, and the ability to convince collectors to invest repeatedly in new artists, so that those artists can pay their rent. Yet a gallery, like a publisher, is often also a place of idealism—lofty philosophies, lofty goals, a group of people working toward a common end that is bigger than they. This is the orientation of my place. But we're a business first, since if we don't succeed, nothing is advanced and all our families suffer—meaning those of my artists as well as my own. In this wealthiest of nations, I've never found that acceptable as an option.

My point? Unless a dealer can get collectors to pay a respect-able sum for the work of artists in their region, then the arts there aren't being advanced. No sort of commerce can grow without the investment of capital, and neither can the arts. When all the well-intended talk is over, if private and corporate collectors aren't putting money on the barrelhead, it's just lip service. Far better for accomplished artists to be paid what they're worth. Your region in general will benefit from that in terms of cultural growth—schools, corporations, institutions, and other disciplines in the arts. Cultural growth, throughout the country, is what I'm most interested in. This is at the heart of what I call the *Regional Renaissance*—a concept we'll get to later.

Convincing collectors to put down real money for art is a chal-lenge I've been dealing with for decades, and I've done the bulk of it in the Midwest—an area not always known for impassioned col-lecting. My drive to achieve this has helped bring us a plethora of projects—an enormous collection for H&R Block Headquarters in virtually all media; an eighty-five-foot sculpture in blown glass for the University of Kansas Hospital; a sculpture in stainless steel for the Museum of Fine Arts, Boston; dozens of works both large and small for a convention center in Kansas City; all monumental sculpture for the National D-Day Memorial in Virginia; a monument of Mark Twain in Hartford; paintings for restaurants and hotels; a monument for the Capitol Building in DC; and thousands of works for private collectors. Steven Spielberg has acquired art through my gallery, as did Charles Schulz and Douglas Adams.

What have I sold these people? A wide variety of art, since I believe that well-executed contemporary, conceptual and rep-resentational works are all legitimate. I've never been interested in debates about the opposing worth of these disciplines. To me, certain of these approaches advance new frontiers while others maintain critical standards. If I'm going to spend time arguing, it would be about the need to curb poverty and offer opportunities to low-income teenage artists, rather than debating the merits of Duchamp's *Readymades* as opposed to Monet's landscapes. To me, both have their place.

WHO ARE YOU?

By this, I mean what are your goals? Do you want to get accepted in juried exhibits? Do you want gallery representation? Do you want representation in more than just your region? Would you like to make a profit from your work? Do you want to give it away? Do you want to shock people? Inspire them? Amuse them? All of these are legitimate goals. I'm just urging that you define yours—although of course you likely already have.

Then after you answer those questions, consider these: Are you content with your work? Do you feel you're pulling the best out of your guts that you can? Do you sometimes curse your fate, wondering why you were born with this inexplicable drive that society so rarely appreciates? Do you sometimes want to pack the whole thing in, only to find you can't? Are you still wondering if you're good enough, no matter how many years you've been working?

Welcome to the family—all this is part of our makeup, it's just rarely discussed. But it's when we address the rarely discussed and taboo that we often learn the most.

Something else: regardless of what kind of artist you are, please never forget that art—music, painting, writing, sculpting, *creating*—is a cornerstone of any civilized society. In fact the nonconformity that art usually springs from is an essential part of any democracy, since no society can progress without a healthy sector of nonconformity. After all if we didn't have nonconformists, we'd still have slavery.

Is the artist's purpose frivolous then? No. It's just as significant as that of the farmer, the architect, the philosopher, the physician, the legislator, and the teacher. Those roles are all interwoven, not one of them more substantial than the other, each with its own critical weight. We are here, you and I, to make sure that society never forgets our place in that roll call.

WONDER BREAD, SEVEN-GRAIN, AND THE REGIONAL RENAISSANCE

When I was growing up in Kansas City in the '60s, our cultural life was much like the Wonder Bread the schools gave us to eat—bland, unoriginal, devoid of passion. For years I thought this was confined to my part of the country, but as I began to travel, I learned it was a

national malaise. Gradually I realized that the malaise had existed even in places like Westchester and Marin Counties. Only in certain pockets—Greenwich Village, Central Chicago, North Beach—had it been any different. Oh every city had its art movement, no matter how small, but the impact this had on the rest of each city was minimal, primarily because these movements tended to be centered in bohemian enclaves whose participants were written off as *weird*.

But now this country is going through a Regional Renaissance unlike anything in its past. In every region—the Midwest, the South, the rural West—art creation is assuming a life of its own outside New York and Los Angeles. What does this mean? For painters and sculptors who for years were told that if they weren't showing in Soho, they didn't count, the story has changed.

The art world is no longer centered in New York, but began dispersing across the country in the '90s, a movement that was much facilitated by the Internet. In Austin, Albany, Columbus, Sacramento, and hundreds of other towns, work is being created that could easily pass muster in Soho. Further, collectors in each region are beginning to participate. Ditto regional art centers, high schools, junior colleges, universities, arts commissions, and virtually every other entity in the game. These organizations, and the people who staff them, have worked for decades in bringing about this change. The beauty of it? Their efforts are paying off.

You can benefit from this renaissance. That's why dealers like me have labored so hard in promoting the artists of our region. We were tired of being frozen out by some of the more closed aspects of the elitist world—brilliant though it often is. So we created a world of our own.

When I was in grade school, my only experience with that world was when the Art Lady—a very kind but rather uninspired volunteer— would come to our class and in a nasal Midwestern accent discuss Monet and van Gogh. I'm not sure that she tapped our passions, but at least she made the attempt, which was more than the district was doing. The Shawnee Mission District, like most school districts at that time, spent a lot of money on football but little on the arts. And while SMSD has since mended its ways to an extraordinary extent, at the time it was as imbalanced as most other districts nationwide.

My mother sensed the injustice of this, and tried to give us a deeper cultural grounding. This was at the same time that she discovered yoga and meditation, when fried food disappeared from our diets, and when concepts of positive thought were reinforced daily. Her journey, and the one she took us on with her, is a curious tale, but I have no room to discuss it here. I've done that in a novel, *Cool Nation*, which I suspect will appear in print one day.

So my mom, who our less imaginative neighbors thought nuts, gave my brothers, sisters and me a rare opportunity to explore individual growth. It was at this time that all Wonder Bread disappeared from our house, replaced by the seven-grain that she bought at a health-food store in Brookside. Not long after that she made each of us read Ram Dass' *Remember, Be Here Now* and other books of that ilk. She even asked my father to read it, which he did, then encouraged him to keep from mocking it, which he didn't.

My dad, a bare-fisted contractor from the Ozarks, was shocked by the changes in his wife, but did his best to change in pace with her, hoping that if he did, it would save their marriage. Unfortunately, it did not.

Why do I mention this? Because in cities all over the country at that same time, other men and women were making similar discoveries. If they hadn't, the renaissance we're currently enjoying would not be taking place. Many of them did this at the price of ostracism, cruelty, and petty gossip that was damaging to themselves and their families. But for those who understood the worth of integrity and growth, none of those things mattered.

Ironically, the opportunities for those changes were rooted in two of the greatest tragedies of the Twentieth Century—the Great Depression and World War II. Had my parents' generation not answered the savage challenges of those events, the seeds of prosperity that made the Regional Renaissance possible would never have sprouted. So my hat is off to that generation, and all the sacrifices they made—which many of them didn't even survive to see the result of. And yet had it not been for the questioning nature of people like my mother, who were willing to listen to the generations that followed, we would never have known that a less conformist

world existed, and would have apathetically gone on eating white bread for the rest of our lives.

Even so, this notion of rebelling against a conformist society was limited mostly to the middle and upper class. In the inner cities, especially among non-whites, the rebellion took on a different tone, since people there were primarily concerned with the rights they were being denied more than the freedom to express themselves. A cultural renaissance would gradually be felt in the urban areas too, but it would take decades for it to have much of an impact. That impact has been minimal, with opportunities for black and Hispanic artists still too few, but they are slowly growing.

What is the upshot of all this? For better or worse, the reins of the country are now in different hands. These generations tend to be more engaged in the arts and less shocked by nonconformity. I mean Cadillac recently ran a series of ads for which the background music was Led Zeppelin. *Cadillac*? This should tell you something. Those in charge now are juiced by the suggestion of nonconformity, even while certain of them are conformist in nature. In fact the by-word for all things accepted, even at the executive level, has become *Cool*.

What does this mean for artists? A broader point of view, and a broader market, have opened up. No matter where you live, you can work with it. How? Keep reading and I'll show you.

STIEGLITZ, GUGGENHEIM, YOU AND ME

When I first opened my gallery, I did so in a bout of blind enthusiasm, gullible ignorance, and uninformed optimism—like most gallery owners. It was only after I opened that I realized the majority of galleries don't turn a profit, and many of the others fail. Every month new galleries open all over the world, and within a year most go broke. Even some of the most noted galleries in history, such as Alfred Stieglitz's Gallery 291, never managed to run in the black.

Stieglitz opened his first space in 1905 in New York, and with the help of Edward Steichen introduced America to artists such as Cézanne, Rodin, and Picasso. He also used 291 as a center of the Photo-Secessionist movement, being one of the greatest photographers of his time. Yet despite Stieglitz's contacts, wealth, and the

thousands of people who went through that space, he couldn't turn a profit and had to close in 1917. This was partly because the market for avant-garde work was so small then, but also because Stieglitz was a far better photographer than businessman. By the time he opened his last gallery in 1929, An American Place, he would amend this condition, but not without the help of many business-savvy people, including his second wife Georgia O'Keefe. Otherwise he'd have probably gone broke there too.

The same could be said of Peggy Guggenheim's galleries in London and New York. Throughout her years as a dealer, 1938-1947, Guggenheim sold very little, though she carried artists like Kandinsky, Calder, and Pollock. In fact many of her shows sold nearly nothing, despite the crowds that packed in to see them. If it hadn't been for her policy of buying at least one work from each artist, many of them wouldn't have sold at all. Fortunately Guggenheim had very deep pockets and could afford to run at a loss. Eventually her efforts at promotion paid off for some of those artists, although most didn't realize the rewards until much later—long after she closed, when the contemporary art business in New York began to boom.

The point is, with both of these dealers it took a very long time for success to be realized, whether for themselves or their artists.

I faced these same challenges when I decided to open not in New York, not in Chicago, but in Kansas City. I certainly couldn't afford to run the gallery at a loss—the needs of my family and artists didn't allow for it. Nor did I have deep pockets. All I had was my wits, a little common sense, and a willingness to work myself to the point of exhaustion every day. That gave me confidence, but those qualities still were insufficient to keep me from going deeply into debt—several times. Later, when the realities of the gallery business came crashing down on me, I was in too deep to honorably quit. Like Stieglitz, I had to succeed. So, this being America, I decided I could. How? Easy—fraud.

Just kidding. Like most small businesses, our path to success was demanding, at times depressing, and constantly threatened with financial ruin. Even so, walking that path has been one of the most rewarding achievements of my life. Along with the headaches, it's given me a lot of pleasure. And if I can't take pleasure in my work at least half the time, I ain't interested.

Since the beginning, I've made it a practice to help my artists become more successful, whether locally or nationally. Several have made significant income, others only modest income, but the careers of most were advanced. We achieved this together—agreeing, disagreeing, and sometimes arguing along the way.

In art school, however long ago that might have been (unless you're self-taught), your talent is cultivated, your medium chosen, your direction established. But who teaches you how to get your first exhibit? How do you know when you're ready to exhibit? How do you get into the galleries? How do you survive in the meantime? How do you deal with the uncertainty, the loneliness, the highs, the lows, the longing and rage? How do you keep these things from destroying you during the bad times, and how do you sustain brilliance during the good? And do I honestly believe that I can help with all this? In some ways, yes. I've done it with scores of artists. My approach certainly isn't the only one that works, but by combining my knowledge with that of others who are experienced in the field, your road will be made much easier than if you go it alone.

So use the book as a guide for whatever vision burns inside you. It's meant to assist you from the day you decide to become a professional artist, until the day you realize you are one.

And for those of you who aren't artists, I've written this for you as well. After you've finished, you should come away with a better grasp of why the art world is crucial to the deepening of our culture. It doesn't seem crucial? Sometimes it even seems absurd? Sure it does—the pretension at certain openings, snobbery run amok, sycophants drooling all over mediocre work that yet sells like mad. But that isn't the true art world. The true one is made up of hardworking people of the earth who hate pretension as much as you and I.

That's the world I write about. By the time you reach the final page, I suspect you'll begin to see it, and the dream-state in which it thrives, as being as crucial to our society as the right to vote, the right to freedom of expression, and even the right to pursue happiness—a curiously American concept if ever there was, but a noble one.

NOW, LET US BEGIN

All right, so you're a veteran of the art world but not yet of succeeding in galleries. Or maybe you recently graduated from college,

gazed out at the vast ocean on which your career must find its way, and said *Now what?* Or maybe you never graduated but dropped out, anxious to begin. Whatever the case, you were born to create. You want your life to be as vibrant as your work. It can be. For all of us it should be. For some of us it even is. But in some sense, you're a graduate. So, now what?

Assuming you've acquired the necessary background in the medium of your choice, do one thing first—congratulate yourself. However recently or long ago you finished your training, it wasn't easy. It cost a struggle of emotions and finances and loneliness and exaltation and odd alliances and odder rivalries but, in the end, it should have brought you closer to your calling. If it didn't, don't worry, hard work will do that.

Self-discipline, as we both know, is far more important than trying to glide along on whatever level of talent you were born with. Learn to rely on the former and utilize the latter, but please don't assume that talent alone will win you your successes. Dedication will take you further down the line than mere reliance on brilliance will. In fact it astonishes me how an average talent often blossoms, over time, into earned brilliance, while born brilliance when mated to sloth usually recedes into mediocrity.

Anyway, you've graduated. So now what?

You can travel if you have the means, and even if you think you don't. You can go to Europe, Asia, the Middle East, South America, anywhere you want. It's all a matter of preference, and desire, and the need to remain free.

Let's say you choose Europe. You can still go there cheaply and live out of a backpack, tour all those great cities, and taste of all those diverse cultures. If you're fresh out of school, you should. Do it now. It can also be done later. If things go well it can be done many times later, but it will never again be as simple as it is when you're young and single. It's good, at that age, to go to older cultures and learn what they have to teach you. It helps you set your bearings straight before starting the larger journey.

So whether you're young or old, find a way to get to another continent. If Europe, great, then go and bask in all that culture, and while you're there let the Europeans humble you. They're good at it, and

enjoy doing it. Then when they're done, ask them if they remember Harry Truman, George Marshall, and their reconstruction plan. The Marshall Plan helped pull the western Europeans' butts out of the fire after World War II, when they had collectively brought on a war, rooted in their previous war, that destroyed many of their cities and a great deal of their civilization. So while we may owe them much, gently remind them that they owe us too. That's what makes the relationship work.

But maybe you can't go overseas now. I couldn't either when I finished college. So I wandered America instead, eventually covering every state. Believe me, there's plenty to see in this country—its vulgarity, its beauty; its greed, its generosity; its violence, its compassion, its appalling ignorance, its stunning levels of enlightenment. It's a country of extremes, and natural wonders. It's also a country of many great museums. Visit as many as you can. How else will you see the masters? Who else will you compare yourself to? No matter where you live in the contiguous forty-eight, there are fine museums within a day's drive, and many smaller ones within a few hours. Going there doesn't have to be expensive. Just travel cheaply, eat out of a cooler, and camp if necessary. But whatever it takes, please go.

In my early years, when I was broke, I often traveled by motorcycle, sleeping in a tent at the edge of each city, or in the apartments of friends. Lord the scenes I witnessed and the people I met, both the maniacal and the kind. That bike was a cheap and very stoked way to get around, although I had to accept the risk of getting killed on it at any given time. But for me it was the only way to see Key West at sunrise, Hollywood at sunset, Cape Cod in summer, and the Olympic Peninsula in full rain.

Road trips of any kind are an adventure. America is a land for road trips. Enjoy the privilege while we have it. Dig on the old architecture, old farmhouses and train stations. Dig on the small towns, both their tranquility and limitations. Dig on the cities, their energy and neurosis. And never cross a major river—the Mississippi, the Columbia, the Hudson—without at least once stopping and standing at water's edge, trying to behold all that has passed there, and all that is yet to. Toss a coin in it. Toss a rock. Pee in it if you want. But most of all try to sense the quiet majesty of it, as all rivers have a bit of that. Then rejoin the frantic rush on the highway.

When you get to the museums, you may want to study the masters—meaning the old ones as well as those more contemporary. Try to learn what they have to teach you. And please, never mock a deceased artist; instead, try to walk in his or her shoes and grasp the challenges of their times. If your leaning is traditional, it will still be worthwhile to appreciate all that Munch, Rothko, and Bourgeois achieved. If your leaning is avant-garde, the same will hold true with Michelangelo, Rembrandt and Cassatt—or whoever works in a way that is distinctly different from you.

While I'm learning from those works, both those that appeal to me and those that do not, I try never to forget that the paintings on the walls, and the sculptures on the lawn, were the same product of insecurity, ego, joy and depression that most work is. Many of those pieces were created in sloppy studios under all kinds of duress, and often were the sole thing of beauty in those distant, ill kept rooms. Sometimes they were the only thing of beauty in many of those distant, tragic lives. The museum setting doesn't change the conditions of the work's creation, it just changes the background. But the artist who created those pieces—whether Kline, Motherwell or Moore—had as many difficulties, and was as full of piss and vinegar, as you and I.

Sometimes their difficulties were incredibly harsh, such as Rodin during his starvation years. It's simply that fame and the passing decades have dulled those bitter realities. But the hardships were just as severe to Rodin and his family as ours are to us. The fact that the works may now be "priceless" has little to do with their creation, since their supposed value has more to do with the greed of speculators than the struggles of the creative process. Further, I doubt that those same speculators would have invited the young Rodin to their tables when he was unwashed, unkempt and unknown—although I know many curators who would.

At the same time, the museum intellectuals who analyze the works, explain them, and in some cases worship them, don't change the essence of the works either. Those intellectuals, while sympathetic to artists as well as essential to the art world, are not made of the same cloth as the people who create the work; the two are different breeds. Normally the intellectuals acknowledge this. But if they don't, don't disillusion them. Everyone should be allowed their bit of fantasy, including me.

More often than not the artist is not an intellectual, does not fully understand why she creates, and doesn't even want to. In addition, the artist would probably never fit into a museum staff job; she can't fill the intellectual's shoes, just as the intellectual can't fill hers. But they need one another. We need the intellectuals to preserve and explore the work, just as we desperately need all you crazy artists to render it.

Don't ever let a museum intimidate you, regardless of whether you grew up in a ghetto, on a farm, or in a mansion. If it weren't for your kind, there would be no need for art museums. Just as importantly, never let a museum kill what the work is about, since some of them, with their excessive formality, do. See the work for what it is and how it was created. Then remember this— *you* are of that family.

So tour the museums, towns and cities. Let no experience pass that thrills you, scares you, or challenges what you think you know. Live fully but not destructively, unless self-destruction is your credo. If it is, that's your business. Just don't take others down with you, as that isn't your due. Creation is your due. Respect that. Let it anger you if it must, let it enrage you on occasion (apologizing later if trespasses were committed), but keep your fire alive, so long as you don't abuse dope or booze to do this.

Many people think they can keep the fire by constantly getting drunk and high, only to find out years later that they were extinguishing it all along. Then they can't rekindle it. Then they die. What do they accomplish in this process? Apart from a lot of partying, very little, either for themselves or the society whose attention they're trying to gain. Sure, we create for the passion and the need to give, but attention is also one of our primary motives. I'm just being honest about it.

In the beginning, it was no different for me. I had that crazy, whacked-out, American need for fame. But as I grew older, I realized how unimportant I was compared to the work I was meant to carry out. That's when the artist's life becomes a responsibility, like serving a calling one is born to. That's when I comprehended how little it had to do with me, especially since I hadn't achieved my successes alone. The craving for fame dissipated, so much so that I remarked

to my literary agent, when I finally got one, that I wanted to go under a pseudonym when my books got published.

He gave me a wry New York look, took a drag off his cigarette, and said, "Paul, don't be a fool."

I took his advice, and am still uncomfortable with it.

SUMMARY

All right, a group of museums and cities are behind you. Now you have to get back in the studio and back to work. You have to engage your passions. Yes, painting and sculpting, like writing, are an 'engagement' of sorts. They're an engagement between the ass and the chair (to paraphrase Hemingway), or the hand and the brush, or the lips and the blowpipe. Nothing takes the place of creating your best work. Nothing has as much bite either.

CHAPTER 2

WHY ON EARTH DID YOU CHOOSE
THIS PROFESSION?

You didn't, it chose you. Or you were born to it. Or it's something leftover from a past life that you've yet to satisfy. Or maybe you don't buy any of that and it's simply what you want to do. Either way it's all good and sometimes bad, but mainly good if you want it to be.

The journey is long and the rewards many, it's just that they rarely come as soon as we want or in the way that we first envision—like many things in life.

Most artists think their work will be ready to show to the galleries long before it actually is—just like writers and publishing. You may believe this too. Good. In a sense you must. That will help sustain you while you go about the process of getting ready. And the ego that sometimes made you ashamed when you were younger, for perhaps being too cocky or arrogant—don't toss it away just yet. You may need it to help bear you through the privations, rejections and periods of self-doubt you're bound to go through. But I do feel it's wise to tame the

ego. Let it serve you, not you it. Eventually your work will speak for itself anyway, and your ego will have nothing left to prove. And if you never went through that in the first place, congratulations—you're rare.

Your journey toward master status may be brief or long, depending on the level of your talent and how the breaks fall. If it proves to be long, don't worry—the greater the struggle, the greater the rewards, as long as you don't give up. Learning patience is an ancient and priceless virtue. I've certainly had to learn it whether I liked it or not—and many times I didn't. So have the vast majority of artists that I've worked with.

So, why did you choose this profession? In all likelihood you didn't. Like me, you were born to pursue it with all due vigor, damning the torpedoes as you left shore. Cool. I applaud your courage. Now, did you remember to bring a life preserver? You may need one before the voyage is over. At least I have, more than once.

CONFORMIST OR NONCONFORMIST?

An artist can be either. There is no written rule that says you have to be radically dressed, tattooed and pierced to dwell in the arts. All you have to be is open-minded. If you can't be that, at least be bloody good at what you do. Chances are though, if you were born an artist you were also born a nonconformist. This is something you won't be able to help and shouldn't want to. In fact you should be proud of it.

Grandma Moses, in her quiet way, was a nonconformist. So was Whistler—God rest his turbulent soul. So were Martin Luther King, Jr., Henry Miller and Simone de Beauvoir. Nonconformists play an important role in our world, forcing conformist society—which also has its place—to question itself, its direction, and purpose. Nonconformists succeeded at this during the McCarthy era, the Civil Rights era, the Vietnam War, and gradually during the escalation of the Iraq War. Conformist society always attacks nonconformists for this, resisting humane change until finally, when outnumbered by voices of reason, they're forced to acquiesce.

Personally I feel obligated to question society, although that has a tendency to cast me beyond the pale. Fine. The artist normally

lives beyond the pale, and is often something of an outcast anyway. At first this may anger you. But later you may see the need for it and the anger will slip away. Let it, although there's nothing wrong with letting it slip back in now and then. Good work can come from that emotion if taken in doses, but self-destruction is more likely if it isn't accompanied by self-control.

DRIVE

Where does this nebulous, hard-to-explain, harder-to-define quality come from, and what is it that, well, *drives* it? I haven't a clue. Is it essential to what you do? You bet. How will you know if you have it? Because of the way it rides you, rarely letting you rest, never letting you forget your calling. Drive is merciless, ceaseless, and in the worst cases heedless. I ought to know. I've been guilty of all that.

My own drive is never-ending. If I don't write, I don't feel fully alive. I feel as though I'm skipping out on an ancient and time-honored responsibility, regardless of whether I feel equal to the task or not. I also begin to feel like my emotions will explode. Does that make it any easier to face the blank page each day? It hasn't yet. Does it give me confidence, even when a day of hard writing may not? Almost always.

Do you need to feel that same drive in order to create? On some level, yes—that is if you want to mature as an artist. Your drive can be mild, impassioned, or insane. But you should feel it in some measure; it's partly where your inspiration comes from.

What if you feel no drive, but simply enjoy working in whatever medium calls to you? Great. You're free of a terrific burden, which will allow you to just take pleasure in your art. After all, it's not required that you be a tortured maniac in order to create. But if you're trying to reach the higher levels of your discipline, being tortured, as well as something of a maniac, can be a handy thing—if you know how to take it. How do you take it? Like most things, by making mistakes then learning from them. I've made plenty. Does that mean I've learned a great deal? That depends on who you ask.

SUFFERING

Contrary to a commonly held notion, we do not suffer more than other people. There is so much unspeakable suffering in the world—

especially from poverty, war, and disease—that many of us in the industrialized nations don't even know the meaning of true suffering, including me. I'm not saying that artists don't have it tough, I'm just trying to put things in perspective.

But even if we don't suffer more than others, we do tend to feel things more deeply. This, combined with our acute sensitivities, intensifies the suffering. Couple that with the usual insecurities, spells of depression, and years of rejection, and baby you've got one suffering artist. Or to quote good old Scott Fitzgerald: "...There are open wounds, shrunk sometimes to the size of a pinprick, but wounds still. The marks of suffering are more comparable to the loss of a finger, or of the sight of an eye..."

He wasn't lying either, since that dude suffered greatly—not necessarily because of what he went through, but because of how he took it. His wife Zelda too, although some claim that by the time she died, in that fire in the asylum in Ashville, she didn't feel those things anymore. Maybe not, but I'd hate to be the one to speculate on the nature of her emotional state when the flames finally reached her.

Will you suffer? As surely as you eat, drink and breathe. Will your work benefit from it? If you choose for it to. Is this a necessary condition of being an artist? I don't know about necessary, but I do know it's common.

All right, so we suffer. But by God, we know how to live too. And by *we* I don't mean just artists, but anyone who thrives through the power of their creative drive. Few people are given the gift to live this way, few are able to feel so alive between the spells of suffering. That suffering is simply a part of the price you pay for your talent, and since you have to pay it anyway, you may as well pay willingly. The alternative is to live an unenlightened existence, and in the end no one really wants to do that.

INSPIRATION

Inspiration is in many ways an inexplicable thing as it tends to come from different places for different people. No one can really tell you how to gain it, maintain it, or renew it. But then you won't need anyone to, since you'll know this for yourself.

As for me, it tends to run like this: New people who intrigue me; old friends I adore. Riding my bike at night through rough parts of the

city, or at 150 down the interstate. Inline skating for miles on a July afternoon. Four belts of whiskey on a Saturday night. No whiskey on other nights. An arousing flirtation. Great music. Great books. Teaching my kids to play baseball when they were younger, teaching them about the world as they grew older, or simply how to give. Telling my wife and sons I love them, but more importantly proving it. A hot night of hard sex where mild pain is as fine as the ecstasy. A cool night of gentle sex where all is sensitivity and warmth. Several nights without sex, since that act must remain special. Backpacking in New Mexico, snorkeling in Key West, canoeing in the Ozarks, surfing at Santa Cruz. Making a sad woman smile. Making an angry man do the same. Entangling myself in a risk that could possibly destroy me. Sunday dinner with friends.

The list is endless. Everyone has their own style, and mine likely couldn't be more different from yours. Find what keeps you alive and challenged then. If you don't regularly renew the challenge, you and your work will run the risk of going stale.

For me, inspiration is at its best when I can weep. I don't mean publicly. I mean when my writing brings tears to my eyes, or some piece of music does, or the thought of an old family tragedy. The tears mean my emotions are fine-tuned, and if my emotions are tuned, I know I can work. If they're dull and flat, then I have to try to work anyway. You have to work through your depressions, bouts of loneliness, dejection and despair. The work might be abysmal during these times, but it might also be great. Don't rely too much on inspiration. Rely on day-in, day-out discipline. That will bear you through more than dreaming, although dreaming certainly has its place.

Wherever your inspiration comes from, whatever you must do to keep it stoked, do it—as long as the process is reasonably sane. Like drive and talent, you must maintain this most mysterious of the artist's traits. Without it, we'd all be lost.

ARE YOU SELFISH?

I hate to say it, but selfishness has its place among us. This common but ugly trait can help sustain you through your initial years of struggle. As those years fall away, you'll likely learn to temper it

with a more balanced attitude. But probably the selfishness will, to some degree, always remain. Without it you couldn't work as well, or with the devotion you'll need to realize your vision. At least this has been the case with me.

Eventually, if the work is good enough and your confidence strong enough, the selfishness may evolve into selflessness. You may find yourself spending time guiding younger artists, or teaching low-income kids, or guiding your own children, realizing that helping them with their little victories and traumas is far more important than anything you'll create. Oddly, realizing this often helps you create even greater work. It's one of those strange contradictions in life, but a damn good one.

So go ahead and keep certain aspects of the selfishness if this is one of your faults, but more importantly, keep it in check. Otherwise you may find yourself without friends, lovers or family. If you're cool with that, fine. If you're not, please just be aware of the risks of this trait when left unexamined.

THE BOHEMIAN LIFE

This lifestyle is often overrated. It doesn't tend to produce great art so much as it does the people who talk about it, and live it. You'll have to taste of this world to know where you fit in, or don't, or whether you even care. Life in the cafés and along the endless trail of gallery openings can have its charms, but you'll likely find that the people who attend so many openings, and adorn so many cafés, rarely create art, they just love being around it. Many of them have either rejected conformist society, or been rejected by it, and wound up finding their home in the art world—a very cool and time-honored practice. After all, this has been a grand tradition since the time of Dante.

These folks—whether they be dilettantes, bohemians, or both— are essential to the arts. They help keep things vibrant. And while they almost never can afford to buy the art they adore, they do keep the openings interesting. Further, if a group of them take you up and talk you up, that's good. They help spread the word about new talent, and genuinely admire what you do with all the passion of someone who almost could have done it, but didn't. Hey, maybe they're

too content to bother with trying to get the world's attention. I, with all the shuddering insecurities that first fired me out of the art cannon, can certainly appreciate the dignity of that.

The point is, you'll have to decide which you are—dilettante or artist. Normally the two are different, albeit similar, types—and I do not feel that one is superior to the other. If you're an artist, you'll find you're better off in the studio than at multiple parties. That isn't to say you can't party, you'll just have to decide which pursuit is more important. As with most things regarding your work, there will be little to decide, since you'll know the answer intuitively.

Speaking of intuition, is it important to develop that sense? To me it's critically important, but only because I have an inner-voice that counsels me with relative reliability. For those of you who don't hear that voice, or don't believe in it, follow what you believe, whether logic or anarchy. But if you do hear it, please be sure to listen. Once well-tuned, that voice can become a magnificent guide through the maze of life.

DOPE

Many of my friends became dope heads when I was thirteen, in 1970. So did I. By the time I was 15, many of us were addicts, forever listening to Cheech and Chong, tripping our way through Led Zeppelin concerts, always en route to the next party. My primary addictions were pot, hash and the occasional hallucinogen; smack and coke were preferred by my more reckless companions. By the time I was 17 I began scaling back, fed up with the destruction of it all, while many of my buddies did just the opposite. I saw talent destroyed and families blown apart. Several suicides resulted, both the actual and the emotional. I watched as people I loved were reduced to lives of waste.

So if this is one of your struggles, naturally I'm a little biased if I urge you to quit or keep a firm handle on it. To me it doesn't matter if it's weed, coke, or ecstasy, you'll never fully get in touch with your artistic power as long as this stuff dominates your life. It limits your growth, ushering in bouts of depression and paranoia, and will tend to make you lazy—a curse for any artist. Eventually good work, with a full life, should be all the high you'll need.

I realized in high school that I would never become any kind of writer if I had all that ganja hazing my brain. I tried to imagine Mark Twain or Eudora Welty smoking a joint before writing, realized they wouldn't, and began distancing myself from the insanity. To me the world is too mysterious and full of possibility to cloud it with such voluntary absenteeism. You couldn't pay me enough to get high again. You could pay a great many of my old friends though, and they'd run right out and buy another spliff.

That isn't to say I'm more virtuous, or without my own vices; hell, I'm as flawed as the average human being. But it is to say that I'm able to contribute more to my world than I would have otherwise. And I've inherited too much responsibility, as I feel we all have, to believe that I can carry out a worthwhile vision from within a cloud of cannabis. Maybe you can—Carl Sagan apparently did—but I find those instances rare.

So like a reformed smoker, I'll probably never be open-minded about this. To me, rampant drug use was the worst thing that came out of the Vietnam Era—although many great things came out of it as well. We're still paying the price, though not the way places like Juarez are paying, where thousands of people have been slaughtered in drug wars that are directly linked to our addictions. There's nothing cool about that.

Even so, many people when young are convinced that they have to get wasted to seem cool. Then in no time their lives become a wreck. This is why so many celebrities go through rehab. Those who are unsure of themselves keep hoping they are cool, but are worried they're not cool enough, so they mistakenly believe that getting trashed with their sycophants will fix it. The tragedies of Heath Ledger, River Phoenix, Janice Joplin, and Jimi Hendrix indicate how well that works. Please don't let it do that to you.

BOOZE

This is the same as dope, and just as bad. It's also one of my vices. I don't drink hard; I drink mostly on weekends, and then try to restrict myself to a few drinks a night. Sometimes I fail at this, mostly I don't.

I have a few drinks in one of the cafés; my wife and friends have a few drinks, she and I go home, I wrestle with the dogs (my kids

having outgrown that nonsense), wrestle with my wife (if she's so inclined), sleep, and wake up the next morning with the sensation gone—as long as it was just a few drinks.

When it becomes six or eight, that's different. The gray cells start dying off; your body suffers; the hangovers become a daylong hell, and before you know it, you're addicted. That's why I only drink moderately, although I didn't always. When I was younger, if Saturday night wasn't accompanied by six or eight drinks, I felt like I wasn't living. Absurd. Eventually I learned moderation, as we all must. I also learned a little more about living.

I know I'd be better off never drinking, like my yoga instructors, but man that sounds so boring. Good bourbon, good gin, or a cold ale are things I've always relished. And I'm just stubborn enough to believe that this vice, in moderation, will never be as debilitating as the drug vice, even though of course that isn't true. Would I be better off without the booze? Sure, and maybe someday I'll even have the guts to drop it.

DEPRESSION: THE ARTIST'S MALAISE

Not until I was in my thirties did I realize that I'd been coping with some form of depression since childhood. This was so much a part of my nature that I never bothered to examine it. Instead I assumed that I was something of a freak and would just have to make the best of it. I hadn't known anything different, and therefore had no reason to believe that I would ever experience a life lived otherwise, going under the delusion that this condition was rare, and that I'd best keep quiet about it, lest the shame of my malady become better known. On top of this I was a bit neurotic, being a writer, but trusted that would level out over time.

Well I never was a freak and neither are you. What I didn't know, when younger, is that the vast majority of the human race is often coping with some form of depression. For some it's just an occasional bout, fleeting and brief; for others it's of greater duration, making even the simplest tasks onerous; for yet others it's so crippling that it makes life itself an impossible burden. Coming from a family of two suicides and its share of emotional illness, I'm familiar with depression of that severity.

Compared to people who are severely, or clinically, depressed, my own case would have been considered mild. It never seemed mild to me—hailing from the background that I did, and the insane adolescence that I went through—but that's because I was the one living it. It's also because, in my youthful bouts of self-pity, I sometimes believed that my life was hard to the point of being unbearable. Well I had a lot to learn about what is truly hard and all the things that are actually bearable.

Does this mean that my difficulties were easy, or that yours are either? No. There is nothing easy about working in obscurity for decades, while still maintaining your optimism, loving others, remaining inspired, taking rejection after rejection like blows to the gut, maintaining your dignity, maintaining your sanity, earning a living, coping with creditors, finding time to sleep, and still giving all you can to your part of the world. That isn't easy. *Life* isn't easy. If it were, we wouldn't learn a damn thing in the process of living it.

When did my depressions begin? I think at about age 8, when I first realized I didn't fit in with conformist society. By the time I was 13, this made me feel unworthy. By the time I was 15, it drove me into bouts of destructive behavior. By the time I was 18, I resolved to deal with it through hard work, aggressiveness, and arrogance. By the time I was 21, I realized the arrogance had backfired, that I'd driven away most of my friends, seemed incapable of making new ones, and felt even farther from finding my way. I couldn't carry on a conversation, couldn't snap out of my inner darkness, and didn't feel alive. What I did feel was unwanted, untalented, and without purpose. My depressions deepened.

This and other complications led to my first breakdown, in college. That was followed a year later by a worse breakdown, when finally I began to contemplate suicide—a definite sign that I was taking myself too seriously.

Why didn't I go that final step? I realized I just wasn't made that way, so decided to accomplish something with my life instead. I mean I felt like I'd been born a loser, that no matter how hard I worked it would all come to nothing, that in the end I'd always fail—at art, love, achievement—and that this fate had been preordained. Realizing this, I said *Hell, what do I have to lose*? From there I began to

rebuild, realizing that every minor victory was a step toward the next. Somehow after that I learned humility, how to poke fun at myself, and rediscovered joy—whether joy in the moment, or in completing some gargantuan task. I've been building from that point ever since.

It was also at that time that I began reading Nietzsche: "The thought of suicide is a great consolation: by means of it one gets successfully through many a bad night."

So I moved ahead with renewed vigor, throwing everything I had into the writing basket. Unwise move? Perhaps, but there are no half-measures in art. It's all or nothing. That's part of the insanity. It's part of the beauty too.

That was in 1982, the year of my last breakdown. Now? I suppose I've been humbled too much, have accomplished too much, and love life too much to ever go down that road again. I tend to approach things with humor, and a determination to never let adversity destroy my underlying optimism—an optimism that has been much tested by adversity. This isn't to say that I don't still have my moments of self-doubt, I've just learned to control them.

How did I manage to leave the world of darkness and come to live in a world of light? By trying to give more than I take. Besides, I've never fully defeated my depressions and am fairly sure I never will. Roughly twice each year I still go through a bad bout for a couple of months. But I know that each will eventually lift, and that I only have to keep my vision intact in order to emerge from it whole. It helps too that I have many people who count on me. I suppose you could say that several of them love me, but only because I've worked hard in giving to them, a thing that I value even beyond my work—well, as much as my work, which is going pretty far for an artist.

Why have I told you this? Because I'm aware that many of you deal with similar issues, but are reluctant to discuss them—as if this common occurrence is a mark of shame. I want you to know that you're not alone. Depression is a part of the human condition, especially among artists. I mean look at what you're up against: when you're unknown, no one wants your work; for years you'll struggle to emerge from the amateur level, then even after you become a master, society will be largely indifferent to whatever you create; you'll have to surmount enormous odds to make even a modest income

from your art; you can't walk away from it because it won't let you; you have to create, even if it kills you; and the whole time you're trying to present this gift of wonder to the world, the world doesn't hear you because it, for the most part, doesn't speak that language. Who the hell wouldn't be depressed?

But take heart. Consider how fortunate you are to have your vision, and to be able to act on it, when many people don't even know the deeper meaning of vision. That is nothing to be depressed about. That is cause for celebration.

NEUROSIS: THE ARTIST'S BADGE

This ties into depression, but must be addressed separately. I'll be brief, since it's more important to focus on your art, the creation of it, and the eventual succeeding of it. The difficulty is I can't do that without first covering these essential subjects.

Just as with depression, in my opinion the larger portion of our planet's population is in some form neurotic—whether mildly or severely. This naturally includes artists. It may well include you. I'll tell you right now that it definitely has included me over the years.

Is an artist's form of neurosis any worse than that of the average person? Not in my opinion. Is it better? No. Is it more interesting? If it produces good work, yes, and sometimes even if it produces bad. Does that excuse artists from confronting, and dealing with their neuroses? No, though not all people are capable of this sort of self-examination. But for those who can, that journey of discovery and self-awareness may be one of the most profound you'll ever take.

Either way, being a bit neurotic doesn't make you different from everyone else, it only makes you part of the family. Please don't ever fall under the illusion that your quirks make you inferior; to the contrary, they make you like the rest of us. Observe them, know them, work on them, but whatever you do, please learn to deal with them. Otherwise, unfortunately, they will in time deal with you. I'd rather you were their master, not the other way around.

LOVE

It may seem foolish to discuss this, but as with the previous subject, I don't feel I have any choice—especially during this time in history when so many of us live lives of emotional alienation.

Few things have been more important to my work than the intense love I feel for certain people. I went out of my way to cultivate this after I hit my 30s, since when younger I excelled at the opposite. Now though love feeds me every day.

When I was a younger man working on my first novels, my self-absorption, anger, and ill-informed opinions tended to drive others away from me. That made for many lonely nights with the typewriter—not necessarily a bad thing for a writer, although there were some days when I just wanted to knock myself off and get it over with.

Living that way at times seemed hard. Oh I had my share of old friends, but our friendships were primarily based on our partying past, with little bearing on the present or future. I also had my share of lovers, but eventually my uglier traits would drive those women away, and I'd be alone with the typewriter again. In other words I wasn't really connecting with anyone, yet so desperately needed to.

This can either make you crazy or make you strive for change. Well I was already crazy, so decided to try for change. I went about it in many ways, but the most basic was by admitting my faults, then trying to improve on them. This was an exasperating process, where for years what little progress I made hardly seemed to compensate for the pain and humiliation I experienced. But still I kept at it, forcing myself to face myself, mostly because I'm one of those people who can never seem to go through life in the way I started out, so am constantly working to evolve to a higher plane.

Fortunately, through all those strange years, my closer friends never gave up on me, and to them I owe a great debt. These were kind people who were happy with themselves, their place in life, and wanted to see me get to a similar place. Their gentle patience was a gift I didn't deserve, but they gave it anyway, which made that time of transition much easier to bear.

The years went by. I became a husband and father, and realized that my children needed to be raised by an adult rather than a self-absorbed, overgrown boy. So apart from everything else I'd worked on, I began working on that. I'll likely be working on that one for the rest of my life, but only in a way that fits—part boy, part man; part mischief-maker, part disciplinarian; soother of insecurities, wrangler

of the same. Sure, I don't fit society's typical definition of an adult. Thank God, since that usually means in order to be an adult you have to lose the kid in you, and a kid's capacity for joy. I simply can't accept that. I'd be dead as an artist, and man, if I did.

As I matured love became easier to win, but more important to give. Love of family, friends, even warmth for the occasional stranger who only needs a moment of my time or a kind word. This is the kind of love that feeds me each day.

Then there is romantic love, which is altogether different but just as important.

I've been lucky enough to fall passionately, insanely, connectedly in love several times in my life, with women who felt the same toward me. It was glorious, wildly erotic, and inspiring beyond words. Each of those loves was precious; not one will ever die, since real love never does, despite the inevitable flaws that all loves have.

When I met the woman who would become my wife though—Annie—I knew we were fated after the second date. She was the only one I'd encountered who was willing to endure the difficulties that we both knew lay ahead, since I was an unpublished writer. I felt she would give me the love I needed, just as I would give her the same. Fortunately we were right. Does this mean it's been an ideal marriage? Judging from our periodic fights, I'd say not. Besides, I'm pretty sure there is no such thing. But ours has been a very human marriage, with all the usual ups and downs. I've no doubt more of those await us. We'll deal with them in our own way, since our mutual respect is deep, and since neither one of us tries to force the other into being something we are not. In other words, we give each other a lot of room.

With the other loves that ended, I always felt changed by the time I recovered from the loss—more open to the world, and more grateful. Had I held myself back, the road would have been calmer but so much less interesting. As much pain as the woman or I might have gone through on parting, I would do it all again just to feel the ecstasy, the certainty that I had known this person before, likely would again, and that it wasn't really ending here. Of course love of that intensity normally doesn't make for a stable marriage—not that marriage is for everyone—but if you're wise enough, perhaps it can.

You can try to work without requited love, like Emily Dickinson or Edgar Degas. They worked exceptionally well without ever realizing their amorous dreams; in fact you might say that their frustrations sparked their work. But to me it's much better if you can open yourself to this emotion, whether you're straight, gay, sexually driven or sexually indifferent. Don't worry if no one taught you how to love when you were a child; it is entirely possible to teach yourself. But other people can teach you even better. Let them. And if you fail to inspire love the first or second or twenty-fifth time out, don't worry. Like depression, this too is far more common than most people admit. But I believe the whole attempt, and journey, can be improved upon with practice. Just be patient with yourself, and by all means maintain a sense of humor.

Romantic love has always been, and always will be, a maddening, ecstatic but painful journey—without maps, with many wrong turns, and a lot of wrecks. Yes it has its risks, but I've always felt that the bigger the risk, the more rewarding the payoff. The deeper the wound too when everything busts up. But wounds can build character, painful though that process is.

Remain open to all that love can offer, if that suits you. It's one of the greatest gifts of living in this world. It can bring the pot to boil. It can open the floodgates. It can set the fires roaring. It can also destroy you if you let it, but that's a gamble you have to take, and since you're an artist, gambles should be nothing new. Within reason, you should be willing to take them all.

SUMMARY

Man, that was a messy, emotional and rather personal chapter. But art largely comes from emotion, and there's just no way I'm going to write this book without addressing these subjects. Of course practical advice, based on my years as a gallery owner, is equally important, and I cover those details thoroughly in the succeeding chapters. But the practical aspects are only half the story, and I simply cannot write a half-book, let alone one with the tone of a motorcycle repair manual. You're all real people, with real lives and challenges. I'm not about to ignore the significance of that. I cover these sub-

jects because I know they must be discussed, yet rarely are. Well now that we've discussed a few of them, we have the foundation and tone with which to discuss the rest.

CHAPTER 3

EMPLOYMENT

Unless you're independently wealthy, like Proust, or marry into money, like de Lempicka, you'll have to take a day job, night job, or some other kind of job. If you're driven, you can deal with the job for eight hours each day and still find another four to do your real work at night. That might not be an easy way to live, but it's not meant to be. The tougher aspects of this life are what cull the good from the average, and the great from the good.

The object is to avoid taking a job you hate. It's also a good thing if the job leaves the art side of your brain free, so that each day as you labor, your talent is subconsciously building up to the hour when you go home and do the work that counts. One of my painters works for a corporation as a graphic designer, but when he gets home each day he's too burned out to paint well. Yet he couldn't think of anything else that had a future, and finally put his art career on hold—a decision he still regrets, though he digs the regular paycheck. Many of my other artists who have succeeded worked a variety of jobs: carpenters, teachers, truck

drivers, web designers. One of them was also a graphic designer, but worked for a laid-back firm that wasn't very demanding, leaving her with less income but more time to paint. Her career has done fairly well, though she wouldn't mind a larger and more consistent paycheck.

As for me, after college I wandered the country for years, working all manner of jobs before settling down, when I married and started a lawn service. To me, at that time, this was the American Dream at its best. I answered to no one, made my own hours, and had plenty of time to write. The money was good and the rewards of being outdoors great. I did this for eight years, wrote four books in the process, read the Encyclopedia Britannica in the pickup on my lunch breaks, and still had time for family.

This job also made me hunger for greater things, since it obviously didn't satisfy my ambitions. It drove me to write harder, whereas a corporate gig with a fat salary might have made me lazy. Too much comfort early on, and a preoccupation with material acquisition, may dull your senses. You could wind up becoming a slave to your possessions instead of to your work. Consequently your work may languish. Luxury, if it ever fits the artist's life, can come later. But be leery of that beast if you let it in the door, since once in, it's very hard to get it back out—even as it's bankrupting you.

Self-employment, if you can swing it, is the best way I know for an artist to control her fate. You can clean houses. You can paint houses. You can work as a fabricator, illustrator, carpet-layer. You can start a dog-walking service. You can work as a landscape designer. You can install the landscapes you design. You can paint custom signs. You can paint bodies. You can start a lawn service. This is America. You can do anything here, if you have the will and the drive.

But one drawback of self-employment is that artists who go this route rarely save much. We tend to just make enough to get by, so that we can focus on our art. Then before you know it you're 50, with nothing in the bank. So if you do attempt this, try to save at least $75 per week, starting in your twenties. If you can maintain that habit, and eventually hire a financial adviser who will help you grow your dough, you'll find you have even more time for your art, instead of

going nuts over unpaid bills. Just be aware that seventy-five per-cent of all small businesses fail. It takes a dedicated entrepreneur to make one succeed. But if you have the talent for this, the freedom is incomparable.

The alternative to self-employment? Take work with a sympa-thetic employer, in a sane job where the demands aren't too great, and where you can go home each night with enough energy to dive into your passions. The choices are yours, as are the jobs. You may not like any of these jobs greatly, but that's okay. Discontentment with those gigs will help drive you to higher levels of artistic achieve-ment. Just try to have a good time with the process, which at its best is something of an adventure.

WHERE TO LIVE

Again, I have to bring up Europe, since there is no substitute for fall in Florence, summer in Provence, or Prague in spring. But since few of us will spend more than a few weeks in Siena, let's focus on this country—which, fittingly, is often an object of longing for Euro-peans as well.

While Europe is a place where art is woven into the fabric of the culture, America, with its love for the commercial, is a place where art still remains largely outside our culture. Fortunately this is a flaw that is slowly changing. More each year, in small cities and large, art is becoming a standard aspect of education and a valued part of life. This doesn't mean we're on a par with Italy yet, but we are making progress.

And while we have overcome many barriers of ignorance, we still have a long way to go. This is less evident in the big cities than elsewhere, but it remains one of our great stumbling blocks. It's also an issue we must address if we're ever to live up to the vision that the founding fathers laid out for us—although Mark Twain felt we'd blown any chance of that long ago, when in the 1890s he wrote America off as shallow, greedy, and violent. The observation still applies, and yet doesn't.

Are there disadvantages to living in certain places as opposed to others? Yes, if you live in a small town it will be harder for you to break out. Sure the Internet has made the world smaller, but there's

nothing like living in a populous city where the galleries are active and the arts alive. This makes it easier to socialize with artists and collectors, invite them to the studio, and befriend them. People like buying art from people they like. Living in or near a population center makes this simpler, but it's also more costly and harried, so there's always a tradeoff.

Even so, there's nothing like taking up residence in one of the major cities for awhile, even if just a few months. In fact I consider it an unparalleled experience. But I'm not recommending that you become overly transient, since in the long run you'll likely do your best work in a studio you're comfortable with, in surroundings that inspire you, in a place that feels like home. If you choose a small town, great; the way you compensate is by being represented in a larger city, and by being active in it.

As for suburbs, God help you if you live in one. These are essentially designed as safe places in which to raise children, in a lifestyle that is primarily conformist, reflecting a frame of mind that is often apathetic. It's not for obscure reasons that Western suburbs— meaning European ones as well—have often been described as *sterile*. How would I know? I live in one.

After marrying, I decided not to subject my family to the whims of my artist wanderings, so moved us into an old bungalow that the developers forgot to demolish when they built our suburb. My wife and I could barely afford the joint, but it set my children up in a great neighborhood with excellent schools: the same Shawnee Mission District in which I'd been reared. Sure, the suburbs might not teach my kids independence of mind or the need to question authority, but I would.

The drawback was I could never seem to write in that place. So I wrote in the gallery. My first space was downtown, amid the street people and office workers and trash. This was a great place to write. The people were fascinating; the neighborhood was good for inline skating, and I was surrounded by old architecture that whispered of bygone lives. My current gallery, in an old part of the Country Club district, is a good place to write too. It may not have the grit of the first, but for me it still beats the suburbs.

In prior years I always lived either in the heart of a city, or deep in the country. Chelsea in New York or central Connecticut. Ballard

in Seattle or a farm on the Olympic Peninsula. Santa Monica in LA or a horse ranch near Solvang. I loved those places, but when the time came to raise a family, I chose a suburb. I'm not unhappy with that, although I sometimes think my more conservative neighbors are. They don't enjoy questioning their beliefs, but with a rebel like me bopping around, they're sometimes compelled to.

All I'm saying is you should either live where you're inspired or work where you're inspired. The part of the country doesn't matter, as long as you're in tune with the rest of the country. Besides, once you start to succeed, you can gain representation in galleries all over the country, who may end up selling your work all over the world. Then you'll be able to live wherever you want.

How will you gain that representation, and the success that ought to accompany it? Read on. With hard work and dedication, I can help you get there.

TELEVISION AND THE MASS MEDIA

The best thing to do with a TV, in my opinion, is to place it on the receiving end of a baseball bat. Little good has ever come from television, and the longer it's with us—with its multiple channels, opiate influences and passion-draining hypnosis—the worse it gets. Oh you can make sound arguments for public television and certain dramas and certain comedies, but the bulk of the programming is corrosive crap, perpetually eating at the foundation of our culture, educational system, and ability to relate to one another. Of course I'm not telling you anything you don't already know.

There's so much else to explore, touch, and know in life that an addiction to TV can prevent us from experiencing. Our job as artists is to be out experiencing the world, not to become homebound, spiritually numb victims of Madison Avenue. So if you're an avid watcher of TV, just be aware that the goal of the networks is to keep you that way, since profit is their primary motive, not cultural growth.

Example: In the late '90s I flew to New York to meet my first agent. I hadn't been there in several years, and was glad to be back. The mood of the place had changed since the '80s, having become more sane and upbeat. There was a sense of optimism that I don't think New Yorkers had felt, really, since the early '60s. In fact many

of the natives, upon learning I was an outlander, asked why I was there. I told them, and in every case they wished me luck. I could tell it made them proud to live in a city where an artist could submit his dreams, and great things might result. I'd never felt more at home in that enormous, swaggering, frenzied metropolis.

I rode the subway across town to my agent's office, and as I did, packed in with the executives and models and Hasidics, I gazed up at the advertising placards. There was Madison Avenue's whole mission laid bare. Ads for one of the big networks, they were listing reasons for why you should watch TV:

It's a beautiful day. What are you doing outside?
Scientists claim we only use 10% of our brain cells. That's too much.
Hobbies, Schmobbies.
Eight hours a day, that's all we ask.
Don't worry, you've got billions of brain cells.

And so on.

It's partly because of garbage like this that I became a writer, and probably why you're an artist. I could almost see the group of miserable souls who, together in some soulless office, composed these passages. It was so corporate—the very kind of corporate bullshit that people like you and me love to battle. Do our efforts matter? They will always matter.

You don't want to be a pawn to these commercial empires. Far better to be hip to their game and use them however you choose.

The Internet is similar. We're daily bombarded with information from a growing number of superfluous gossip blogs, e-magazines, and celebrity-driven websites. If you browse too many, you may wind up neglecting your work and dulling your senses, as if you've cut yourself off from the feast of life. I find the Internet in general, and social networks in particular, are adept at helping to deepen that sense of isolation. So while I participate to a degree, I'm careful to keep all that stuff at a distance.

Sure, part of your job is to be informed about the state of the world and its many cultures, but the other part is to live outside that world at the same time that you live within it. There's nothing wrong

with being well informed; in fact it's a kind of duty. To that end I read the paper every morning, listen to National Public Radio each evening, and read the *New York Times* weekends. I'm just careful to avoid getting sucked into the vortex of useless information while staying abreast of events. Sure, I also surf useless websites on occasion; hell, it can be fun. But for the most part I only utilize the Internet where necessary, whether in marketing art or conducting research for a project.

What I much prefer is conversation with a new friend, debate with an old one, a bout of volunteerism, a long jog, a brief swim, an engrossing book, a bad play, a good night's work, or a night of great sex. I get more out of these things than I ever will from an evening of televised tabloids, canned laughter, and websites that steal from my soul rather than feed it.

FIT

My brother calls it *mood maintenance*, his need to regularly bike, ski, rock-climb, or whatever. He loves how this helps him combat the blues. To stay active energizes us; to be energized helps us control our depressions; controlling depression allows us to work better.

I'm no jock but I do dig pushing my body, simply because the high gives me pleasure—hiking to the bottom of the Grand Canyon and back; learning to surf in my fifties; swimming twenty laps on a Saturday afternoon—before going out and drinking several beers on a Saturday night. Habits like this make me feel I can accomplish anything, and since I've often been faced with crushing odds, that's helped more than a little.

Why bring this up in a guidebook for artists? Because I've noticed that somehow, from art school forward, many artists get the idea that it's not cool to exercise. I don't know about cool, I just know that if you don't do it, the aging process sets in much earlier. And since a career in the arts tends to be something of a marathon, being out-of-shape just makes the challenges that much tougher.

For some people, getting exercise simply amounts to taking a walk each day, while for others it means training for triathlons. Either way, I'm not here to tout this rather obvious maxim. I'm just trying to make your journey easier, and staying fit is one of many things that,

by my experience, helps. Or as one of my gin-loving friends once put it before yoga: "Honey, you gotta detox to retox." That's not exactly my take on the issue, but to each her own.

THE SIMPLE ART OF READING

Do I really have to address something so obvious as this? For those of you who read regularly, of course not. But for those who don't, I feel I have to mention it for the following reason—the Internet, the magazine trade, and television are slowly killing what used to be a national drive to read books. This is a dangerous trend for any democracy, although I have little faith at this juncture that it will be reversed.

Whether you're self-educated or attended a university, knowledge is likely something you'll always hunger for. A great deal of that is acquired through experience and conversation, the rest through books.

I can't emphasize enough the inspiration that can come from a balanced reading habit. This will broaden your knowledge of the world, history, and artists, which will definitely affect you and your work. It will also assure you of how art is woven throughout all cultures, all peoples, all historical events. Sometimes art is influenced by those events, often it presages them. By reading about the people who populate the history of art, you'll learn about the natures, drives and adversities of artists from other eras. By studying other subjects, whatever those might be, you'll simply learn.

None of these things interest you? No problem; perhaps biographies will. When well written, a biography can read like a magnificent novel. If the book's about an artist you admire, then by the time you finish, you'll realize how much you have in common—the struggles, the despair, the successes. The book will also fill in educational gaps relating to the humanities, geography, and the commonness of the human experience.

Some of my favorite biographies have been on Orson Welles, Simone de Beauvoir, Degas, Truman, Duchamp, Gertrude Stein, Jim Morrison, Jackson Pollock, Sylvia Plath and George Bernard Shaw. Naturally these works not only discussed the life of the person concerned, but the lives of related figures and events. Then

there are the novels and books on history that I love to read, and reread.

Beyond books there are the usual art magazines and periodicals that you'll find relevant. Some of these will relate to your interests, others you'll be indifferent to. The right periodical though will keep you abreast of new installations, exhibits, debates, petty squabbles and emerging artists. Most of this is worthwhile, some is not. Either way, the exploration of it can be a great deal of fun.

Combined with new experiences, travel, and devotion to your work, reading will take you places that nothing else can, and open inner doors like nothing else will. It's the best way I know to commune with those who passed before you. But then I would say that, being a writer.

GRADUATE SCHOOL?

Before we go on to some of the more practical topics, I'd like to touch on graduate school a bit. Whether you went or not, or whether you intend to go, I feel it's important that you grasp the fundamentals of this option.

An M.F.A. is not for everybody, either financially or inspirationally. For those of you who are confident in your talent and connections, it may well be a waste of time. For those of you who don't feel this way, it would give you a couple of more years to develop your work, as well as those priceless connections that the art world so much revolves around. Even if your instincts guide you toward graduate work, there's not necessarily any hurry in signing up. Take a year off if you like. Move to some other part of the country, or some other part of the world. See how this affects you. Then when you're ready, make your return to academia.

Before choosing your school, you might ask yourself why you're going back. Is it to grow artistically, or are you merely going to kill time and chase boys/girls? Do you want an M.F.A .so you can teach? If you do wind up teaching, will academic life impede your artistic growth or will you thrive within it, despite its inevitable politics, intrigue and obligations? All these can be good reasons for getting the degree, I'm just asking if any apply to you.

If you do decide to return, you may want to consider selecting a school that's new to you, in a part of the country that's new as well. This will broaden your experience, and the credibility of your resume.

Assuming you gain acceptance at the school of your choice, what can you expect? Greater freedom, for one thing, to choose the courses you want and to spend a lot of time in the studio. Many of your required courses will be behind you. Now you'll be able to focus on your work. Also, other artists in the program will, like you, be at a higher level of accomplishment. You'll find this stimulating—and on occasion frustrating, especially if you feel they've outdistanced you. Please don't think that way; you should run by your own clock, not anyone else's.

You'll also get the chance to meet established artists who may occasionally visit campus. Get to know them, if you can. Older artists, for the most part, love helping younger ones. You'll benefit from their experience, and perhaps pick up a contact or two.

Apart from all this, you'll also get to spend time with professors who have been in the game for decades. They'll likely take you more seriously now than when you were an undergrad. Bull sessions over wine or coffee will give you insight, encouragement, and on occasion, discouragement, depending on the nature of the prof and her level of optimism/cynicism.

Many of those professors will tell you about their work, their lives and experiences. Some of them will be outstanding artists as well as outstanding teachers. Some will be average artists but amazing teachers. Others will be just average as both artists and teachers, burned-out on everything—teaching, students, art, life itself—which isn't to say they didn't breathe fire at one time, before the burdens of living wore them out.

Try to gravitate toward professors who inspire you, and who have a realistic view of the world you'll soon enter. Their wisdom is critical.

If you choose to enter that world as an instructor, please just make sure you're as devoted to teaching as you are to your work. If you don't feel the drive toward creating as deeply as you do toward teaching, fine. Perhaps that will be your art. If so, I can think of few things more needed or selfless.

HERITAGE

Whether we like it or not, America is the country that formed us (unless of course you're from a different country). We're citizens of the world, sure, and most of us labor to attain a world view. But whatever our view, this remains the country that gave us the opportunity to pursue our calling, and that formed many of our attitudes.

As Americans we've accomplished much for the world that is good, and have rendered plenty that is bad. We're by turns a mediocre, whining, dissatisfied people, using up resources far in excess of our needs while always demanding more. Yet we can also be brilliant, stoic, generous, and we do remain, despite our various flaws, one of the world's great republics. I try not to take that for granted, though I often do. I also try to remain mindful of the people who came before me, sacrificing for the right to vote, the right to an education, and the right to a life of dignity.

I don't discount either all those soldiers who died on our own soil, on faraway beaches, or in distant jungles and deserts; some for the preservation of democracy, others for the most paltry of capitalist motives. Most had no choice but to serve, regardless of whether politicians sent them for reasons of nobility or greed. And going to war changed their lives irrevocably, whether through the loss of time, career, limb, or life itself. Some of them were artists, and many of them hated war.

Regardless of the war, or time in history, those people served so that you and I could have the privilege of drinking beer on Friday nights and complaining about what a bitch it is to be an artist. I know; I did my share of that when younger. Now I just try to remain grateful that I'm able to pursue my dreams and overcome my hardships, since the bulk of the world's artists will never get that chance.

Grapple with your hardships—you're meant to. Then transcribe the experience into brilliant work—you can.

CHAPTER 4

How do you begin the process of putting your career together, gaining a following, and achieving your goals? Well that's a complex, multi-layered question which I'll address in stages. I'm going to begin with some fairly obvious topics, since I'm obligated to cover the basics before moving on to the subtleties. So even if you feel you've already mastered these aspects you might want to browse this section; you never know when a useful idea will come up.

HOW WILL YOU KNOW WHEN YOU'RE READY TO SHOW PUBLICLY?

By this I don't mean showing in a gallery, but in public venues, since before most galleries will consider your work, they'll want to know where you've exhibited. But before you begin that process, you may want to ask yourself whether you've realistically evaluated your work, since we're all on occasion guilty of self-deceit. To do this, ask a few qualified critics to give you feedback. And please note, by *critic* I mean someone who isn't in love with you, isn't a relative, and doesn't owe you money.

Rely on people who will be honest, who have a good eye, and appropriate sophistication for what you do. This means that if your work is avant-garde, then a devotee of Thomas Hart Benton would likely not be a good choice. Whoever your critics are, consult them, and the harsher aspects of your inner voice, before you commit to exhibiting. After you've covered these bases, then by all means proceed.

Example: In my case, how did I know when I was ready to begin approaching literary agents? Because after having written for fifteen years, I'd become confident in my work and my critics felt the same. Once I achieved that, I doggedly went after the agents. Four offered me representation.

What if I had approached them five years earlier? I'm certain that all would have turned me down, and I'd have slid into that common pit of rejection/despair. My work wasn't mature enough at that point. Similarly, I advise that you don't push too hard for public exhibition until you know you're ready. There's no rush; take the time to prepare and grow so that you blow away your viewers the first time out.

You may still be in art school when this occurs, or several years out. However it works, you can be sure of one thing: there's no way you'll be as well prepared for your first show as you will be for your fifth. But diving in and undertaking that first show is how you'll learn to prepare for the later ones.

ESTABLISHING GOALS AND SETTING DEADLINES

If you're working to become a successful artist you're essentially working to become self-employed, building a career that eventually allows you to quit the day job. One of the best ways of achieving this, apart from creating magnificent work, is to master the task of defining goals and setting deadlines. I realize this is a given, but have noticed that artists don't tend to excel in this area of career-building, while other professionals—architects, executives, lawyers—often do? Why? Because the firms they join assign them goals and if they don't fulfill them they're fired. For artists and other entrepreneurs, goals must be self-fulfilled. No one fires you if you fail, but if you're always broke and your career going nowhere, it amounts to the same thing.

Most artists would frankly rather just create than be bothered with this stuff. I don't blame them; so would I. Unfortunately if we don't have a specific goal that we're constantly working toward—with a deadline assigned to it—we likely won't create with as much drive and focus. I constantly have to assign difficult goals to myself and my staff, then we must achieve them in a certain amount of time if we're to take care of our families, as well as all the careers we've been entrusted with. I dig some aspects of that, especially when success results, but do weary of the process now and then. I'd a hell of a lot rather just be working on my novels. Unfortunately they're not bringing home the bacon yet, so I must remain focused on setting goals and deadlines. Because I enjoy the art biz, that's not such a bad thing.

Everyone I know who is successfully self-employed, be they artist or restaurateur, is faced with this same chore. Those who master it normally succeed; those who do not normally don't. Of course it would be great if all you had to do was get into a gallery, blow everyone away with your first show, then sit back and field the calls from collectors, critics and talk-show hosts. After all this does happen—to maybe one artist in a million. That's what is known as *Right place, Right time*, whether you're a sculptor, actor or musician. For the rest of us, building up a career is a process that takes many years. You may as well accept that likelihood, with the self-imposed goals and deadlines that will help make it happen. It's not really a drag, especially when accompanied by successive achievements, and a lot of fun, along the way.

Goals and Deadlines: An effective way to handle this task is to write out the goals you want to achieve this year, then over the next few years, then over the next ten. You should assign a deadline to each, since a goal without a deadline is just a wish—to paraphrase Antoine de Saint-Exupéry.

Set your sights high but be realistic. Otherwise you'll needlessly set yourself up for failure and depression—which none of us needs more of. Go back and review the goals every few months, adjusting them to suit the changing course of your life, since all our lives are constantly evolving: tragedy, ecstasy, failure, success. Honestly assess if you achieved what you set out to, and if you haven't, why

not? Don't be too hard on yourself, since you are your own best ally, but do kick yourself in the butt if necessary. That's been a regular practice of mine all my life, though I do it kindly.

Example: Here's a set of goals that I helped a painter in his late '20s throw together. It's typical of what I'm referring to. In fact you can find dozens of sample goal sheets online, but this one of course applies to artists.

—⊗— —⊗— —⊗—

Jake's Ten-Year Plan

This Year:

Join an artists' coalition.	Start:_____	End:_____
Get accepted by a cool gallery.	Start:_____	End:_____
Participate in at least one group show.	Start:_____	End:_____
Submit to six juried shows in other regions.	Start:_____	End:_____
Participate in Open Studios Weekend.	Start:_____	End:_____
Finish one painting every two weeks or so.	Start:_____	End:_____
Get a handle on my partying.	Start:_____	End:_____

Two Years from Now:

Submit to six juried shows in other regions.	Start:_____	End:_____
Design a new website.	Start:_____	End:_____
Increase prices.	Start:_____	End:_____
Book first one-person show in the gallery.	Start:_____	End:_____
Finish fifteen strong pieces for the show.	Start:_____	End:_____
Submit work to art magazines to get press.	Start:_____	End:_____
Finish one mature painting every week.	Start:_____	End:_____
Finally get to Europe.	Start:_____	End:_____

Five Years from Now:

Be in in three galleries in various regions.	Start:_____	End:_____
Participate in at least one show per year.	Start:_____	End:_____
Submit to six juried shows in other regions.	Start:_____	End:_____
Finish one mature painting every week.	Start:_____	End:_____
Land magazine and newspaper articles.	Start:_____	End:_____
Increase my prices.	Start:_____	End:_____
Drink cheap champagne to celebrate.	Any date will do.	

Ten Years from Now:

Be in five galleries in various regions.	Start: ____ End:____
Participate in at least two shows per year.	Start: ____ End:____
Continue submitting to six juried shows.	Start: ____ End:____
Finish one great painting every week or so.	Start: ____ End:____
Make enough money to quit day job.	Start: ____ End:____
Prices reflect my many achievements.	Start: ____ End:____
Return to Europe; drink better champagne.	Any date will still do.

Unfortunately Jake didn't get accepted by a gallery until the second year, but adjusted for that by completing several paintings for a one-person show he set up at a swank restaurant on 39th Street in Midtown. Of course the show had a deadline, which he either had to meet or infuriate the restaurant owner, so he met it. Nor did he exactly finish a painting that he was happy with every two weeks, but the last I heard, he was holding himself fairly close to this. All of the other goals for his first year he fairly well achieved—thanks in part to this rather tedious list, and the deadlines he assigned to each task. Did he enjoy drafting this? Not much. Did he dig it when things began to click? Sure. Will he keep redrafting this after he begins to succeed? Likely not.

If you don't feel you need this, cool. Some people can do it just by keeping a mental list that they check off periodically. But that is not a common trait. So you might try this in a way that suits you, as long as the process stays in step with your inspiration. Go back and update it as needed—especially sticking to the deadlines you assign yourself.

I fear that if you don't do this, or something like it, your career will not really move forward. Hence that coffee shop where you go to hang out with friends and talk about your careers, and how you wish yours was farther along? Ten years from now you'll still be having the same conversation, only with less passion. Please don't do that to yourself. Set the goals, set the deadlines, then achieve them repeatedly, since this is a process we pretty much follow our entire lives. Once things go well, you can write me a note from your vacation spot

in Jamaica, and tell me how glad you are that you kicked yourself in the butt all those years ago. I would enjoy receiving that.

PHOTOGRAPHING YOUR WORK

I'm not a technical writer, so I'm not going to get into the intricacies of photography in that sense, but I will cover the basics.

I used to hire photographers to shoot slides and transparencies of my artists' work. Now we do everything digitally, whether I'm working with a professional or one of my staff members. A pro will typically charge by the hour, whatever the going rate is. This doesn't mean you have to hire the most expensive shooter in town. Instead, try to find an emerging pro who shoots out of his home. You can locate these people on the Internet, or through photography societies. Later, as you learn about the process, you'll be able to shoot your own work competently if you wish.

One of my artists shoots her abstract oils outdoors against the wall of her garage, using a basic digital camera she bought for $250. The lighting is adequate, she crops the garage out of the shot, enhances the contrast digitally, and the galleries all think the photos were taken in a studio. If the day is sunny, she simply puts the piece in mild shade. Because almost all galleries review digital images before asking to see originals, she doesn't bother printing photos unless this is requested.

This rather unorthodox method works, but ultimately it's best if you set up a corner in your house where, with the proper lights, you'll be able to shoot your work indoors, night or day. When you do, don't use a flash. Like direct sunlight, it will wash out color and cause glare. It's best if you shoot under controlled studio lighting with covered strobes. If a background must show, it should be neutral.

It used to be a standard practice to shoot both slides and prints, but now most artists keep everything on disc or some form of digital storage, printing only what they need. When a client or gallery requests images, you simply send them by e-mail, following up with a printed photo if necessary. Normally that isn't needed, as everyone is trying to use less paper these days.

Finally, do you need to photograph every work that you create? If you feel compelled to, sure. If not, just shoot the ones you're hap-

piest with. But please, always be sure to shoot and document a piece after it is sold. You can use the fact of the sale, and where it was placed, for marketing purposes later.

Speaking of which, please try not to look down on words like *marketing* and *promotion*. Robert Rauschenberg was a master promoter. So were Diego Rivera, Pablo Picasso and Georgia O'Keefe. It's an essential part of the business. It can be a distasteful part if handled poorly, or rewarding if handled with integrity and passion. We tend to prefer the latter approach.

RESUMES

A succinct, well-written resume is an essential tool. Below is a typical one, this for one of my sculptors who works in stainless steel. Some of the achievements I've listed are substantial, some not. I list them all regardless, since as a whole they seem more impressive than they do individually.

ARLIE REGIER

Education:
1955 Degree in Sculpture Design, CO State University,
 Ft. Collins, CO.
1962 Studied sculpture under Richard Stankiewicz, New York, NY

Juried Exhibitions:

2010 Group Show, Leopold Gallery, Kansas City, MO
2009 Two-Person Show, Adieb Khadoure Fine Art, Santa Fe, NM
2008 One-Man Show, Leopold Gallery, Kansas City, MO
2007 Boston Museum of Fine Art
2006 One-Man Show, Adieb Khadoure Fine Art, Santa Fe, NM
2005 One-Man Show, Leopold Gallery, Kansas City, MO
2004 One-Man Show, Khadoure Fine Art, Santa Fe, NM
2003 One-Man Show, Khadoure Fine Art, Santa Fe, NM
2002 Sculpture in the Park, Loveland, CO
2002 One-Man Show, Leopold Gallery, Kansas City, MO
2001 One-Man Show, Khadoure Fine Art, Santa Fe, NM

2000 Sculpture in the Park, Loveland, CO
2000 Two-Person Show, Khadoure Fine Art, Santa Fe, NM
1999 Sculpture in the Park, Loveland, CO
1999 One-Man Show, Leopold Gallery, Kansas City, MO
1998 Two-Person Show, Shidoni Gallery, Santa Fe, NM
1993-97 Sculpture in the Park, Loveland, CO
1993 Laumeirer Contemporary Craft Show, St. Louis, MO
1992 Sculpture in the Park, Loveland, CO

Galleries:
Leopold Gallery, Kansas City, MO
Adieb Khadoure Fine Art, Santa Fe, NM
Vail Fine Art, Vail, CO,

Select Commissions:
2010 "Abacus," BKD, LLP. Kansas City, MO
2009 "Deep Sphere," Warner Brothers (for the film *Watchmen*),
 Los Angeles, CA
2008 "Hemisphere," BKD, LLP. Springfield, MO
2007 "Five Rings," University of Kansas Hospital, Kansas City, KS
2006 "Sphere," H&R Block, Kansas City, MO
2005 "Horizon Interrupted," Loveland Sculpture Garden,
 Loveland, CO
2004 "Stellar Outpost," Private Collector, San Diego, CA
2003 "Giving More Than You Take," Osborne Plaza, Olathe, KS
2002 "Design & Innovation," Overland Park Convention Center,
 Overland Park, KS
2001 "Picasso's Eye," Private Collection, Boston, MA
2001 "Design and Innovation," Mack Truck, Bethlehem, PA
2000 "Floating Sphere," Private Collection, San Diego, CA
1999 "Ripened Grain," DeBruce Grain, Kansas City, MO
1998 "Hemisphere in Steel," Douglas Adams (author),
 London, U.K.
1997 "Pathfinder," Private Collector, Santa Fe, NM
1996 "Elevators, Wheat" Kansas City Board of Trade,
 Kansas City, MO
1996 "The Journey," Private Collector, Las Vegas, NV
1996 "Westward," Private Collector, Miami, FL
1994 "Monolith in Steel," Private Collector, Denver, CO

Media:
Kansas City Star
Shy Boy and She Devil, Museum of Fine Arts Boston
Not By Bread Alone, Paperback Book
Southwest Art Magazine
Kansas City Star Magazine

This resume fits onto one page and reads quickly. Do I mention that Arlie nearly gave away his first commission? No. Nor, when I was building up his career, did I ever discuss how many rejections he received in the early days. The only thing I discussed was what an exceptional sculptor he was, and the incredible future he was facing. Once he began to achieve his successes, I was willing to discuss his difficult years with clients, since it's a great story and inspires admiration. Likewise, I advise that you only discuss your work in terms of success, not failure, until the failures are behind you.

Example: When the Beatles, largely unknown in 1962, were preparing to leave Liverpool for a gig in Germany, their manager printed posters promoting a concert they were to give prior to departing for their "European Tour." That tour was a long-term engagement in a Hamburg nightclub, where they slept in a dank backroom and played eight hours a night for pfennigs. Did this type of promotion detract from their following? To the contrary, it helped establish them. Within two years they were on the Ed Sullivan Show, and the music world was changed forever—if not certain aspects of the world itself.

If your work has substance, these mild exaggerations do no harm. It's the work that counts; the promotion merely helps you get the public's attention so they can assess it for themselves. So fill out the resume, exaggerating if you must but never lying. As the years go by you'll achieve things of greater significance, making moot the need to exaggerate. Of course it would be great if you never had to do this, but rarely will you meet a successful artist who didn't have to in the beginning. Very rarely.

BIOS

If you haven't accomplished enough yet to make for an impressive resume, you can write a biography. A bio sums up your education, philosophies, exhibitions, etc. Just make sure it has real substance. Here's one we currently use.

Jennifer Boe Bio

Jennifer is a graduate of the Kansas City Art Institute, and has been working in fiber since 1998. She creates works in needlepoint, interpreting different aspects of contemporary society: junk food, tobacco products, everyday retail items... The fact that she takes a demanding craft best-known as the pursuit of women from another era, and interprets contemporary culture with it, provides an ironic commentary that requires no explanation. Jennifer considers her work a combination of aesthetics and artistic philosophy.

Private collectors nationwide own her work. Other collectors include the Nerman Museum of Contemporary Art, H&R Block, and the University of Kansas Hospital. She was recently featured in *Bust Magazine*.

This is a brief bio for a young artist. Naturally our bios for established artists are longer. If you can glean any ideas of how to write yours from this, be my guest.

ARTISTS' STATEMENTS

Keep your statement brief, and if possible, keep it to one page. Put in your educational background, and any relevant experience or shows that you have behind you. Otherwise, just let the images of your work speak for themselves.

Your philosophies, inspirations, and ideas? These are an important reflection of what drives you. You can detail them if you want, but again be brief. The people viewing your work, for the most part, aren't as interested in that as much as in the work itself. We live in an age where everyone is bombarded with too much information daily. There's not much point in adding to that, when your work is supposed to provide relief, shock, or contrast to those very elements in our lives.

PORTFOLIOS AND PRESENTATION FOLDERS

These are not as essential as they once were, since many artists now just email a link to their website, which serves as an online portfolio (I'll get to sites later). But still I find the physical portfolio an irreplaceable tool. Yes they're a hassle to assemble, but if you look on the portfolio as a work of art itself, utilizing a presentation that is stunning, it won't seem such a bore. Spend the necessary money on it, and on the photography, to make it look strong. For those of you who have no interest in selling your work, create the portfolio in whatever way you wish. Make it sleek, make it jagged, make it out of duct tape if you like, so long as the finished product accurately represents your art.

Basic approach:
- Portfolio Size: Any of the larger sizes, such as 20"x 26"
- Size of Photos: 8" x 10" or 5" x 7"
- Inclusions: Resume or Bio, Artist's Statement, Press Clippings.

Lay out the photos two-to-a-page or four-to-a-page, depending on the size. My preference is two 8" x 10s" per page, because they create the strongest visual impression—and that first impression is the most important one you'll make. Please never forget this, since you won't get a second shot at doing it.

After you've laid out the photos, put the resume and artist's statement at the end. I never put these at the beginning, because I want the viewer to be knocked out by the visuals first. Once they have been, they'll be happy to read about the artist.

You'll also need a photo page that shows the works in the portfolio in the form of large thumbnails. Along with that sheet you'll need a CD that shows each image in the portfolio, as well as your resume, contact information, and other works. It would be cool if you'd take the time to make a cover label for the CD utilizing one of your images, with your contact information printed on the label. Always have several copies of the CD in the portfolio, so you can leave one behind with a prospect.

Anytime you show your portfolio, try to have an original with you, since the work itself will always read better than a photo. If a gallery director or collector likes the portfolio, you can reinforce this

by casually showing them the original jewel you have at hand. Note use of the word *casual*. Contrary to general misconceptions, the art business does not function at its best in a mode of tension and pretension. Rather it works best when everyone is relaxed—artist, dealer, collector. Relaxation leads to trust, trust leads to sales, as well as lasting relationships.

If you can't afford a portfolio, or don't like lugging one around, then use a presentation folder. You can find these in any office supply store. I prefer the ones that are made of recycled paper, with two pockets inside. They're the size of a notebook, and can make an impressive visual statement—although not as impressive as a portfolio. One advantage, however, is that you can make up several presentation folders to leave with or mail to various prospects. You should design a label for the front with whatever design you prefer, unless you can afford to have it embossed. A business card should go inside.

Along with the photos and resume, you'll need to include any press clippings you might have garnered over the years, and a select list of clients. What? You don't have those things yet? Don't worry. I'll go over the getting of press, as well as how to acquire that coveted list of clients.

Finally, on your laptop you should always have an updated PowerPoint that serves the same purpose as a portfolio. In fact some people prefer these to a physical portfolio. I use both. But when I'm having coffee with a prospective client for the first time, opening a huge portfolio doesn't exactly work, and anyway it limits me to the number of images I can show rapidly. So in this case, a PowerPoint is preferable. I can also email these to clients, and cover any given project or artist comprehensively. You can do the same.

But since you'll only be showing your own work, and not that of thirty other artists, a physical portfolio can make a grand impression. Further, you can leave the client a PowerPoint on disc in the presentation folder that covers the same territory, so they can review after you've gone. Many people, as the digital age advances, prefer this approach. I do in certain instances. Otherwise, to me, nothing quite makes the impact of a physical portfolio. There's something time-honored and beautiful about clients turning those enormous pages,

and staring at your work in wonder. And while I do use PowerPoint the majority of the time, I'll always fall back on portfolios when the situation calls for it.

ARCHIVAL PROCESS

How many times have I had an artist enter my gallery who had created a great work of art, but wasn't familiar with the basics of archival process? Dozens.

Maybe it was a framed etching, but backed by acidic cardboard. Maybe it was mixed media utilizing various types of paper, but the paper hadn't been sealed—meaning the piece would eventually fall apart. Maybe it was a sculpture composed of various metals that would begin corroding in five years because of metallic incompatibility. Repeatedly I've seen instances of this, and couldn't carry the works because I can't sell art that is at risk for deterioration.

What happens if you don't pay attention to these details? You'll get a reputation for shoddy work. Galleries will drop you. Clients will drop you. Clients may demand refunds. Career on a downhill slide.

So it's important to understand this process, though I realize it's a bore. Likely you were taught about it in college, or have taught yourself. Either way, here are some basic points:

- UV Glass for Works on Paper: It's your choice whether to use UV glass or not. Sure it costs more, but you're protecting the client's investment, since they may hang it in a sunny room (unless they live in England). Regarding the additional cost, just add that to the price.
- Framing Works on Paper: I know this seems obvious, but always make sure that the image doesn't touch the glass after framing, and that only acid-free materials are used. If you're a pastelist, you may want to consider applying fixative before framing, else flaking may result within a few years.
- Stretchers: If you paint on canvas, please make sure that you use kiln-dried poplar, or some similar wood, for stretchers. Why? I've seen painters use pine that they dug out of some scrap heap, and it invariably warps. Another solution is to buy pre-manufactured stretchers. They're often cheap.

- Varnishing Paintings: Naturally varnish protects oils and acrylics against moisture and dirt. If you like working with it, make sure it's applied after the paint has cured. If this means going to the client's house six months after they bought a piece, great—that opens the door to renewed contact and further acquisitions.
- Metal Sculpture: When you fabricate, if you use more than one type of metal, make sure the metals you choose won't undergo galvanic corrosion owing to incompatibility. This means you can't mate stainless steel to mild steel, bronze to mild steel, copper to mild steel, etc. Any metallurgist or metal supplier can advise you. Me? I get advice from a group of Missouri rednecks who do our fabricating at a nearby shop—flawlessly—and who don't charge for advising, except the odd latté. Yeah, rednecks drink lattés around here.
- Warning Labels: Clients do on occasion hang works in direct sunlight. To help inform them, I advise you put a label on the back of any piece that can be damaged by UV rays, stating how the work should be hung. Of course an alternative is to tell them to hang everything in direct light, then maybe they'll come back and buy a new collection in ten years, but I wouldn't advise it.

As a gallery owner, I've never had a client complain about a piece, its assembly, or fragility. This is because I work with my artists on approaches to take if they're inexperienced in that area. I mean an artist is so consumed with creation, that sometimes these details elude them. But one reason I keep getting referrals is because we pay attention to these details. If you handle these details well, your reputation for professionalism will only broaden. That's a fancy way of saying you'll make more jack.

PRICING YOUR WORK

How do you establish fair prices for the works you create—meaning fair to both you and your collectors? Easy. Get a dartboard, tape a range of prices to it, toss six darts at the sucker, and see where they land. The middle figure wins.

You don't like that? Then try this: go to several galleries, find works by established artists that are in some way similar to yours, then

compare prices. If the established artist is in the range of $15,000 per painting, this is likely not a realistic comparison. If they're in the range of $700 to $4000 per, depending on size, that may be more suitable. Even then, it would not be practical for you to charge the same prices right away. The artist whose work you're viewing has probably been at it a long time, paid heavily in his dues, and is now reaping his rewards. If you're in the beginning stages of your career, you may not be at his level yet, though in time you should be.

The same rules apply to sculptors, glass artists, ceramists, etc.

Of course I can't tell you what prices to set, but I can say that initially they should be moderate. Why? You want to sell as many works as possible, which for emerging artists is typically achieved through moderate pricing. Your collectors can then be listed on your resume and website (if they're private collectors, you'll have to get their permission), which will lend your work greater credibility as your career expands. In the beginning you want to make it easy for collectors to buy your work. It should be easy later on too, just at a higher price.

In relation to this, I'm often asked by novice browsers why paintings and sculptures are so "expensive." In my gallery, prices currently vary from $800 to $25,000 for in-house pieces, and up to $300,000 for large commissioned works. This is hardly expensive by New York standards, but these prices are understandably high for the majority of the populace who are just trying to get by, get their kids through college, and save a little dough along the way. The question is a reasonable one, so I always give a reasonable answer.

I do this by explaining that my artists have been working in their disciplines for anywhere from twenty to forty years. They've established, through decades of struggle, techniques that are unique to them, have now reached the point where they're due compensation for the privations they've suffered, and that their families have often suffered as well. To charge any less would be an injustice. I carefully explain all this, and then ask the questioner if they'd been down such a long, exhausting, risk-imperiled road, what would they charge? Invariably they say, *More.*

I say, *Very good*, then proceed to close a sale.

CHAPTER 5

WHERE TO SHOW IN THE BEGINNING

I f you're not in a thriving gallery yet, how do you get your work before the public? Easy. In fact here's a list of possibilities.

Corporate Offices: Every corporation has a group of art lovers within, and potential clients throughout. There are thousands of corporations throughout this country, and in most other nations for that matter. This means that no matter where you live, there are several corporations in relative proximity to you. Choose the ones you want to work with, and contact the person responsible for displaying art. Sometimes this is an executive assistant, sometimes an office manager. Of course most corporations have never done this. Great! This is your chance to introduce them to something new.

You can install your work in the executive offices, main lobby, or elevator lobbies. Wherever you install it, you want it seen by the largest number of people possible. Price and title each piece, and put out a resume with your contact information on it. Make

sure the area where you install is secure, and if possible, have the corporation insure the works, though they'll likely resist that.

After installing, organize an opening. Invite your friends, their friends, their business associates, etc. Try to make sure that people who can afford art attend, along with your usual cast of characters. Make yourself accessible at the opening. Don't be aloof or drunk, and never worry about being nervous—that's a perfectly human and endearing quality. But mostly, engage others. You don't need to talk exclusively about your work, although if you want to sell, conversation will have to gravitate in that direction, and you or someone who is with you will have to try to close on sales. The easiest way to do this is to allow people to take a piece home for consideration; if they like it, it probably won't come back. Equally, you must try to get the corporation to buy a couple of pieces before the show comes down. If a private collector or the corporation resist buying, offer to come down ten percent on the price, twenty percent if you must, but no more. Coming down too far demeans the work, and you.

Even so, don't make discussion of your work the sole focus of the evening. Relax. Tell a few jokes. Have a few glasses of wine. Have fun. Fun, like trust, leads to sales.

Restaurants: Any well-patronized, well-lighted restaurant will do. Talk to the owner. Chances are, if they're not exhibiting art, they'll be thrilled to have your work there—assuming they respond to it. If they don't, talk them into it anyway. You're not selling to the owner, who may have no appreciation of art whatsoever, but to her customers. They're the ones you want to reach. Try to choose a restaurant of some affluence, since that will make sales more likely. Then call a meeting with the wait staff, offering each a ten percent commission for every buyer they send you. If they're passionate about your work, they'll be happy to discuss it, hand out postcards, and send clients your way. Naturally they should be rewarded for going to the trouble.

City Offices: Many city halls and administrative buildings are open to exhibiting art. You may not get many sales, but at least it's a venue and a line on your resume. If you're a painter but are not allowed to hang work on the walls, use easels. If you can't afford to buy easels, build some. Lumber is cheap, and anyway your designs will likely be more interesting than those of the store-bought variety.

Other Venues: Churches, university galleries, upscale bookstores, upscale hair salons, hotels, architecture firms, interior design firms, law firms, convention centers, airports, private clubs, or a showing in some socialite's home. You don't know any rich socialites? Tap someone who does. This may lead to introductions, which may lead to interest, which may lead to sales.

Cooperative Galleries: You could always try to start one of these if you like. They are essential to the art world, and for over a century have contributed to America's understanding of, and coming to terms with, art. They're fascinating, can be a great deal of fun, and almost always lose money.

If you do start one of these, make sure the director has sound business as well as aesthetic sense. Rarely does an artist have the former, since we don't tend to be wired that way—although there are always exceptions, Dale Chihuly being a case in point. So if you don't have business experience, no matter, there are many other ways you can assist—you can hang the shows, you can paint the walls, you can update the website. But please assign the bulk of the business and marketing decisions to someone with appropriate talent. If that happens to be you, fantastic. However this role is filled, it's best if more than one person participates, since it takes a qualified team, with cooperative attitudes, to effect winning strategies.

If you do start a cooperative gallery, I salute you. It's a noble undertaking with ample difficulties: organizing shows, attempting to interest collectors, paying rent and a multitude of other expenses, dealing with marketing and staffing, and trying to ensure that everyone gets along. It's no easy task. Should that gallery wind up closing, it's quite possible that you'll be tired of the art business by then, and that those who started the cooperative will no longer be speaking. That's all right. Get it out of your system, admit your trespasses, forgive the trespasses of others, and move on. We've all had to do that in one way or another, including me.

Whether it succeeds or fails, opening a cooperative gallery can teach you valuable lessons about the art world in general, the art business in particular, and the challenges of both. If the cooperative doesn't fold, everyone gets along swimmingly, and you even turn a profit, please tell me how you did this. It's rare.

PRESS

When I first opened my gallery, I immediately set about learning the art of the press release, and developing relationships with journalists that were based on mutual respect. It would take years of accomplishment for those relationships to bear fruit, since no journalist wants to cover you unless you have a worthwhile story to tell. Eventually we would have dozens of stories to tell, but in the beginning no one wanted to cover an unknown gallery—and without press in the arts, you die.

To compound this, I regularly got the response from certain papers that they could cover my artists completing a commission, but not the gallery, because that would seem as though they were plugging us. I couldn't believe my freaking ears. Here I'd busted my butt to land the commissions, risked every cent I had to promote regional artists, worked as project manager and sometimes co-designer, and the media couldn't give us credit? Not a day went by that they didn't give credit to H&R Block, Hallmark or Sprint for their successes, but apparently we were supposed to go unmentioned.

This was my introduction to one of the curses of the gallery business, meaning, if your artists are applauded the gallery is often ignored, as if it had nothing to do with their success. In fact a gallery will sometimes be condemned for trying to turn a profit from art, as if that's an evil practice. The hypocrisy of these attitudes goes a long way toward explaining why so many galleries fail. In my view, neither the gallery nor the artist is more important than the other: they are equal partners who must work together to succeed.

But if a gallery can't get credit for its work, it will indeed fail. This will cause the culture in your region to suffer. Why? Because when an artist can make income from their work, they'll stay in the area and contribute to it. But if no one buys from the gallery that reps them—which amounts to making an investment in that artist—they'll flee. That act of fleeing has been a practice in the provinces for over 200 years, where few serious artists stayed, since their own regions refused to support them. I was determined to help reverse this trend, but knew that I would need the help of journalists to do it. First, however, I had to convince them that if it was okay to write

about Garmin, it was okay to write about us. Eventually I did and they've been fantastic allies ever since—especially *The Kansas City Star*—recognizing that what we were doing was both culturally and financially important for the region.

All told, getting press is not that difficult. Journalists are creative people and tend to respect artists. Thanks to them, my artists and I have appeared in over one hundred articles, and have been interviewed on TV and radio dozens of times. Did this happen by luck? I wish it had; that would have saved me hundreds of hours writing releases and making phone calls.

Anytime you organize a show or major installation, you should try to get it covered. That will prove a pleasant diversion for the journalist, who may otherwise have to cover political scandals, robberies, and murders. How do you get their attention? With a press release, accompanied by solid photos.

Below is a release I sent out to area papers and TV stations as one of my projects neared completion. My releases tend to read more like a letter than a form, since I prefer addressing each journalist personally. Note that I open with the essential facts, since journalists have time for nothing else.

Media Organization
Name
Address
City

Dear _____:

Earlier this year H&R Block commissioned dozens of regional artists to execute site-specific works—some of them enormous—for the new H&R Block Center. Installation of the lobby and exterior works will begin on 10/16 at 9:00, concluding on 10/18.

Some of the artists whose works we'll be installing: Lisa Grossman, STRETCH, Lonnie Powell, Leslie Reuther,

Vernon Brejcha, William Lobdell, Dierk Van Keppel, Brent Collins, Adolfo Martinez, Dave Regier, and seventy others.

We only used regional artists for this project, with the intent of advancing culture in our area. I hope you'll help us celebrate this collective achievement, which we feel will garner national praise. If you have any questions, just let me know.

Sincerely,

Paul Dorrell
Director/Art Consultant

You can send this via email or postal service. I alternately use both methods, depending on the journalist I'm working with, and their level of inundation. With the advent of email, some journalists receive up 200 queries a day. You don't want to get lost in the hubbub. In those instances, a mailed release with visuals will likely get closer scrutiny, followed up by email once the journalist knows who you are.

With most stories I've landed, follow-up has been necessary to ensure that the journalist received the release, and to learn if they're interested. By politely persisting, you may get your story, but please note the word *polite*. Journalists owe us nothing, are overworked in a demanding profession that is going through convulsive changes, and they often receive only moderate pay. It's important to try to understand the realities they cope with. In addition, if they feel your current story doesn't warrant coverage, you have to let it go. Never try to force coverage, as that will earn you disdain—although you can always pitch the same story to a writer in a different department.

You don't have to be involved in an event as large as Block to get a story. We've gotten press on single murals, a single outdoor sculpture, or an emerging artist having her first show. Any public event will do, and often corporate events as well, as long as there's a human-interest angle. Never assume that reporters won't cover your story; just send them the information and let them decide.

RECAP ON SENDING OUT A PRESS RELEASE

- Three weeks before the event, write a one-page release.
- Enclose or attach at least one stunning photo and, if relevant, a bio.
- A few days after mailing, call the reporter and casually inquire as to whether they'll be covering. If they're not sure, tell them you'll check back later.
- If you haven't heard from anyone within a week, check back. Don't make a nuisance of yourself, but politely try to get a commitment.
- If you feel the story will interest TV and radio stations, approach them as well.

What if the paper wants to do the story, but can't send out a photographer? Shoot the event yourself, then send the best shots to the journalist. Why? You're dealing with a visual world. An article without a photo is about as useful as a bike without wheels.

After the article appears, cut it out with the date and name of the paper pasted at the top, then place it in your portfolio. If you have a website, transcribe the article and place it on the appropriate page of your site—buying copyright permission from the paper if necessary. The more articles, the better. Just as important, list the occurrence of the article on your resume.

What if no paper is willing to cover the event? Then, if it's an opening, make sure that they list it in their events calendar. In fact you should ensure they do this even if they cover the story. If your paper doesn't have such a calendar, petition them to create one. It is the obligation of all papers to inform the public of cultural events. This includes art openings, just as it includes museum functions and social fêtes.

Major installations are the easiest things to get press on. Any large, commissioned work constitutes a story. My gallery routinely installs large works for a variety of clients around the country. I always involve reporters in these stories, and they invariably dig covering them.

Apart from works that we sell to private collectors, my gallery in the '90s was best known for the massive bronzes that one of my

sculptors, Jim Brothers, created for the National D-Day Memorial in Virginia. He labored heroically on that project for ten years. I consulted on it.

These monumental bronzes facilitated our getting press with media all over the country—*The Washington Post*, the *Associated Press*, *People*, *National Geographic*, the *New York Times*... But none of these periodicals would have covered our efforts if I hadn't spent hours contacting reporters and doing the follow-ups. Because I took these steps, we received the recognition, which helped us gain future contracts.

You should never let a large installation pass without alerting the press. Only in this way will you get the credit you're due. But please don't rely on coverage alone to bring you new business, since that may not work. You'll still have to rely on networking, marketing and promotion. This includes Internet promotion, meaning updates on your website and/or blog, as well as updates to your social network site. Sound tedious? It can be. Lord knows I get tired of it. But it simply must be done, whether by you or someone else, if you're career is to continue advancing, enabling you to live well by your work while taking care of those you love.

Despite all this, I'll welcome the day when we never have to send out another release. In light of the world's manic obsession with celebrity, I frankly don't enjoy drawing attention to our achievements, and would prefer to do things more quietly. Unfortunately that's a sure road to bankruptcy in the arts, since if your achievements go unnoticed, future commissions and sales will be less likely to come your way. So as long as my artists have stories to tell, the releases will go out. This helps ensure that the phone will keep ringing, their careers humming, and that we'll be able to care for our families. We just keep it all in perspective, since collectively and individually we understand that none of us are important. Hopefully, though, what we contribute is.

POSTCARDS AND NEWSLETTERS

Whether you're in a gallery or not, postcards are a fantastic promotional tool. All you need is a quality photograph of a strong work to produce one. Most postcard companies can help you with layout, which can be done online via their websites.

On the front of the card the most important thing is the image and the quality of the reproduction. Use the best image you can, then decide whether you want your name on the front of the card, along with title, medium and size of the work; or whether you want the front image as a full bleed, with all the text on the back. In my gallery, we always put the artist's name on both the front and back. This helps clients understand, at a glance, who did the work.

On the reverse side, you'll need your name in large font, and beneath that the contact information, along with details for a show, if that's what you're promoting. If you're just printing a general card to hand out to clients, you can list your contact information and a brief bio. Please be careful to not place your address along the bottom portion of the card; if you do, the postal computers may read this as the mailing address and send it back to you. In fact according to postal standards, you must leave the lower 5/8" of the card blank.

Below is a basic layout:

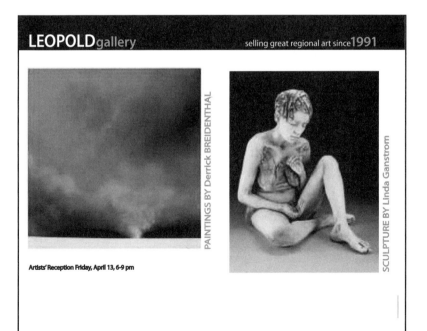

LEOPOLDgallery

324 WEST 63RD STREET | KANSAS CITY, MO 64113 | P 816 333 3111 | F 816 333 3616 | LEOPOLDgallery.com

Artists' Reception Friday, April 13, 6-9

Oil Paintings by **Derrick Breidenthal**
Derrick's collectors include H&R Block,
MMGY Global, Saint Luke's Hospital,
and private collectors throughout the region.

Sculpture in stoneware by **Linda Ganstrom**
Linda has work with Kansas State University,
Saint Luke's Hospital, Sias University in the Henan
Province of China, and private collectors
throughout the region.

LEOPOLDgallery.com

You don't need to have a major show to qualify for printing post-cards. You don't need to have landed a commission. You don't even need to be in a gallery. All you need is one or two pieces that represent you at your best. If you do produce a card, you should also create an e-postcard that resembles the printed version, so it can be sent out electronically. This saves paper, which theoretically saves trees.

The same applies to newsletters—whether printed or online. All of our newsletters are sent via email. We publish one per month, promoting upcoming shows, discussing new installations or artists, and plugging nonprofits that I believe in. Some of my artists use newsletters also, but primarily those whose careers are sufficiently advanced to warrant this.

Don't worry if your career isn't to that point yet; with effort and dedication, those things will come in time. Besides, the bulk of all newsletters are composed partly of fluff. Their only purpose, really, is to inform clients that your career is moving forward. You don't care to write one? Perhaps you'll join a gallery that does, and that will include you. Whoever writes it, make sure it's brief, based in fact, with crisp images and an impressive layout.

Whether you use postcards or newsletters, the printed word when married to impressive images is a powerful combination. Cards are obviously the simplest approach. By handing these to prospective clients, you'll find that you look established and feel established. I advise you to do this early in your career. It's a good practice to develop, especially when dealing with the public at juried shows, open studio nights, and art fairs.

What about those fairs? When will I discuss them, how to get into them, and whether they're worth the effort? Why in the next chapter, after we cover the New York scene a bit.

CHAPTER 6

NEW YORK: WHAT IT MEANS
AND WHAT IT DOESN'T

To be honest, I can't say whether any of my artists will ever be adopted as the latest rage in Soho or Chelsea, which are tough places to figure and tougher to break into. To be even more honest, we haven't approached any of the galleries there, since my strategies have mostly focused on artists and collectors west of the Hudson. Some of my artists would undoubtedly do well in New York, if we ever get around to placing their work there. But because we haven't needed to, it's never become a goal. Sure I love the town, but being or not being a part of the New York scene doesn't determine our success.

Many galleries on the Soho/Chelsea front obviously carry magnificent work that will stand the test of time. Just as cool, I've met scores of New York dealers who are quite aware that where one lives is not a determiner of talent. These people know they can as readily make their next discovery in rural Alabama as the Upper West Side.

But those who are caught up in the fame machine appear absurd, even ludicrous, for their perpetual courting of what they

hope will be the next hip thing. Not only will they ignore the artist from Alabama, but also those from Brooklyn, Harlem and Jersey—unless they have a well-dressed entourage. This excessive posturing bears little substance beyond name recognition, money, and some warped notion of celebrity. Talent and discipline are often last considerations in these sorts of galleries, superseded by what has tragically become a primary consideration—image.

Despite its aura of self-importance, this portion of the New York scene has minimal impact on the rest of the country. Soho and Chelsea, amazing places though they are, represent only a fraction of what is now occurring in the arts in America. And while exhibitions like the Whitney Biennial are finally beginning to pay attention to artists in other regions, a good part of the Manhattan scene is still under the delusion of assumed superiority based solely on location. In truth, the New York mystique is what it is because of where it is, not necessarily because of what is carried there—although some of the finest work in the world is indeed carried there. But the American art scene is no longer centered in New York; it began dispersing across the country in the '90s, a movement whose time had finally come.

Prior to that, from the 1840s onward, Manhattan was necessarily the center of America's art universe. Where else would Childe Hassam and Diane Arbus have based their careers? Kansas City? We both know better. And while artists like Judy Chicago and Wayne Thiebaud did very well by launching from California—another mecca of a different sort—without a nod from New York, their impact would have been less significant. The entire country, if not the entire world, has been enriched by the cultural wealth of Manhattan. Whether an artist makes a pilgrimage there, or is distantly influenced by its many movements, the place is incomparable. That much is a given. So is this—things have changed.

All the time New York was bearing its influence, the provincial regions were struggling to grow and stand on their own cultural feet. Now they've begun to, whether in art, film, music, or literature. The process is far from complete, but it's come a long way in a very short time. Avant-garde work that used to mostly come from places like The Village can be found in any city now; and whenever that is flourishing, it's a sign that other disciplines are as well. This is significant.

Why? Because without that growth, the country as a whole can't realize its own potential, and artists in Austin or Minneapolis who can't afford to live in New York (not that artists there can either), get a better shot at a viable career.

Since the time of the 1913 Armory show, Manhattan has been the launching pad for whatever was revolutionary, outrageous, or new. It still is, but so are dozens of other cities. They may not yet have the cachet of the Big Apple, but because of the Internet and a burgeoning national art market, their influence is growing.

This doesn't mean that Soho and Chelsea will ever be replaced. It does mean though that they are sometimes out of touch with the rest of the country. That wasn't so important in 1960; now it's critically important. This also means that artists who have been locked out of the New York scene no longer have to look to Manhattan for approval. Mutual respect on both sides would be a good thing though.

I bring this up because some of you may not yet be acquainted with the New York scene, but may be curious about it. I'm just assuring you that your success can mirror or eclipse ours without representation there. You don't necessarily need that to have an outstanding career, but having it under your belt is certainly a great thing if you can land it. So go ahead and submit to the New York galleries if you wish. Should you only meet with rejection, don't worry, you'll be in great company. While you're in the process of making those submissions, you can still do exceedingly well in the other markets, which are vast and numerous. All you have to do is go after them, using techniques I'll cover soon enough.

Despite some of the beefs I've listed, I will always love Manhattan and the surrounding boroughs. As with many writers, I owe the place a great debt, since my early years in that city had a profound influence on me.

That's why it was so harsh to go back in September, 2001—which was like returning to a place that had once been home, only to find it had become a battlefield. The strange quiet of the city, the grief, the look of shell-shock on the faces. Yet also the compassion and unity, the newfound levels of patience and consideration—horns that honked less, people saying *please* and *thank you,* many of them with

subtle warmth. After all, it's not easy living in a place so crowded while still maintaining sanity and civility.

Then my visit to Ground Zero: the mile-long line of dump trucks, the barricades, the solemn crowd, many of them praying—Christians, Hindus, Jews, Muslims. And fliers for the missing posted on windows—Christians, Hindus, Jews, Muslims. Also atheists, spiritualists, janitors, executives, party animals, firemen, cops, and without doubt a fair number of artists. Then there was the site itself—the shattered buildings, the mountain of rubble, the cranes and dust and stench. As I gazed on it, I realized I was looking at a mass grave.

I had been greatly depressed ever since the towers collapsed, as most of us were. Now my depression deepened: the hatred and savagery that brought all this on—hatred that went back for centuries on many sides. I stared at the wreckage and felt so irrelevant, the profession I was born to and the thing I do. Oh I know it isn't irrelevant, but at that moment I felt only futility. How could anything in the creative world seem worthwhile in the face of this?

And yet it is. Whatever calamities we may face, life goes on, just as it always has. And as life goes on, so does the work of the artists who examine events, interpret events, and help us make sense of what all too often seems senseless. I thought of these things as I walked from Downtown to Soho, passing fire stations and police stations with their shrines to the dead out front.

At Spring Street I stopped at a café. The waitress was friendly and the busboy polite (I had to keep reminding myself that this really was New York). The busboy, of Arab descent, was singing along with a John Lennon song on the radio: "You may say I'm a dreamer, but I'm not the only one. I hope someday you'll join us, and the world will live as one."

I asked the waitress if she thought the busboy was a good singer. She gave him one of those sidelong New York glances, laughed, and said, "Neah."

He just smiled and kept on singing.

I drank a cappuccino, wrote some postcards, and left.

That afternoon I caught my plane and flew out over the city, where smoke was still spiraling up from the ruins of the World Trade Center. I knew that New York would eventually be New York again—

with all that is both great and awful about it. In the end, it's still one magnificent town—so American, so full of excess, at times trend-ridden and self-obsessed, but always incomparable. In the end it has dignity, resilience, and strength. This country wouldn't be what it is without New York, and neither would the arts. As long as I write, and run a gallery, I will remain mindful of that.

Of course I've been back to the city many times since, but of all my visits, that one remains the moist poignant. That one burns the brightest. I think it always will.

JURIED SHOWS / ART FAIRS

After an artist achieves master status, he will rarely participate in an art fair unless it's an exclusive event through a museum, gallery, or similar entity. But while he's building up his reputation, it's essential to regularly participate in public exhibitions, whatever type of gig it might be. All of my artists have shown in various exhibitions and fairs, as have most successful artists I know. For those of you who only execute installation-based or avant-garde work, art fairs will be of little relevance. Instead you'll want to seek out juried shows that are an appropriate venue for what you do—the edgier the better, as long as they have strong attendance. But for the rest of you, the right series of fairs can help give your career a serious launch.

Just what is an art fair? In the worst case, an outdoor event arranged by well-intentioned dilettantes for a largely indifferent public. Are they all this bad? No. Many are well run, providing excellent venues for selling work at the lower price levels, and for meeting hordes of potential collectors. The trick is learning to choose between the fairs that are worthwhile, and those that aren't.

The best story I ever heard about a fair came from Vernon Brejcha, a glass artist whose works have been placed with museums worldwide, and who studied under the great master Harvey Littleton. But in the beginning Vernon was as unknown as any emerging artist, and so decided to do a few fairs. He told me how once, in the '70s, he was sitting a booth at a Dallas show when a man, woman, and their daughter walked up. The trio stared at his glass, stared at him, then the father said to the girl: "See now, Charlene. This is how

you'll wind up if you don't start getting better grades." They turned and walked off.

Vernon was rather more selective in choosing his fairs after that.

Regardless of whether the show is an outdoor fair or an indoor exhibit, it must be juried. It means nothing to be accepted in a non-juried show. Besides, in non-juried shows you don't know what other kinds of work will be exhibited, or whether you'll be stuck next to some guy who does paint-by-number landscapes on saw blades.

Amusingly, the jury members in some shows are no more qualified to serve on the panels than the average car salesman. In fact they may have no background in art whatsoever, but are chosen because their niece is chairwoman, or they think it would be a creative thing to do, or, hopefully, because they genuinely want to see a great show result, with scores of artists selling tons of work. However the jurying is done, most shows do advance awareness of the arts to a certain degree. That can only be a good thing. Besides, if you win a prize they usually give you a little dough.

Shows that are well established are obviously the best choice, like the Navy Pier Show in Chicago (if you can afford the booth fees), or the Brookside Art Annual in Kansas City. But even if it's a newer show that doesn't yet have a reputation, as long as it's well run, well attended, and in a proper setting, this is better than letting your work sit in the studio and collect dust. You're in the process of building up your resume. It's a gradual process, and you'll have to be proactive and patient in carrying it out.

HOW DO YOU LEARN ABOUT THE SHOWS?

The simplest way to learn about shows is to use the Internet. Enter appropriate key words in a search and you'll be off and running. If you're only interested in fairs in a particular city or state, just specify that in your search.

In addition, all states and major cities have arts commissions—at least at the time of this writing. Most of these have listings of shows that are held in their region. Search their websites for information. If they list nothing, call and ask for guidance. Also ask to be put on their mailing list. This will keep you informed of shows, as well as various commissions that may arise.

The College Art Association, which has been around for over a century and has a comprehensive website, can also provide you with lists of exhibition opportunities that occur nationwide.

In the same vein, most cities have an artists' coalition of some sort. These too will have listings of various shows, especially those held in nonprofit or cooperative galleries. These shows can be quite worthwhile in terms of meeting people who can be of help to you, such as architects, collectors and gallery owners. Like anything else, these can be a waste of time as well, depending on the show, its attendance, and how well you handle any opportunities that arise.

You can also call any of the major galleries in cities where you want to exhibit, and ask them about reputable shows in their area. Most gallery managers will be realistically informed about the viability of each.

The more shows you attend, the more you'll become aware of: other artists will help inform you, as will show organizers and attendees. Who knows? You might even sell some work along the way.

SHOWS I'VE DONE

When I first got into the art business, I worked at it part-time out of an office in my basement. Because my artists were mostly unknown, I made it a priority to place them in out-of-state shows. I did this because I realized that local clients would take them more seriously if they knew those artists had exhibited in other regions. The adage that *the genius is always in the next town* bears true weight in the arts. Local collectors will almost never take you seriously until you've had proven success outside your region, especially in a major city. And when the time comes to approach galleries, the same will hold true.

So I sent out all those sheaves of slides—in those days when we still used them—and got my artists accepted to shows in Chicago, Sedona, Denver, St. Louis, etc. As it turned out, getting them into the shows was the easy part. Making a profit was another matter.

A TYPICAL SHOW

One of the shows we did was Sculpture in the Park, in Loveland, Colorado. Loveland is north of Denver, and during the '90s became a center for bronze sculpting in the rebirth of the figurative movement.

Believe me, you can find it all there, from the shallowest sort of kitsch to figurative pieces of true power. And it's all pretty much exhibited at Sculpture in the Park, from one end of the spectrum to the other.

I entered bronzes by Jim Brothers, a figurative sculptor who was one of the first artists I represented. Jim's work was accepted; we loaded the van and went off across the plains, with visions of sales dancing like mirages before us.

The exhibit was held in a park beside a tranquil and very blue lake, with the sculptures displayed in massive tents. We were shown to our display area, set up, and I manned the booth while Jim did what he does best when not sculpting—he went off and drank beer with other sculptors.

The crowd began filing by. They filed by Friday night, all day Saturday, all day Sunday. I talked to several hundred people, many of whom took home photos, resumes, and business cards. I later wrote each prospect, made the follow-up calls, and in general did everything I was supposed to. Not a single piece sold.

For the most part, the only artists who were selling were the established ones. While Jim's work was every bit as good as theirs, we were not yet established, so his bronzes sat idle.

Ditto the shows in Sedona, Denver, and St. Louis. Some of these were dismal affairs where almost no one sold anything, where the crowd filed by and the artists sat their booths, staring out at the people who stared back, a gulf of miscommunication separating us. After a day of that I would retire to my van, and try to sleep off the depression that these failures brought on. Then in the morning I would adjust my attitude, say *this is the day*, and go back at it again. And again. And again.

The fact is I experienced no significant sales in any of these shows. Not until our last one, an impressive affair in Chicago, did we sell anything—a small piece that barely covered expenses.

Did I notice any particular sorts of work that sold well? Yes, inexpensive paintings and photography, colorful ceramic, colorful glass, and whimsical sculpture. Apart from this, the works that did best tended toward craft.

The artists who succeeded at these fairs were veterans of the circuit, setting up booths that were like miniature galleries, well aware

of the price points that worked. Some of them turned a reasonable profit over the course of a summer, wandering from show to show. But the downside, they all told me, was the expense of the travel and significant time away from home. It takes a lot of work to profit from the show circuit, and reasonable business sense to make the best use of the contacts.

Business sense or not, every artist I've ever known who did well at shows admitted one thing to me: they'd rather let galleries focus on the business end of things while they focused on the art.

What did I get out of all this? Expanding resumes for my artists and experience for myself. Also lots of fine nights with a lot of fine people, drinking beer, cursing our fate and having a great time doing it. All those shows, in light of this, were hardly a wasted effort. But by the time I did our last show, I realized I'd had it with arranging exhibits in far-off venues, and dealing with prosperous *collectors* who underwent sticker shock at anything over $500. I decided that from then on I would run my own blasted shows, and that the only time I would hang another painting would be in my own space. I decided to open a gallery.

Looking back, it was one of the best decisions of my life. It's also a good thing I didn't know what it would take to succeed, how grueling the journey would be, or how long the odds. If I had, there's a fair chance I wouldn't have done it. But that's how life is for most of us. It's also why it is sometimes good to be a little bit naïve.

Anyway I decided to open a gallery.

God help me.

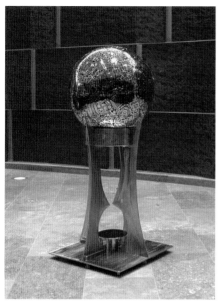

Sphere
Stainless Steel
46" x 22" x 22"
Dave and Arlie Regier
Composed of 5000 pieces of used stainless steel, it also appeared in the WB film, *Watchmen*
H&R Block
Kansas City, MO

Fissure I
Pyrograph Burn Drawing on paper
48" x 18"
Susan White
H&R Block
Kansas City, MO

Two Towers
Oil on Panel
24" x 24"
Derrick Breidenthal
H&R Block
Kansas City, MO

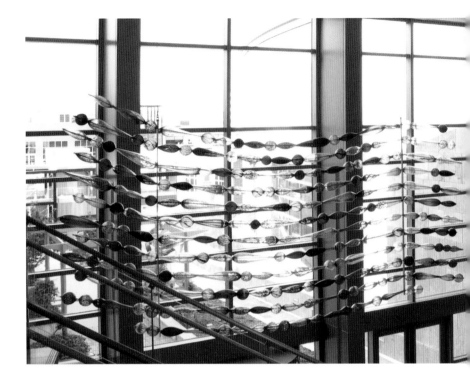

Pax Mundi
**Bronze
6' x 6' x 6'
Brent Collins
H&R Block
Kansas City, MO**

Field Flow (left)
Blown Glass
15' x 22' x 1'
Vernon Brejcha
Design assistance
and installation
by Leopold Gallery

Converge (right)
Wood and Steel
8' x 30' x 2'
William Lobdell
H&R Block
Kansas City, MO

Constant Clocks
Oil on Panel
24" x 36"
Richard Raney
H&R Block
Kansas City, MO

Block 1955 (above)
Oil on Panel
36" x 48"
David Spear
H&R Block
Kansas City, MO

Block 1975 (below)
Oil on Panel
36" x 48"
David Spear
H&R Block
Kansas City, MO

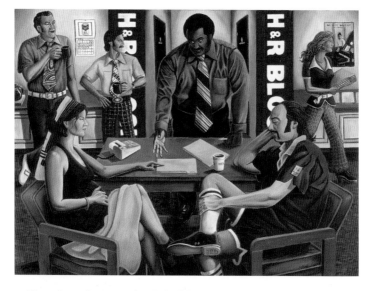

These two pieces are loaded with humor and social statement.
The calendar in each reads *April 15.*

Quan Yin: Goddess of Prayers
Stoneware
27" x 26" x 17"
Linda Ganstrom
Private Collection
Leawood, KS

But It's a Real Tuxedo
Acrylic on Glass
39" x 39"
M.J. Rigby
Private Collection
Mission Hills, KS

Stop This Train
Oil on Canvas
24" x 30"
Private Collection
Kansas City, MO

Boy with Ball, Kajjansi,
Archival Photo
16" x 16"
Gloria Baker Feinstein
Private Collection
Kansas City, MO

This boy lives in a Ugandan orphanage
that Gloria helps to support, ensuring
that all the kids are well-fed, clothed,
and get a decent education.

Weave, **Blown Glass**
9' x 32' each, Drew Hine
Design by Ed Tranin
Design assistance and installation
by Leopold Gallery
University of Kansas Hospital Kansas
City, KS

Dining Out 2
Hand-Dyed Silks and Cotton
49" x 39"
Annie Helmericks-Louder
University of Kansas Hospital
Kansas City, KS

Pulse Flow
Blown Glass, 19' x 85' x 12'
Vernon Brejcha and Drew Hine
Concept by Ed Tranin
Design assistance and installation
by Leopold Gallery
University of Kansas Hospital
Kansas City, KS

Summer-Filled Sky
Oil on Canvas
30" x 40"
Allan Chow
University of Kansas
Hospital
Kansas City, KS

Let Them Eat Cake III
Embroidery and Xerox
Transfer on Flour Sack
28" x 34"
Jennifer Boe
University of Kansas
Hospital
Kansas City, KS

Disc
Stainless Steel
32" x 32" x 6"
Dave and Arlie Regier
University of Kansas
Hospital
Kansas City, KS

Phuket, Thailand
Oil on Panel
24" x 36"
Derrick Breidenthal
Private Collection
Kansas City, MO

Three Columns
Sculpted Stoneware
98" x 14" x 14"
each (on average)
Carol Fleming
Private Collection
Kansas City, MO

A Day at the K
Found Objects
and Mixed Media
5' x 6' x 7"
William Lobdell
Kansas City Royals
Kansas City, MO

Wall Piece, **Blown Glass
6' x 14' x 6"
Ed Pennebaker
BKD LLP
Springfield, MO**

Fog
**Oil-Graphite on Panel
48" x 48"
LaDawna Whiteside
BKD LLP
Springfield, MO**

Self-Portrait
**Oil on Canvas
80" x 50"
Morgan Frew
BKD LLP
Springfield, MO**

Radiant Heart
Blown Glass and Aluminum
16' x 7.5' x 7.5'
Ed Pennebaker with Leopold Gallery
Saint Luke's Hospital
Kansas City, MO

The River
Ceramic Tile
16' x 4' x 4' each
Phil Epp and Terry Corbett
Saint Luke's Hospital
Kansas City, MO

Root Woman
Fiber
38" x 74"
Nedra Bonds
Saint Luke's Hospital
Kansas City, MO

Surreal Sofa
Acrylic on Panel
44" x 44"
Adolfo Martinez
Saint Luke's Hospital
Kansas City, MO

Avoidance #2
Cast Resin with Prosthetic Eyes
27" x 19" x 12"
E. Spencer Schubert
Ron Castor CPA
Overland Park, KS

Flint Hills Diptych
Acrylic on Canvas
36" x 72"
James Borger
Saint Luke's Hospital
Kansas City, MO.

Corridor
Overland Park Convention Center
Overland Park, KS

Lightning Strike
Acrylic on Canvas
9' x 4'
Phil Epp
Overland Park Sheraton Hotel
Overland Park, KS

Beginner's Mind
Acrylic on Canvas
Carved Wood, Lead
68" x 48"
Robert Wright
Emprise Bank
Wichita, KS

Stop Here
Oil on Canvas
18" x 24"
Jane Pronko
Private Collection
Prairie Village, KS

Storm Reflections
Oil on Canvas
30" x 40"
Louis Copt
Private Collection
Kansas City, MO

Kinetic Grouping
Copper and Steel
18' x 9' x 9'
Lyman Whitaker
Chidren's Campus of
Kansas City
Kansas City, KS

Scaling the Heights
Point du Hoc
Bronze
1.25 x Lifesize
Jim Brothers
National D-Day Memorial
Bedford, VA

Death on the Shore
Bronze
1.25 x Lifesize
Jim Brothers
National D-Day Memorial
Bedford, VA

Arlie Regier and me attending an artists' reception at the Museum of Fine Arts, Boston, 2007. That's his *Hemisphere* in the case, included in a collection of contemporary craft.

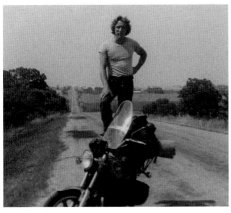

Returning to my father's farm after yet another bike trip, this one in 1979, from Kansas City to Key West to New York, then home through Canada. A good summer.

Annie, our sons and me in 1999, when we were always broke but with a wealth of love. Oddly, it was with the onset of the Great Recession that our fortunes finally changed.

Our sons, Denny on the left and Josh on the right, working on an installation at University of Kansas Hospital. With them is Adam Small, informally a member of the family.

Some of the hundreds of teenage artists for whom I've been a mentor, but not without the considerable help of their teachers and scores of volunteers.

CHAPTER 7

Before I discuss how to get your work into galleries, it would be useful for you to know a little about what it takes to run one. Why? Because the more you know about the challenges of the art business, the better prepared you'll be. The story I'm about to tell is pretty candid, but I find that deeper knowledge often springs from candor, while virtually nothing springs from insincerity.

A COMMON ENOUGH BEGINNING

I grew up in the suburbs of Kansas City, but found the conformist tendencies of suburban life oppressive, so tended to rebel in fairly extreme ways that I'll not bore you with here. Let's just say that the local cops knew my buddies and me pretty well.

Once I decided to pursue the arts, specifically writing, my dad was baffled but reluctantly encouraged this choice because he respected me. My mom? She believed in my writing completely and urged me to give it all I had.

I attended the University of Kansas with an assortment of outlaws, wrote my butt off, and was mentored by a group of eccentric professors who gave me abundant guidance. My uni-

versity days were marked by earnest study, earnest partying, and an inexplicable involvement in the boxing club. I normally owned a motorcycle then, as I do now, and often took long bike trips during the summers, eventually wandering through each of the lower forty-eight, picking up odd jobs as I went, once even working for the Hepburns in Connecticut.

After college I went to Alaska to work on a halibut boat, survived a shipwreck, then later moved back to Connecticut, where I took a job as Director's Assistant of Hill-Stead Museum near Hartford. This storied place, once a private estate, housed masterpieces by Monet, Manet, Degas, Whistler, Hokusai, Cassatt and Dürer, to name a few. I kept that job for several years. It was insanely inspiring, allowed me time to write, and provided me with beautifully forbidden places in which to have trysts, since I had the keys to the mansion. It was also close to New York and Boston, where I often spent weekends. More even than Alaska, this experience altered the direction of my life.

Then I went to Europe, backpacking everywhere I could.

Then I returned to Kansas City. There I met a dark-eyed beauty named Annie, she took pity on my proposal of marriage, and we moved in together. Annie believed in me as a writer, just as everyone else did—a thing you can never really repay. I preferred self-employment to working for the man, so I started a lawn service. We had two boys, moved to Lawrence because we loved its bohemian atmosphere, and proceeded to have a great life there.

Lawrence—where I'd lived when I went to college—is of course home to the University of Kansas, Jayhawk basketball, and thousands of college students. William Burroughs lived there at the time. I used to mow his lawn while he watched from the porch, pistol on hip. Afterward he would sometimes offer me tea, show me his shotgun art, and complain about publishers.

In Lawrence, like most college towns, there are artists and bands everywhere. That passion spoke to me. I wanted to make a difference in regional culture, and decided, in 1991, to begin representing regional artists, realizing it was time to abandon the lawn biz. I started by running an art consultancy out of our home, but soon realized I'd have to open a real gallery in order to have a real impact. The problem was I knew nothing about running a gallery. Neither did my artists, but they very were excited about the prospect.

My decision to make this move was brought on by the fact that, the year before, I'd landed a gig with G.E. Aircraft Engines, who ordered twenty bronzes by Jim Brothers. After casting expenses Jim and I made a reasonable profit. My share was quickly eroded by debt, taxes, and the cost of raising kids; also a week in Colorado with my family. Afterward I had $10,000 left—enough, I convinced myself, to open a gallery.

Jim, who had been sculpting and starving for thirty years, advised against it. He'd seen countless galleries go down in flames, and although he was enjoying our initial success, his pleasure didn't override his skepticism. He warned me that while people do need clothes, food and shelter, nobody really needs art—at least not in the same way. He knew the odds I'd be up against and didn't want to see me fail.

I thanked him for the advice, but all my instincts told me I had to do this. They also told me that things would work out if I just stayed in tune with my intuition and worked bloody hard. I trusted I would.

Annie trusted the same when I told her my plan. She wasn't sure if $10,000 would be enough to open a gallery, but believed that somehow things would work out. Matt Kirby, one of my favorite contemporary sculptors, agreed. In fact we talked about it one night in the Free State Brewery while downing a few ales. As usual the place was packed and you had to shout to hear yourself.

"Oh man, you'd be great at it," Matt said.

"Why do you think so?"

"Because you've got this practical side, and none of the rest of us do."

"So I'm on occasion practical. Does that qualify me to run a gallery?"

"More than me." He took a drink of beer. "I mean, you know how to relate to people, so you'll be able to sell. You know how to write, so you'll be able to market. Man, in a few years you'll make us all rich. I just know it."

Here I'll stop a moment. You know in cartoons when a character is a little wacky and his eyes spiral around in circles? That's kind of what Matt's eyes did when he was excited. It was symbolic of his genius.

"Just like that?" I said.

"Well, more or less."

I took a drink of beer and looked at the crowd: young artists, old artists, and waves of students headed for every conceivable profession. It was a crowd like you'd find in any university town. But I knew if I was going to open a fine art gallery, it wouldn't be here. Lawrence, charming though it is, wasn't large enough to support the kind of gallery I envisioned.

In addition, many collectors waited each year for the local art center's auction, where the works were virtually given away in raising funds for the center. The art center meant well by this, as did the collectors, but what none of them understood was that they were undermining the art market, unintentionally sending out the message that artists deserved no better. This wasn't really collecting, where people with disposable income pay appropriate prices for works they value. This was politely mercenary.

I realized we'd have to move back to Kansas City to succeed, and already dreaded the move, but knew that it would be necessary.

"What do you think?" Matt said.

"I think I'm opening a gallery."

He clinked his glass against mine. "Man, I was hoping you'd say that."

We toasted our future success.

THE FIRST GALLERY

I finished renovations and opened for business a few months later. We weren't opening in the Country Club District or the flush suburbs of Johnson County. We were opening in the old Hotel Savoy, in the midst of what was then a neglected downtown. The urban core needed renewal and I wanted to play a role in that, however minor.

The Savoy was a faded place that housed a glorious restaurant—the Savoy Grill. Since 1904, Kansas City's elite had been chomping on lobster and chateaubriand there. A joint like this, I figured, would host the right clientele for a gallery. So I talked the hotel owner into leasing me a store front for $200 a month. If he hadn't been so generous, I couldn't have opened, since renovation and marketing costs had already used up all my dough.

Two months later my banker, Glenn, called to inform me that I was overdrawn by $5,000. I owed an additional $3,000 on ads, phone bills, and expenses. By now I'd sold three paintings for a total of $4,750, half of which I'd kept, the other half going to the artists. In other words, we were already running in the red. The buckets of money we'd hoped for had turned out to be teaspoons.

Glenn, a patient man, asked if I had any contracts pending. I told him I'd landed Jim Brothers a commission to execute a monument of General Omar Bradley. The fee we were to be paid was $95,000. I would make $25,000 and Jim would get the rest. Glenn, relieved to hear this, advanced me $10,000. And so began my dance with debt.

I thanked him, hung up, and tried again to devise a marketing plan for selling art, because the art just wasn't selling and I didn't understand why. The problem was I couldn't see my mistakes. I had run ads in the best magazines, my gallery had been written up in all the papers, my location brought in reasonable traffic, and yet no matter how many people came through the door, almost no one bought. I didn't get it. What was I doing wrong?

Plenty. I hadn't learned to network, to reach out to prospects, or develop the corporate market. Also, the regional boom in art-buying that I would help inspire hadn't begun yet. But I knew none of these things. I honestly believed—and this is the funniest part—that I only had to open a great space and the work would just sell.

Finally I said *Screw it*, put on my inline skates, and went out into the April air. I skated down to the River Market, back up to Allis Plaza, then farther up to the Lewis and Clark bluff, where I sat panting among the hip hoppers and their booming cars, looking out over the Missouri River and wondering what the hell I was doing in the art business. Then, sweating, I cruised back down the hill to the gallery, to wait for the evening diners to appear and try to coax them into buying. Many people would appear; none would buy.

I was home by 10:00. Annie was waiting. I went into the rooms of our two little sons and kissed them as they slept, trying to forget that their lives were passing by while I worked twelve-hour days. Then I poured a bourbon and joined Annie on the battered sofa. She was tired too, since she ran a day-care center to help make ends meet, and so she could stay home with our rascals.

"How was your day?" she said.

"Not bad. Yours?"

"Oh. Little kids and diapers. Sell any art?"

"No, but I got some leads. Some of them should pan out."

"Do you have mortgage money?" She asked this kindly, as compassion was Annie's nature.

I took a drink of bourbon. "Sure."

"What about taxes?"

I took another drink. "You bet."

"And you're saving for college?"

I drained the glass. "Like clockwork."

That was three lies in a row, but I figured they were forgivable. Of course she assumed that I was progressing like any other disciplined entrepreneur. I didn't have the heart to tell her that the art business wasn't like any other; she already had enough to deal with.

She sensed my stress and put her hand in mine. "You're okay?"

"Sure."

"Would you like a massage?"

Upstairs I lay on the bed while she lit a candle and spread a satin sheen of oil across my shoulders. I felt her hands, and thought of how I'd made her and the kids hostages to the arts. They deserved better. It was then that I vowed to make this gig work, no matter what it took out of me. We were never going to be a frame shop. We were going to be dealers in original art, like galleries in New York or London. By God we were going to do it.

She finished, then I massaged her, then she looked up at me and asked, with the candle still burning, was there anything else she could do?

In the morning I rose early to go get groceries. When I got back Annie and the boys were up. My sons and I played in the yard, meaning basically that the collie and I chased them around while they yelled, then they chased us. Afterward I kissed the boys, kissed Annie, and went off to work.

Business debt now at $15,000. Other debt, excluding mortgage, same.

The large monumental commissions that I began to specialize in were more conservative than what I really wanted to do, but they did serve several important purposes. They memorialized certain events in history, showcased Jim Brothers' talent, and saved my financial hide. They were never lucrative enough to get me out of debt, just lucrative enough to keep me afloat while I sank gradually deeper into debt.

The first was a monument in Griffith Park, Los Angeles, the second a bronze of Mark Twain in Hartford, and the third was the one of Omar Bradley.

The Twain story is a pretty good one. It involved Jim being "commissioned" to execute the monument for some businessman in Hannibal, Missouri. Jim negotiated the contract before I'd begun managing his career, and priced the piece at $20,000, which meant he was making about three bucks on the deal—without an advance. This set of circumstances, where the artist is putting up the dough, is not a commission.

Nonetheless Jim set to work. What emerged after six months of struggle was, in my opinion, the finest monument of Twain yet to be cast. It showed his mischief, latent bitterness, intelligence and scorn. The piece was brilliant. Inevitably the businessman—of a variety that Thomas Hart Benton referred to as *pig farmers*—didn't want to pay for it. He wanted to renegotiate the deal. Jim went through the roof.

When he came back down we reviewed the contract, and realized Jim could get out of it if the dude failed to pay, which he indeed had done. So now Jim was free of the Hannibal businessman, but had spent all his money on the sculpture. I told him not to worry, I was sure we could sell the piece to the City of Hartford. Twain had written his most famous novels in his mansion there, which was now a museum. I knew Hartford didn't have a monument of him, and suspected they would want one.

I sent photos of the work to the chamber of commerce, and told them the price I wanted—much more than $20,000. They loved the piece, contacted a local businessman—of a variety that I refer to as *enlightened*—and he said he'd be happy to pay for it.

We unveiled the monument on a sunny afternoon downtown. For a day Jim was a hero to the city. The director of the chamber was grand to us, as were the journalists who covered the story, as were some old friends of mine, who took us out for a celebration that night. In fact one of the celebrants, a young woman from city hall, had too many martinis and, I think, ample coke in the john. She was wasted, so we gave her a ride home. But damn that was a good day.

The Twain? It's still revered in Hartford. The only thing we regret is that Jim sculpted it life-size instead of larger-than-life, so that it looks somewhat diminutive amid the skyscrapers of downtown. But don't tell anyone in Connecticut I admitted this; I want them to go on loving that bronze just the same.

After my first year in business, sales began to increase owing to my marketing efforts and media coverage. Eventually I began meeting some of the wealthier people of the region. A few bought work, most did not, reserving their business for galleries in New York, Chicago, or Santa Fe, since they believed that that's where the "real art" was. In time I would convince many of these people that regional artists were doing work just as sophisticated, but initially this was not a popular notion, especially with the stuffy moguls who ran the city then. On the rare occasions those guys did buy, they expected large discounts. My artists and I were broke, so I had to give the discounts.

No wonder the Midwest was still, then, a cultural backwater. The moguls, who were interchangeable with their counterparts in other cities, were retarding cultural growth with their refusal to invest in regional talent. Adversely, many of my middle-class clients gladly bought regional work and normally paid the listed price. These people loved art, and were happy to participate in a growing movement.

People like these: The housewife who fell in love with an abstract oil, but didn't have the $2,400 to pay for it, so paid it off in installments. The woman lawyer who came in each May to buy a Phil Epp painting, always paid full price, and had a casual way of flirting as she did. The New York marketing consultant who stopped by when he was in town, and who, over time, bought several of Arlie Regier's works in stainless steel.

Clients like these helped keep my leaking gallery afloat, which was better than sinking, but I was still only one step ahead of the creditors. Then there were my credit cards, which I'd used to pay income tax and business expenses, and which were spiraling out of control. I needed to change things, drastically, but didn't know how.

Business debt now at $25,000.

Because I was next to the Savoy Grill, but outside its frantic pace, the people who worked there often came by to visit—black chefs, Hispanic waiters, gay and straight waiters, busboys and managers. Most were intimidated their first time in, professing they knew nothing about art. I told them they only had to look around and respond from their gut, but that if they didn't like a piece, they should at least try to understand it. When I gave them this formula, they tended to look at the works in a different way.

I extended the same advice to all others: office workers, dockworkers, executives. They would come to the gallery, forget about their work troubles for awhile, then later leave with an altered frame of mind. They all assumed that I was growing rich. The truth is, most of them made more money than I.

The gallery did two things for my writing: first starved it, then fed it. That first year I had no time to write, which built up a lot of pressures inside me that I had trouble bearing. Then a book burst out as no book ever had before and I felt fulfilled again—not the way my children's laughter, Annie's touch, or long road trips fulfill me, but in the only way artists can be: by doing their best work.

In the mornings I'd come in, look at the sunlight on the paintings, and with the glow of all that color around me, set to work, writing for two hours before people began to wander in and the phone to ring. Afterward I'd concentrate on gallery business, knowing that my own work had been done and that I could go back to it fresh the next day.

That book was a story of two friends who take a motorcycle trip to Colorado, the characters they meet, the tragedy they endure. I sent it to the literary critic for *The Kansas City Star*, Ted O'Leary, hoping

to get a nod from someone in letters. He was a nationally esteemed critic, and very busy, so I figured I'd never hear from him.

He called a week later.

"Young man, this is one of the finest manuscripts I've ever read."

It took me a minute to get up off the floor. "You've finished it?"

"Couldn't put it down. Why don't you come by the house? I'd like to meet."

The next night I went by. His house was an old Tudor that sat on the bluffs west of The Plaza, looming over Brush Creek. It took him a long time to answer the door, but he finally did—an exceedingly slender man in his 80s who walked very slowly and with great pain.

"Glad you sent the book. I don't often get to meet a writer on the way up."

"I don't know that I am."

"Oh. We'll see about that." He talked to me as he shuffled through the house in his slippers. "Drink?"

"Please."

I followed him between towering stacks of books—Ted owned about 10,000 of them—literally. Publishers had been sending him books since 1939. He'd reviewed original copies of *For Whom the Bell Tolls*, *In Cold Blood*, and *Tar Baby*. The books were neatly stacked and the house a mess. I made no comment on the mess and right away we understood each other—housekeeping took a back seat to the arts. I wish I could have met his wife, but she'd recently passed. Ted lived alone, quietly grieving for her.

He poured a pair of scotches in his grimy kitchen and we went down to the den, where there was a large flat screen. On this he religiously watched Charlie Rose and Jayhawk basketball; the former because he loved intelligent discussion, the latter because he had been an All American forward for KU, 1930-1932. In other words, Ted had played for Phog Allan and studied under James Naismith, later reviewed books by Faulkner and Harper Lee, then went on to write for *Sports Illustrated*. It dawned on me that my scotch had been prepared by a legend. We settled in while the Jayhawks disposed of Colorado.

"I like your book. It's a piquant tale." He leaned back and with grunting effort put up his feet. "Problem is, you're in the wrong era."

"What do you mean?"

"Well this gadget," he gestured at the TV, "has robbed you of a third of your audience. Computers are robbing you of another third. Thirty years ago your book would have been snapped up. Today?" He shrugged his wasted shoulders. "Who knows?"

I sipped my scotch. This wasn't good news. "What do you suggest?"

"Keep writing. There are always exceptions. Look at Cormac McCarthy. Look at Fannie Flagg. You'll find your niche. Just don't give up."

Don't give up; three simple words that all of us must learn to live by.

An hour later I thanked him and left, knowing I'd found a new mentor.

My gallery was now two years old, and I was developing a reputation of sorts. Among snobs I was normally dismissed, since I had the audacity to carry landscapes as well as contemporary work; among artists I was normally embraced, since I worked so hard to advance careers. The landscapes sold better than the contemporary pieces, allowing me to stay in business and feed my family—a basic need that snobs normally fail to grasp.

Because of our growing reputation, more people than ever came by to browse, but still few would buy. I couldn't seem to break through that general attitude where the prosperous spend hundreds of thousands on their homes, then put framed posters on the walls for art. And this ain't just a Midwestern phenomenon. It's an issue in every region—including New York and LA.

The problem breaks down like this: while roughly thirty-five percent of Americans can afford fine art, only about ten percent buy. Why? Because many won't go into galleries. They feel mocked by our friends, the snobs, for not having the proper background, not being hip enough, or whatever. And I can assure you that no successful businesswoman or surgeon will tolerate being mocked. Do you think BMW dealerships treat them this way? No. But for some reason, many art dealers feel this is a grand tradition.

So I had to convince the public that this wasn't our attitude, get them in the door, then get them to slow down long enough to respond to the work—especially in this era of overworked, over-emailed, over-cell-phoned frenzy. I've excelled at helping browsers do this over the years, but in those early days I was a novice at it, and the resulting poor rate of sales was driving me mad.

It was at about this time that I began to keep a bottle of bourbon in my desk. I never hit it during the day, but in the evening as diners filled the restaurant and gallery, I'd take snorts off that sucker and watch the non-buyers file through. I was going broke, was enraged at the position I'd placed my family in, and was still unpublished. I blamed myself, the art business, and the crowds of non-buyers who took up my time. I'd begun to despise them.

A wide-eyed woman coming through the gallery, staring at all the work without seeing a thing, then turning to me and saying: "My. Did you do all this?"

Me at my desk, feet up, shoes off. "You bet, ma'am. I painted every painting in here. Did the sculptures too, but only in my spare time."

Still the wide eyes and kind expression. "Oh, you must be very creative."

"Why thank-you, ma'am. I sure try to be."

A group of similar men and women, squinting at the work and muttering about the prices as they filed through. One of the men turning to me and asking the same question.

Me blearily looking up, taking a sip of bourbon, and saying, "Buddy, I couldn't draw flies with my shoes off."

All of them filing out in bewildered silence.

The occasional serious collector stopping in—whether from New York, Texas or Kansas City—but I was often too bitter to give them appropriate attention, which they sensed, which caused them to leave.

I'd think of opportunities missed, opportunities that never came, and soddenly go home to see my family. My kids on my lap, too

young to realize my condition as we watched *It's A Wonderful Life*, me feeling wrecked inside. Thinking about my life insurance policy, wondering if they'd be better off. Annie watched all this from aside, uncertain if she knew me anymore. A wall of misunderstanding began to build between us then. She felt it. So did I.

Owing to overwork and stress, I'd begun to forget to do the little things—soft words, caresses, the taking of walks, flowers for no reason, the occasional seduction before the fireplace, phone calls just to ask how she was. I'd begun to forget those things, and so had she. I knew then that our marriage, and my gallery, would either have to undergo an evolution or fail. The problem was I didn't feel capable of an evolution. I needed one though. I needed one badly.

Well, one was about to come.

The first Sunday in March I rose early and drove down to the East Side, near the old ball stadium where the Monarchs had played. Some folks call this area the ghetto, but really it's just another neighborhood where people work and kids go to school—although an impoverished one. I went there to remind myself how lucky I was, and that I could get out of my predicament if I was just creative enough. Cruising Prospect I drove among the old apartments, the derelict storefronts, the sleeping viciousness of the streets. Only the faithful were awake, where in the churches they had already begun to gather and sing. Otherwise the place seemed vacant, except for the odd prostitute or crack addict, wandering the sidewalks, having yet to sleep.

I looked at this place and thought how most of these people had not been born with my opportunities. I thought of how minor my struggles were compared to theirs. I mean, wealth could be found throughout my city. To tap into that, all I had to do was employ greater discipline and vision. If it could be done in any country, it could be done in this one. Well then, I would do it.

I got out and walked for a couple of miles along Brooklyn, to feel the desperation and rage (for reference, read Gordon Parks' autobiography). Next to this, I had it easy. I had it made.

Feeling less depressed, I went to the gallery and wrote until noon. Then, happy with my work, I went home to fix brunch for Annie and the boys.

That night the hotel manager called to ask if I was watching the news.

I asked why?

He said because my gallery was on fire.

I let the words sink in to be sure I understood them, but of course didn't, so he said them again. As he paused, I could hear men shouting in the background and the sound of gushing water. I told him I'd be right down.

I parked on Central and walked up among the fire engines, firemen and cops. Smoke was billowing out the gallery door and water pouring down the steps. When everyone realized I was the owner, there were quiet words of consolation. Then a platinum blonde with a microphone in her hand, and a cameraman at her side, walked up. She asked if I wanted to be interviewed. I looked at her tense, career-driven face and said, no, I did not want to be interviewed. Then I went inside to look at the gallery.

The fire had started in the storage room behind my space, where someone had left a smoldering cigarette in a napkin. It destroyed half my gallery. Most of the art, thankfully, had been moved out by the firemen. Everything else—files, computers, furniture—was ruined.

I looked around at the mess as the fire captain came up, a big dude with a handlebar mustache. He expressed his sympathies. I thanked him, and thanked him also for having moved out so many of the paintings.

"Aw, we were happy to do it. But man, I sure hope you got good insurance. Your business is a wreck."

My policy had lapsed three weeks earlier, since I'd opted to pay other, more pressing bills. I'd been planning to renew it in another week.

"You bet. I've got real good insurance."

When I finally got home Annie asked if everything was okay. She was sitting up in bed looking worried, certain we'd been ruined. I told her about the damage and the extent of it. She asked if the insurance would cover us.

"Oh sure. It'll pay off the debt. We'll open a new space. Everything will be fine."

She kept watching me, as if trying to be sure that what I said was real. Finally she smiled and said she was glad. Just seeing that smile was worth the price of the lie. Later she went to sleep and slept very soundly. I got to sleep at four, then rose at six to go downtown and face the mess I'd gotten us into.

The damage came to $40,000, almost enough to square my debt and set me up in a new space—had I only been insured. My gut wrenched in triple knots when I thought about it, but there was no point thinking about it.

The next day while I was cleaning up the mess, one of my sisters called. A skilled businesswoman living in LA, she told me the fire had been necessary.

"Really? How?"

"Simple, you're not making it where you are, so the fire's forcing you to make a decision—get out of the biz, or move and reinvent."

"Really? Just seems like a goddamn disaster to me."

"It won't be if you have a fire sale." She thought this was funny, and laughed.

"Honey, this is the art business. We don't have fire sales."

"Then you'll be the first. Just mark everything down 20 percent, move on, and rebuild. Two years from now everyone will forget you ever did it."

I realized she was right, and took her advice. With the help of my mom and some artists, I cleaned the paintings and sculpture, cleaned the gallery, and reopened. Then I called in the press, including the platinum blonde. By the time they came to interview me I was upbeat again, and told them you can always rebound, you just have to decide you will.

The sale was a success, and with the $24,000 we grossed I rented a larger space. It needed a lot of work, so I spent my days running the old gallery and my nights renovating the new one. In instances like these, artists have much in common with farmers—long hours, poor pay, forever working with our hands. I didn't care; we were on a new trajectory now. The challenge drew Annie and me closer, knocked some sense into me about my drinking, and inspired me to work more effectively. Good. It was time.

Anyway, March had certainly brought an evolution.

Business debt now $90,000. Other debt: don't ask.

BROOKLYN BRIDGE

My drive to avoid bankruptcy stoked my writing in a way that prosperity never could have, the way your own difficulties can also compel you. So writing hard every day, I finished my first mature novel in that summer of '97, then queried several agents. A month later I got a call.

"This is Robert Landis with the such-and-such literary agency. I'm looking for Paul Dorrell. Is he in?"

I feigned nonchalance despite the pace of my heart. "Speaking."

"Ah, wonderful. I want you to know that I've read *Walk by the Sound* and think it's marvelous. If no one else has offered, we'd like to represent you."

I'd waited seventeen years, two million words, ten books, and many difficult nights for this call. Naturally it didn't seem real, but it was. "I'd be honored."

"Excellent."

"When shall we meet?"

"How soon can you come to New York?"

A month later I emerged from the subway station at Union Square, walked over to Avenue of the Americas, found Robert's building and took the elevator up. Like most writers their first time in, I was expecting a Hollywood version of an agent's office—sleek, modern, dripping with wealth. What I found was a place that looked more like a university English department—casual, worn, and underfunded. But I did see the one thing I'd hoped to: shelves and stacks and piles of books, a form of heaven to all writers.

A British secretary showed me to Robert's office, which was like the rest of the place—worn and literary. Robert, who wore wire rims and had graying hair, was worn and literary too. I liked him right away, a casual kindness that told me he was honest. I saw all this in the first minute, and really didn't need to see anything further, but took the proffered chair I'd come all that way for.

"Oh yes," he said. "Oh yes. I think it will do very well. Now of course I can't predict how the publishers will react. They're so jittery these days. But I know several who I think will love your work. In fact I feel quite good about it."

"All right."

"By the way, how did you come to set it in Connecticut? I live there, you know, and by God you nailed it."

"Used to live there too."

"Marvelous. Marvelous." He laughed and lit a cigarette, which surprised me, but the windows were open. "And what will your next book be about?"

I told him, and as I did he leaned forward, listening. This book would go into new territory for me, and I could tell from his face that he knew it.

"What's the title?"

"*Cool Nation.*"

"Well please get it right to me. That one sounds like a winner."

We chatted for thirty minutes, then I let him get back to work. Like me, he had careers to advance—scores of dreamy writers who hoped he could get them in the door. Now I was one of them, which was a bigger break than ninety-eight percent of all writers get. I knew how lucky I was.

Out on the street I took my time crossing Manhattan, going from Italian to Irish to Puerto Rican neighborhoods. I passed Cooper Union and old Peter Cooper, went on through Chinatown and Columbus Park, until finally I got to The Bridge. Sure I walked across it, kind of as a tribute to all the writers who ever had. And when I got to the middle of that long boardwalk, I stood over the East River and looked back at the city—this place that could make a difference in an artist's life like no other. I was finally in a gallery, so to speak, and whispered a word of thanks. Never had I loved New York more.

THE SECOND GALLERY

The new space was on a quaint block in the old Country Club District. This vast area was mostly built in the '20s, when racism determined who would and would not live there, as was the case with similar districts in Chicago, Saint Louis, and elsewhere. Certain of the elite worked hard to maintain that policy for decades—and would have gone on doing so had it not become illegal in the '60s. By the time I opened, few of that old guard remained, and the racist views of those who did were normally rejected by their own adult children.

Some of the surviving members even did business with me—gladly, as they were convinced I was one of them. Had they known I was descended of Cherokees and Jews as well as English Protestants, it might have been different. They all thought I was a WASP too, when actually I'm not anything, just human.

Ted O'Leary hadn't been so fortunate. As a young man he'd been one of the local tennis pros, and a popular member of a now-defunct tennis club. After marrying, he took his Jewish bride to the club. The manager told him that he could come on in but his wife could not. Ted promptly decked the dude, then joined the Jewish club. He never played tennis at the other one again.

I finished remodeling the gallery and opened. I still didn't have an assistant or a proper business plan. I hated writing business plans, and anyway that would interfere with finishing the new novel. So I focused on landing big sculpture projects, reasoning that those would give me the most time to write while still elevating the gallery's status.

To that end, I'd sent a proposal to the National D-Day Memorial. They were impressed with the installations Jim Brothers and I had completed, and invited me for a meeting in Virginia. I could have flown, but a road trip sounded more interesting. So I went to Virginia via Louisiana.

Stops along the way: Memphis, where you could walk Beale Street for free but had to pay to see Graceland, so I walked Beale. Oxford, Mississippi, where I got coffee at Square Books, then took a walk out to Faulkner's home. The French Quarter, where I worked on the novel in the Café Du Monde, watched by a woman whose drunk husband was ignoring her. Biloxi, where I worked on the novel in a waterfront café while two men cast nets from a dock. Monroeville, Alabama, where the courthouse looks like the one in *To Kill A Mockingbird*, and where I watched a black cop arrest a white drug dealer. The Alabama woods, where on a moonless night I hiked through a pine forest, only to feel a chill go up my back as though I were being watched—a barista in Auburn the next day told me it was the ghosts of lynched slaves. An old man hitching in the rain, me picking him up and giving him a sandwich, he eating it while waving at passing truckers, me leaving him at a truck stop in Atlanta.

Each night I slept in the minivan to save money—a necessary practice for years. Motels could come after we made it.

I met with the D-Day Committee in Roanoke, where their architect expressed complete confidence in Jim and me. "Son," he said, "I can feel it in my bones. You boys are going to exceed our pedestrian expectations."

The meetings lasted all day. After lunch we went to the site—a hilltop in a valley beneath the Blue Ridge Mountains, near the town of Bedford. None of us knew it yet, but Steven Spielberg was making *Saving Private Ryan* at the time. He would later become involved with the memorial, as would Stephen Ambrose and Charles Schulz. These would prove great breaks for everyone.

The next day I headed home, contract in hand.

Ted and I sipped scotches while watching TV: Charlie Rose interviewing David Foster Wallace. Ted admired Wallace's books as well as his tennis-playing. So did I. Finally the interview ended and he turned to me.

"I read the opening chapters of *Cool Nation*."

"Oh?"

Long pause. "Magnificent. This one should get published."

"Thanks. I hope so."

"It will." He sucked on a cube. "I may not live to see it, but you will."

"You'll probably live quite awhile yet."

"I hope to hell not. Tired of the whole business."

Which he was, wasting away, lonely, missing his wife each day. No one could really fill that void, and he just wanted to move on. I didn't blame him.

"When will it be done?" he said.

"Fall."

"Good. Bring it to me then."

Our vacations were modest, but each year we managed to take one.

The occasional trip to Santa Fe, where we'd stay with one of my sisters, driving the 750 miles in one day to save on motel fares, wandering the galleries on Canyon Road, taking the boys for hikes at Tent Rocks or up in the Sangre de Cristos, rafting the Rio Grande below Taos, then after a week, making the long drive home, once having two flats owing to worn tires.

Visits to friends in Denver, going backpacking in the Rockies, once cooking dinner by an alpine lake, careful to not bring any food into the tent, later turning in, then at midnight hearing a huge snuffling at the tent wall, pulling out my hunting knife, waiting, then finally hearing a hoof-fall—elk, not bear. Annie flicked on a flashlight, hoping the boys weren't awake—their eyes wide-open, both of them pale. "Mom, what was that?" Coaxing them back to sleep.

The year we drove to the Grand Canyon, where in the 100-degree heat we hiked five miles down into its vastness, packing plenty of water, passing a teenager on the way back out, he leaning against a boulder, pale and shaking, holding an empty water bottle, me asking if he needed help and him saying *No.* Annie and I looking at each other, then she saying *We'd like for you to come with us anyway.* He gladly followed, drinking all our water, hanging onto my belt as the boys and I dragged him to the top. His name was Jonah, from New York. He didn't know people died from dehydration down there.

Parked on a deserted highway in Utah, me down in an arroyo studying the rocks when I heard a car stop, looking up to see a big dude with a goatee staring at Annie, me climbing out of the arroyo and walking over to his car, knowing that this guy covered with jailhouse tattoos and menace was probably packing. He was very surprised to see me and asked for directions as he pretended to look at a map. Then suddenly he grew agitated and jumped out of his car, with me blocking his way, thinking *No violence no violence.* He stared at all of us, weighing things, then finally wished me luck and went speeding off. I went back to the van and asked Annie: *Why didn't you drive away?* She said she just couldn't. The boys listening to headsets in the back seat, oblivious.

Canoe trips in the Ozarks, where Tom Geiger, Keith Stevenson and I taught our kids how to pitch tents, handle a canoe, identify copperheads. In the frigid waters we would go snorkeling and cliff-diving and spelunking.

When we couldn't afford road trips, our own town was almost as good—catching fireflies, B horror movies, neighborhood water fights, neighborhood dodge ball, building a tree house, hanging a rope swing, bicycle rides through the West Bottoms, the days on which the museums are free, watching *Psycho* with the boys and

their friends, putting them to bed, then me dressing up like Norman Bates' mother and busting into their room and scaring the crap out of everyone, visiting artists' studios and teaching the kids about each discipline.

You don't have much money. There aren't summers in Europe. You were born to the arts and to a degree privation. But never do you not feel alive.

Any night was good for making love good. Friday and Saturday nights were best. Massage oil, shay butter, different lotions she'd discover. Sometimes raucous, sometimes soft, always emotionally deep, since if there isn't that... The dropping of inhibitions. Feeling amazed that the lovemaking would get better each year, when we never thought it could. Saturday nights wearing each other out until two, collapsing, me rising in the morning to fix brunch, the kids embarrassed from all the noise that had come though the floor during the night. Me making jokes until their faces went beet red.

She and I had never been closer, yet tried to make sure that the closeness was in more eternal ways as well, since the lovemaking would go one day and there would have to be something deeper to take its place.

As summer ended I approached the completion of the novel. I loved going back to it each morning, knowing it was breaking the new wood for me. Finally in September it was finished. I sent it off to Robert. He said he hoped I had my seatbelt on. Already I was making plans for hiring a gallery manager and moving to Italy. I'd done my job in the Midwest; it felt time to move on.

What was the story about? It was set in the '60s and '70s, with all that those two decades destroyed and recreated. It focuses on one family, whose experience mirrors that of the nation—the war, the decadence, the addictions, with tragedy for some, victory for others, and the passing on of the poison from one generation to another, along with the passing on of hope. Now that I'd finished it, I knew the coming contract would give me the confidence to fulfill my vision, and allow me to focus on literature from here forth. Then I could quit worrying about my family, and quit working myself to exhaustion with

both the gallery and writing. At last this hostage-to-the-arts thing was going to be over.

I thought of The Beatles, and wondered if they would have ever gone beyond Liverpool without their initial success. Would there have been a *Sgt. Pepper* without the triumph of "Please, Please Me?" Doubtful. And while most of us love our Liverpools, we're anxious to land the break that helps us go beyond them, since creating new work decade after decade without any acknowledgement or income, pulling it out of your guts each time, can grind you to pieces. I wasn't ground down yet. In fact I felt I was just beginning.

Either way, that book was rejected thirty-six times before Robert finally gave up on it.

Seething and drunk I punched the wall once, then again, then a dozen more times, collapsing onto the floor, weeping. Annie sat down next to me.

"Don't."

"But I'm no good. You know it. You should've never believed in me. I should've lived alone so I wouldn't fuck up anyone else's life."

"Stop."

"I should've. I should've."

We talked that way for half an hour, sitting in the drywall dust beneath the holes I punched in our bedroom walls. We kept on talking until finally I cracked a joke, she cracked a joke, and we regarded those jagged holes. Some mess. Fortunately the boys were heavy sleepers.

The next day Annie hung large photos of the rascals over those holes, which I didn't repair for several more years, as a reminder I guess of the passion. So I got my head on straight, realized how fortunate I was in many respects, and that I'd only gone through what ninety-five percent of all artists do—repeated rejection. Okay, that simply meant the day of acceptance had just drawn another step closer, as long as I didn't give up.

PASSING POLES LIKE PICKETS

Robert reluctantly gave up on *Cool Nation* in 1999. He felt the book was gripping but that it needed sophisticated editing, the truth

of which I realized when I went back to revise it in 2011. The problem was he couldn't find anyone in publishing willing to spend the time—a common dilemma. Nor was he a flashy rep who could afford to dazzle editors with $300 lunches and weekends on Fire Island. Even if he'd had the money, Robert wouldn't have done that, since it wasn't in the Max Perkins tradition. He would respectfully submit a book and wait. Unfortunately that wasn't enough anymore.

I wanted to give him a bestseller. But the truth was, unless I had the name of an actor, athlete or tycoon, a bestseller wasn't likely. So I began thinking about nonfiction. Robert and I discussed this on the phone one day.

"Isn't nonfiction easier to publish than fiction?" I said.

"Right-o."

"So why don't I just write a work of nonfiction?"

For the first time in months he sounded excited. "Oh Paul. If you did I'm sure I could get you in print. And that might open the door for the novels."

"Then we could start having meetings in Jamaica?"

He laughed. "The only Jamaica I can afford is the one in Queens."

"Well get ready for the one farther south." I started to hang up.

"Hey. What's it going to be about?"

"Artists."

Jim Brothers' work on the National D-Day Memorial was superhuman. The figures were raw and emotional and one of them quite clearly dead. All the monuments were huge and each had to be sculpted so that they did not trivialize the sacrifices and slaughter of that day. Jim and his assistants did this in three years, when many sculptors would have taken six. It was a gargantuan effort of physical and mental strain that would have broken a less resolute man.

This achievement helped me land more commissions for my other artists—in corporations, parks, restaurants. Did we do world-class work from the start? No. Some of our early installations were disappointments to me, despite how happy the clients were. But only by finishing those early works were we later able to improve.

What else happened that year? I bought a Harley, used and cheap. I'd always owned bikes, and to go a long time without one

tended to make me feel caged—especially since I was chained to a computer most of each day. This bike had a flame-out paint job, straight pipes, and a hi-performance carb. On the interstates I took it up to 120 now and then, but mostly I just cruised. Annie loved it—morning rides to the River Market or up to Lawrence. Friday and Saturday nights? We rarely rode then, since that's when bikers regularly get whacked by drunks and texting teenagers. I didn't want to get whacked.

"What do you mean, ball?" the opposing coach said. "That wasn't a ball! That was a goddamn strike."

"Take it easy, bud," the ump said.

"Take it easy, my ass. I'm sick of your bad calls."

"Get sick then. You'll be ejected if you don't watch your language."

"Ejected," one of the fathers said, "I'd like to see you try it."

"Yeah, just try it," the opposing coach said. "I'll have your ass fired."

With those words the parents on his team—many of them of a violent nature and a couple of them sucking beers—began to pace and cuss.

I stood at third base and listened to this, knowing I couldn't let it go on. So I called time, jogged in, and addressed the crowd, reminding them that we were there for the kids, and that it was our job to have a civilized game. Some of the parents didn't know what to make of this, a long-haired artist-type as a ball coach, but whenever things got heated they somehow listened to me.

What was I doing coaching ball? Simple. You go this journey with your kids once, and have to put into it everything you can. I wanted my sons to develop athletic skill, and the best way to do that was by becoming a coach.

I soon learned that kids' sports are a disgrace—screaming parents, abusive attitudes, occasional fist fights. Just as bad was the way uncoordinated kids are rejected, since elitist coaches won't play them. We welcomed all kids onto our team, jocks and klutzes. My assistant coaches and I spent years helping them shine. Yeah it cost me: lost sales, lost opportunities, playing catch-up on weeknights. Well, I figured karma would balance the account later.

After the crowd calmed, I jogged back out to third and took in everything—the brown of the dirt, the blue of the sky, heat waves rising off the field, a party-mom with a hangover, a young couple watching their son with devotion, an uninvolved dad on a cell phone, one of my sons coming up to bat.

When I was in college I'd pictured myself in Italy by now, with several successful novels behind me and a literary career opening up ahead. Instead I was on a sun-baked field in Kansas City with a bunch of kids looking for guidance, Annie watching from the stands, and a gallery lurching from paycheck to paycheck—the same gallery that stole precious time from my writing. Yet somehow that was enough for now. Italy? It might eventually happen. If it didn't, we always had Italian films.

The pitcher made his wind-up, the crowd tensed, and my son cocked his bat.

I finished that first edition of *Living the Artist's Life* by summer's end. Robert was pleased, certain that this one would at last let me in.

A month later he called with news that absolutely blew my mind.

"They love it but feel it's too unique. They don't know what to do with it."

"I beg your pardon?"

"They don't know how to market it. The book's just too different."

"It's supposed to be different. All original work is. Hell, I'll help them market it. Just get me a meeting and I'll talk them into a tour. I'll make it work."

"I know you would but there's nothing I can do. They won't see you."

I ran my hand through my hair, trying to not throw the phone against the wall. As with all my books, I'd banked too much on getting this one published. But I was as sure of it as I had been of *Cool Nation*. I knew that after I got on tour, it would all click. I just needed for someone in publishing to once say *Yes*, but the answer was still *No*, as it had been all my life.

"What do you want to do?" he said.

"What I always do. Write another one."

"What'll it be about?"

"A soldier coming home. He's a sculptor, had to go to war, and it drove him insane."

"You've already sketched it?"

"Sure."

"While you were writing this one?"

"Sure."

He paused. "Wow. Well let me know when it's done. And Paul, don't let the rejections get to you. They're a part of the business."

"Yeah. I know."

Me at 140, zipping between the cars, the Harley screaming, telephone poles passing like pickets, drivers honking as though I were insane. Perhaps I was, since at that moment I didn't give a shit if I lived or died.

Now I had to make a profit from art as never before, especially since my overhead had risen and college tuition was coming. This drove me to higher levels of innovation, with the requisite hours.

My new assistant and I reasoned that if I'd landed D-Day, I could land other big projects. So we began going after them. Four months later I was commissioned to oversee all art for the Overland Park Convention Center, in a suburb of Kansas City. This job would change my approach to regional art. In fact it would open a variety of doors, including those of perception, as I sought out exceptional talent in my region—both the well-known and the unknown.

Why didn't I become more proactive sooner? Simple—I never wanted to be a businessman, since to me that smacks of conformity, the kiss of death for any artist. So I had to learn to become a businessman without betraying my rebel nature, which meant I still wore jeans, occasionally injected quotes from Whitman into meetings, and refused to let the corporate world kill the teenager in me. Still I approached each project with absolute professionalism.

As a result we began to get some interesting gigs, one of which was a monument of Eisenhower for the Capitol Building in DC. Jim Brothers sculpted it and Bob Dole, a vet, loved it, standing in front of

the piece getting his picture taken for twenty minutes. Nancy Pelosi was also there and gave a dignified speech. Jim and I got our photos later, after all the politicians split.

Other projects included large, blown-glass installations for the University of Kansas Hospital, several corporations, and private collectors. About this time Douglas Adams, author of *Hitchhiker's Guide to the Galaxy*, bought two Regiers for his London collection. Other international collectors followed suit.

Then in May of 2001 we dedicated the National D-Day Memorial. About 25,000 people jammed the site on a rainy morning where the clouds eventually parted and drifted east. There were French politicians, British politicians, Secret Service agents with their sunglasses on, and President George W. Bush. But especially there were veterans, thousands of them. I watched as they toured the monuments and as several wept. I knew then that Jim had got it right.

The ceremony was a long one, with speeches and bands and a flyover.

At one point a vet who was on the committee leaned over to me and said: "You boys have sure done us proud. Look what we have here now—the President of the U-nited States." He wasn't a Bush fan, being more enamored of Eisenhower, so it was a form of joke. I smiled.

Owing to these projects, for the first time in years I was up-to-date on taxes, had some money in the bank, and was building up my sons' college accounts. I knew the convention center would be well-received, and anticipated that the thousands of people who would visit it would later approach us. I assumed that all our successes would at last cause the phone to ring, and that I could quit chasing obscure leads late into the night. I still had a lot to learn.

Ted and I settled in the den with our drinks. He stirred his cubes.

"So none of them would publish it, eh?"

"No."

"Pity. Good book. But like I told you, you came along at a tough time."

I didn't say anything.

"Going to give up?"

"Hell no."

He laughed into his glass. "That's the spirit."

We watched Charlie Rose, me glancing at Ted now and then. He'd been thin when we first met. Now he was emaciated. He sensed me looking at him.

"Don't look so good, do I?"

"You look okay."

"Bullshit. Look awful. Feel worse. Don't have much time left."

I paused. "You miss her terribly, don't you?"

"More than you'll ever know."

"Do you believe you'll be with her soon?"

He laughed. "Well I never did go in for any of that when I was younger, but it's certainly tempting now." He set his glass down. "I want to tell you something."

"What?"

"Eventually you'll go on a book tour, and if you're lucky the book will do well. But whatever delusions you fall under, you must never think you're special. You must remember you're flawed, like all of us. That'll make everything easier, especially the disappointments. Don't overrate the fact of getting published. I've seen writers do that for fifty years, then wind up in the gutter. I don't want that happening to you."

"Thanks, man."

"Don't mention it."

He picked up his drink, stirred the cubes again, and took a sip.

Within three months Ted was gone. Wherever he is now, I sure hope he and his wife are together.

SAVING THE SHIP

I closed the book, thanked the crowd, and waited for the applause to stop. Then I took questions and signed books. This, the Art Students League of New York, was a pretty fabled place to sign books in. Georgia O'Keefe and Jackson Pollock had studied here. Thomas Eakins and Saint-Gaudens had taught here. To be invited to give a talk in this place was a pretty high honor. I'd spoken in a lot of nice places during my tour—legendary bookstores, art centers, universities. All that was winding down now.

I looked outside to see how the sun was hitting 57th Street. The September shadows were long and the windows across the street golden with evening light. It was getting late. I thanked everyone once more and left. An old friend of mine, Eddie Lohman, was meeting me for dinner in The Village. I caught the B Train downtown and walked through the doors of a Korean restaurant on Bleecker thirty minutes later. Eddie was waiting. Right away he started telling me about a job he was going to take with some new startup in Silicon Valley. The startup was called YouTube.

"Do you think it will go?" I said.

"Who knows? But they've given me a good offer and a lot of stock."

"What if the stock proves worthless?"

He stopped eating. "Paul, my stock never proves worthless."

Which was true. Eddie understood finances. He would never have opened a gallery. Even so he envied my lifestyle. I envied his solvency.

We finished dinner and walked over to Washington Square, where the overlapping vibes of Victorians, Beats, Hippies, and Hip-Hoppers mingled in the New York night. We watched as a young dude recited poetry beneath the arch.

"Your tour's almost over?" Eddie said.

"Yeah. All I have left is New Haven, Rhode Island School of Design, and a few stops in Florida."

"You should be proud. The reviews have been great. It's done well?"

"It's done okay."

"I'm so happy for you. I know you risked everything to do it."

"Yeah. Well. Kind of seemed like I didn't have any choice."

"But you proved the publishers wrong. You've had a successful book."

I was too exhausted to think of an answer. He laughed.

"Look me up in Frisco. I'll show you this You-Tube place."

We said goodbye at the station and I caught a train to New Haven, where I was due to give a radio interview the next day.

My tour of 50 cities was nearing its end. I didn't tell Eddie, but I'd resolved to close the gallery in another two months. It was a relief

making that decision, like a cancer patient finally letting go. I'd been fighting the battle for fourteen years now, and didn't want to fight it anymore. It's hard enough to turn a profit selling original art in a place like New York, but almost impossible in a provincial Midwestern city. Unless something changed, we were done.

But I'm getting ahead of myself. Let's go back a little.

Two years earlier I decided to leave Robert, my agent. For six years he'd tried to get me published, but we just weren't a fit. I wrote him, thanking him for everything he'd done, and made a clean break of it. He wished me luck.

Then I hired a skilled editor to teach me how to publish a book as though it came out of one of the big New York houses. He did, we published it, then submitted to all the major bookstores and distributors. Each of them took it. That book, *Living the Artist's Life*, formed the basis for this one.

Soon I hired a publicist and he began booking my tour. As he did, the review copies went out and the reviews came back in, all of them positive. Then I started receiving letters from readers. And while the reviews were gratifying, what mattered most was the readers. I set out to meet them.

Charles Dickens did over 100 dates during his first tour of America—many by stage coach. If he could do that, I figured I could do 50. So I told my publicist where I wanted to go and he lined up the cities all in a row.

As usual, I slept in the van. I slept in the Texas heat, the Minnesota winter, on a Florida beach and the Malibu bluffs. A few vignettes from the tour:

The signing in San Diego where eighty people showed, loved the book, loved the talk, and poured me several glasses of champagne after.

The signing in Tucson where no one showed except an old woman with arthritic legs. So I helped her to a chair and gave a performance for one.

The cops who woke me in a swank Chicago suburb to ask why I was parked there, were impressed with my story, and left me alone.

The time a German woman in LA said, "I vant to learn about ze arts," and sent her boyfriend off to get lattes so she could give me her card.

A single Hispanic mother of a teenage artist in Dallas, and how that boy was just dying for male attention. I took them to coffee and gave him all I could.

Two old friends from Connecticut attending my signing at the Yale bookstore, both of them proud beyond words.

A packed signing at Square Books in Oxford, Mississippi, where I'd been interviewed on the radio earlier in the day. As the signing ended a phone call came in—the director of the Faulkner home wanted to give me a tour.

Inevitably I had to set up a blog, since my friends convinced me that readers would want to ask questions. So I started it and the questions began pouring in: ten, twenty, fifty a week. I answered every one, often past midnight.

Over time the reviews began piling up on Amazon, various blogs and websites—even from readers in London, San Paulo and Florence. The majority were favorable, but some harsh. Good. I like contrasting points of view.

Then there were all the thousands of characters I met on tour: painters, sculptors, novelists, musicians, surfers, or just people who wanted to break free of their routines. They all bought the book and to them all I owe thanks.

Publishing the thing, with the tour, cost $35,000, borrowed money, of course. Time spent away from the gallery cost God-knows-what. But my intuition told me this had to be done if we were to go to the next level. I'd used up our savings, once again maxed out the credit cards, and sold the Harley. What hurt most though was cleaning out my sons' college accounts. I'd struggled so hard for so many years to build them up, to give the boys opportunities I'd been denied, to allow them to start life with a well-rounded education, with confidence, and without a mountain of debt. Then in one day all the money was gone. My self-disgust had never been greater. After I did it I sat in the bank parking lot and wept.

Sometimes I felt my head would explode from the pressures, the hours, and the creditors. My health insurance had been cancelled,

the bills were stacking up, and the clock ticking down to the moment when it would all finally collapse. Only when I was in front of an audience did none of these things matter. Only then did I feel a new future beckoning, if I could just hold on. I was forty-eight and getting tired of holding on.

By now you'd assume we were selling tens of thousands of books and making a killing. But publishing is rather unique. How? Each year 250,000 new titles are put out, and out of those roughly ten percent sell 5,000 copies or more. The rest fall below that mark. Worse, publishers have to buy back all unsold books. Now imagine if Target were allowed to return unsold merchandise to the manufacturers. Not only would the manufacturers go broke, there'd be a revolt. But publishers have to deal with this every day.

The book was selling well and about to go into its second printing. We'd already broken into the top five percent for that year, and had to maintain that. But there's no simple way to do this once your tour is over. Either readers like a book or don't. Now my work's fate was in their hands.

Yet no matter how well a book sells, the amount you're paid is so minor it's laughable. In truth I hadn't counted on profiting, but had gambled that if the book succeeded, it would open new doors. It hadn't. And the meager profit it would eventually make wouldn't come to us for another year. I didn't have another year. I didn't even have another month. This, then, was the end.

I'd always taken care of the arts, believing they would in turn help me take care of my family. My intuition told me that if I published the book, everything would click. But the crash seemed unavoidable this time. Well, at least they no longer had debtors' prisons.

My last signing was in Kansas City. I talked to the crowd about more than art careers that day. I discussed the importance of corporations investing in the regional scene, of how they were the new Medicis, and why it was time for the smaller cities to develop their own culture and quit importing it from the larger ones. The talent was here, but until we gave those artists a chance, nothing would change. It was damn well time for a change.

I finished, answered questions, signed the books and split. I had to get back to the gallery and learn about filing for bankruptcy. This dance was over.

When I returned my assistant Sharon had this silly smile on her face. She could have left my sinking ship by now, but Sharon was going to stay until the end, don a life jacket, and swim to the next job. Her loyalty humbled me.

So anyway she had this big smile, which was odd since neither one of us smiled much anymore.

"What happened?" I said. "Win the lottery?"

"No, but I think you did."

She handed me my messages. On top was one from H&R Block. Two executives had attended my talk and wanted to meet. They were building a new headquarters, were looking for an art advisor, and liked my ideas.

I met with them the next day. They hired me two weeks later.

Like the fire, like D-Day, like so many things that unfolded for us, this was one more turning point that allowed us to keep progressing—in the nick of time, as usual. Perhaps the arts would help me care for my family after all.

The Block complex is a sophisticated design eighteen stories high, occupying an entire city block. Every floor required art, but the primary focus was the ground level, with its various lobbies and courtyards. This is where the largest works went—blown glass, ceramic sculpture, paintings, bronzes, stainless steel. Some of these pieces were enormous, some average in scale. I was careful not to install too much work, wanting to avoid a sense of clutter.

This project allowed me to prove, conclusively, that the Regional Renaissance was real. The artists of my region rose to the task, some executing work at a scale they never had before. Where did I find them? Everywhere. We sent out a call across Kansas and Missouri, and were inundated with 650 submissions. The collection received national praise. Even better, the careers of several artists were advanced. I treated the structure in all media, all styles—conceptual, contemporary, representative.

Inevitably some local "experts" complained that I should go to New York to get the blue-chip artists and forget regional talent. But no matter how much I love New York, I couldn't do that. It was my job to help regional artists become blue-chip, which I made clear. After that those experts just kind of faded away.

Devising the master plan, reviewing the submissions, and coordinating the project was a little demanding. In fact here's an average day from that time:

Rise at 6:00. Work out, read paper while eating granola, walk dogs, kiss Annie, roust sons, dash to gallery. Espresso. Listen to Vaughan Williams while working on new book. Send a dozen emails. Head to site, meet with project manager, head back to gallery. Read David McCullough's *Truman* while eating lunch. Work for several hours while listening to the Chili Peppers, review budget, call a dozen artists, call a dozen clients, deal with marketing issues, write letters, write a magazine article, send more emails, take a call from a friend only to ask if I can call him back on my cell? Call him back while driving back to job site. Coach ball game at 6:00, return to gallery by 8:00. Answer emails. Post on blog with photo of a work in progress. Proof postcard for upcoming show. Home by 10:00, having missed dinner with family again. Visit with sons, visit longer with Annie, try to listen to everyone as I try to shut down. Read Benvenuto Cellini's autobiography until falling asleep at 12:00. Next day, repeat.

I'd been running this pace for several years, and would for several more. Did I burn out? Sure, my mind was in tatters, inspiration absent, legs aching, and ears ringing from rising blood pressure. But this is hardly unique. Constantly I met other professionals with the same issues, which is only a reflection of our society's manic pace. I hate that pace. But college accounts, debt, and artists' careers left me no choice. Besides, people all over the world work these hours their entire lives just to have enough to eat—and often don't.

Long hours or not, I had it easy.

THE THIRD GALLERY

The larger Block installations required boom trucks, scaffolding, hammer drills, and patience. My sons, teenagers now, were part of the crew. Annie would often come downtown to bring us espresso or Thai, which was one way of having dinner together, since I was so rarely home anymore.

After the job was done Block threw a party. The artists were treated like the other professionals, and felt honored. Convincing your region to recognize that, then support it with real budgets, is part of what the sacrifice is all about. Block had done this. Damn I was proud.

This was followed by an equally complex job for the University of Kansas Hospital, which, with their generosity, I structured along similar lines.

With the cash from these two gigs, we moved the gallery to our third and, I hope, last location. It's an enormous space with great traffic and two floors. Sure it was a wreck. Sure it had to be renovated. Sure I picked up a hammer and worked with the crew. Protecting our capital had become a habit I couldn't seem to break. As it happened, that would prove a good thing.

Six months later, in December of 2007, I got a call from an architect I often worked with. He and I had been developing a million-dollar sculpture project for a city park. He loved the concept, and felt the city would raise the money with ease—that is until he called.

"What's up?" I said.

"Just this. You can forget about the project."

"Why?"

"Tax revenues are down. The worst in thirty years. I can't say for sure, but I think this country's economic house of cards is about to fold."

"Do you think we can get moving again within a year?"

He paused. "Paul, I don't even know if I'm going to have a job in a year. There might be bread lines in a year. I sure hope you've prepared for this, because businesses like ours will be the first to go."

I realized he was right, and my heart stopped. After finishing Block I thought we were safe, since for the first time in my life, major clients had begun seeking us out. Overnight that evaporated as a

psychology of fear settled in, and as every project I'd landed got cancelled. So I increased my workload to eighty hours a week, intent on finding answers. In order to do this I had to sacrifice the one thing that made me an artist, and made me feel fully alive—my writing. I had to become a full-time businessman. Fuck.

I managed to line up several new projects.

In short order, all those were cancelled too.

Then people quit buying art and I had to put things like payroll and phone bills on credit cards, taking consolation in the fact that I was only one out of millions doing the same. Annie and I made jokes about it in order to hide our fear. I tried not to lose my perspective as millionaires in the financial industry got bailouts, bonuses and tax breaks while everyone else just got screwed. And there wasn't a damn thing we could do about it; the system had become too corrupt. There would be no bailout for the rest of us. Knowing that, and the injustice of it, sometimes made it hard just to control my rage.

Well I still had the kids. Not just my own, but inner-city teenagers I'd begun working with. These were artists from urban high schools for whom I'd structured mentoring programs. Why? Because as everyone knows, talent has nothing to do with race or economic status. I just realized it was time to start doing something about it. When I was younger, I always assumed that would happen after I was financially set. But if I waited for that I might be dead. So I started structuring the programs. The time had come.

I saw him leave the group and walk down into a treeless valley, wandering through waist-high grass, head down. I could tell something wasn't right and walked after him. Terrell was a half-mile away.

The other kids had broken up into various groups—photographers, painters, sculptors. With each group was a professional artist who instructed them as they wandered through these prairie hills, sketching a place of solemn quiet that none of them had seen before. Later I would host a show for them at the gallery, but first we had to complete this day.

Terrell had stopped and was running his hand through the grass. The wind blew softly and the sun was warm and the sky a deep September blue. I came up beside him but we didn't speak for a minute,

and didn't need to. I'd made a point of getting to know him, since Terrell didn't have a home—or rather wouldn't stay there, where the dope was bad and the fighting worse. Instead he crashed on the sofas of friends' houses. Occasionally he would come by the gallery to hang out or talk. I was glad he trusted me but still felt rather helpless with him. Unlike some of the other kids, who had earned scholarships and were going on to college, Terrell's future didn't look so bright.

"What're you doing down here, man?"

"Thinking."

"What about?"

He started to cry—this boy who was as big as a linebacker and plenty tough. He had to be, to survive where he lived, along a murderous stretch of Prospect. I gripped the back of his neck, gently. He let me.

"It's just this place. It's so beautiful. Made me think of my brother."

"What about him?"

"Got shot last year in a drive-by. They shot him and I coulda stopped it."

"How?"

Now he really started crying. "I don't know, man. I just could have."

There was nothing I could say to that, so I listened. Terrell told me about his brother, parties they'd gone to, girls they'd chased. Then he told me about a carnival on Van Brunt and a fight that broke out. His brother won the fight and was shot a week later. Things at home were already bad. Afterward they got really bad. That's when he moved out.

He wiped his face. "I'm sorry."

"Don't be. I'm glad you told me."

"I mean, I appreciate you folks bringing me here and all. But I don't get what you do it for—have shows for us and that. I ain't as good as them."

"As who?"

"Them!" He jerked his head toward the horizon, and the white world in general—a place where so many kids were programmed to succeed.

Compared to the other kids, Terrell's paintings were primitive, and his technique untutored. Sure he had a lot to learn and had a lot stacked against him. But his passion was pure, as was his intelligence. He just needed to be in a more nurturing environment. I couldn't give him that. All I could give him was this field trip, an unspoken regard, and a show in my space. That wasn't much, but I was hoping it would make a difference.

"Look, you're as good as any of them. Do you think I'd have invited you here if you weren't?"

"I don't know."

"Well I wouldn't have. So get back to your easel, finish your sketch, go back to school and do your painting, and let's have one damn fine show."

"Do you care what I paint? I mean, do I gotta paint these hills?"

"I don't care if you paint my ass, as long as you mean it."

He really laughed at that. "Man, you got a skinny little white man's ass and I damn sure ain't painting that. Ooh! That's scary."

"Then paint your own. Now let's go."

We walked back up to the ridge. I knew I'd reached him, a little. I didn't know if it was enough.

It wasn't. He submitted a piece for the student show. The opening was packed. Terrell attended. You could see he was proud, but he didn't smile once, even when I took his picture. I bought his painting, and those of two other kids. The other two, who had strong GPAs, went on to college. Terrell dropped out before he ever got the chance. I never saw him again, nor did his teachers, but I hope someday, at some point, he'll remember what we were trying to tell him—he was good enough.

My point? If the recession was hard on people like me, think how hard it was for kids like him, who some days didn't even have fifty cents for lunch at school. That's when I decided to really start working for those kids, and make sure they not only had the fifty cents, but also a path to college.

SAVING THE SHIP—AGAIN

The Great Recession ground on, sales stagnant, consulting dead, my debt having zoomed from $30,000 to $200,000. Galleries

all over the country were closing, as were thousands of other small businesses. Even some of the veteran journalists I'd worked with for years lost their jobs. Opening my new, expensive space coincided with this disaster. I believe that's called *timing*.

I thought of all the people I'd known in the gallery world, and not one had really profited. They'd always had secondary income, inherited wealth, or framing to fall back on. What made me believe that didn't apply to us? Simple: the business model I'd finally built provided several revenue streams. If I could just outlast this recession, I was sure my theories would prove sound. But how would I last? The stock market was in free fall, nothing was selling, and my credit was nearly shot. Man, I was so worn down by this never-ending grind.

So what did I do? Loaded my family in the minivan and drove to New Orleans via the Mississippi Delta. We listened to blues in a Clarksdale dive, saw Robert Johnson's crossroads, saw the old hospital where Bessie Smith died, saw the general store where the Emmett Till tragedy began. We toured plantations and searched for gators and spent three nights in the Quarter, savoring the soiled beauty of the place. We ate in cheap crawfish restaurants, walked the levee in the fog, and in the evenings drank wine in the hotel courtyard. We met prostitutes and street musicians and evangelists, taking in the human swirl of the city. By the time we returned home, I'd paid out the last of our money on the gamble that the trip would sufficiently restore me to deal with this umpteenth financial hurricane. Then I stepped back into the harness.

It would be pointless, now, to detail how we once more pulled a rabbit out of a hat. But that Southern journey gave me the juice to roll the boulder back up the hill and hold it there for three more years until the storm began to calm. The workload did a number on my health, my passion for life, and my life overall—but by God we survived. The other things I figured I'd get back later. Until then, all that mattered was that the ship stayed afloat.

Good things came out of the recession too though, primarily that it forced me to become more innovative. Within two years I'd paid off most of the debt and we were again in profit, landing consulting jobs

and selling art. In fact part of my debt had been owed to a group of artists who hadn't needed the money right away, having day jobs, and so gave me time to get caught up. Just as in the early years, they didn't want me to close. The banks weren't making loans so these artists in essence became my bankers, for which I paid them interest.

As I went through that process, business just kept improving. Oddly, it was as though we were being guided through the storm now. All I had to do was call prospects, make a presentation, and I was hired. Other times they called us. This was bloody strange. At last my reputation was taking hold.

About this time Warner Brothers contacted us and said they wanted to acquire some sculpture for the film *Watchmen*, specifically pieces by Brent Collins and Dave Regier. So we closed the deal.

Soon after that I was contacted by a publishing firm in Seoul. They asked if I would let them put out a Korean version of my book, I said *Sure*, and soon it was released. I understand it's done well, but still can't read a word of it.

Soon after that I won an honor from the Academy of Motion Picture Arts and Sciences. How? I'd adapted one of my novels to the screen—the story about the wounded vet coming home and trying to readjust. The Nicholl Fellowship, affiliated with the Academy, placed it in the top five percent of scripts that year. Next I heard from a score of producers. They all liked the script, but didn't want to take a chance on a film about the war in Iraq. So I told them that I'd scripted a reality show, a tear-jerker that gave deserving teenage artists from various ghettos a break. One of them liked the concept, this kind dude named Adam, and soon he had a major actor interested—a man who'd won two Oscars. They wanted to have dinner, so I bought a ticket for the coast.

I was walking near the Coast Guard station on the north side of the Golden Gate when a Brazilian couple gave me a camera and asked me to take their picture. It was a bright day, with the bay a deep blue and that titanic bridge arching overhead. As I took the shot there was a huge splash a half-mile out, beneath the bridge. The Brazilians didn't see it. We chatted for awhile, and as we did a

Coast Guard cutter went roaring off from the station. The Brazilians moved on and the boat came back, an ambulance waiting for it. The cutter's skipper waved off the ambulance crew, grimly shaking his head.

I watched as they set the body on the dock, draped in a plastic orange sheet with both feet sticking out. I could tell that the worn brown shoes belonged to a middle-aged man, and on seeing them felt a deep sorrow. The Guard began making preparations to send the body to the morgue, discreetly, so that the few tourists in this cove wouldn't notice. I didn't stick around to watch, wanting the guy to have privacy.

Why had he jumped? A broken romance? Uncontrollable depressions? Or just a string of failures that he couldn't overcome? Man I knew how that felt. We all do. Watching his death unfold put a black pall on my day. The only thing that lifted it, a little, was knowing he was at peace now.

I'd just come from Napa, where one of the wineries agreed to a major installation. People were still saying *yes* to my proposals, with little prodding on my part. After all the years of rejection, this still felt weird. It was like I'd entered a new realm. I just wished the guy on the stretcher could have experienced the same. My depression over his death deepened.

To shake the feeling I drove on to Santa Cruz. Earlier in the summer I'd surfed with my sons in Bolinas, where the waves were smooth and easy, heaving you toward shore with a softly accelerating rush. We loved it. But on this day, with a storm brewing, the waves were violent and running at cross-angles. A group of pros sat on the beach, glumly looking at the ocean, not even bothering to go out. I had to, since I'd already rented a board. So I tried to ride those crazy waves, getting my butt kicked for two hours. Chilled and exhausted, I finally gave up and took my board back to the surf shop.

The guy who rented it to me smiled. "How'd you do?"

"Not so good."

"Yeah, but you had fun trying?"

"Sure."

"That's all that matters, dude."

I left for LA the next morning, the guy on the stretcher still with me. He would stay there until the end of the trip.

With a golden sunset over West Hollywood, Adam and I sat at an outdoor café, eating sushi and drinking Sapporo beer. As we did, two young vets went past, one in a wheelchair and the other on crutches, missing a leg. The one in the wheelchair was a woman. They were long-haired and drunk and wore stained fatigues. For a minute they stared at the well-healed crowd on the terrace. Conversation quieted. Then one of the vets muttered *Rich motherfuckers* and they went on. Gradually conversation picked up again.

Adam gestured with his chopsticks. "That's what we should be trying to get produced. Your script about that vet coming home from the war."

"Unpopular subject."

"Won't always be. Wait a couple of years. Someone will take it."

We were eating alone. The actor had to cancel, calling Adam's cell at the last minute, Adam telling him *Dude, it's okay. No he won't be mad. Yes we understand. Let's just make it next week. Sure. Sure. So long.*

I realized then that the actor wasn't going to work out, and that we'd have to find someone else to get us in the door, which only happens in Hollywood about 10,000 times a day. I was okay with it.

"Doesn't sound like he's going to attach," I said.

Adam looked up, his worry showing. "Oh he will. He just couldn't make it tonight. Things are like that for him—new movie deals, the gig with A&E, his family. But he told me to tell you he still loves the concept."

"What do you want to do?"

He shrugged. "Wait for the right time. Everyone's still freaking out about the economy. They're worried this recession will be the new normal. Now if you were famous, we'd have been green-lighted by now. But without that…"

"Yeah. I know."

He raised his hand to order two more beers. "I mean I'm sure people will love the show. The concept's a natural—dignified, a tear-

jerker, makes an impact on people's lives. You have any other ideas like that?"

"A few."

"Well write the treatments, baby. Sooner or later I'll get you in the door."

We finished dinner, he spotted an actress he knew from a crime drama and went over to chat. Later on we split, walking down Wilshire in a warm LA night where the traffic is never quiet, the town never really asleep, and where the hustle pulses like a perpetual beat of dissatisfaction. I loved how this place was so different from any other town. It would be cool to work here, but if nothing clicked, it didn't matter. I already had more work than I could handle—two hospitals, a new corporate headquarters, an NFL stadium, shows to plan, and a charitable foundation to structure. I'd decided to start funding scholarships for the teenage artists, and my clients were going to help me raise the dough. Our first goal was $100,000. So if things didn't click in LA, no worries. Life was pretty damned good.

We got into Adam's Porsche and sat on its cool leather while he went scooting up Laurel Canyon, crossed over Mulholland, and down to his home on Hollyglen. He and his wife put me up that night, as they didn't want me staying in a hotel. They were that kind. In the morning I caught a flight out and returned to my life in the Midwest. Work was stacking up, and Annie and I were planning a trip to Italy. My Italian sucked, as did hers, but we had time to work on it. Until we left I had a new bike to play with, a Triumph street racer. It topped out at 150 and handled like a jet fighter—a nice release after a long day at the computer. Yeah, not only was life good, it had never been better.

When I was younger I used to leave much of my fate up to what I hoped was karma, but found that it worked only half the time. The other half was made up of that common burden we all share—endless toil. I'd finally created a balance between the two, along with a desire to live at a slower pace.

Will my novels ever get published? The better ones, I think, but my life doesn't hinge on that. It hinges on the people whose lives I've

touched, those who have touched mine, and the difference we've tried to render.

Why have I told you this rather personal and involved story? To assure you that you're not alone in despairing at the odds. Forget the odds. Achieve the goals no matter what roadblocks arise. Become a master at avoiding those blocks, or driving through them, or better yet, trying to understand why they're there in the first place. You can accomplish anything if you're passionate enough, disciplined enough, and a bit of a dreamer.

When I first started this entire process, I had trouble envisioning anyone less suited to running a gallery. I felt so inept, so incapable, so much the perpetual loser. What I didn't know was that I was winning experience, strength and knowledge all the time. It helped that I tried to learn from every mishap, refusing to let booze overwhelm me, bitterness dictate my outlook, or self-pity my end. But countless other things helped as well: the generosity of others, the love of family, and my boneheaded refusal to give up. Would I do it all over again? Only if I had to, and I hope I never have to.

Of course nothing guarantees that our success will last for the rest of my life. If I handle it wisely, it likely will. If I don't, it won't. Besides other recessions—or worse—will come, as they always will until our economic system is more sustainable. We'll deal with those disasters too. Such is the march of history: times when we have it easy, other times when we're tested, where when each time of testing ends we only have to ask ourselves if we handled things well, if we helped others with their struggles, and if we remembered to enjoy life in the midst of it all.

Do I have any regrets? Sure, that the demands of the recession took so much time from family and friends, taking a toll also on my marriage. I had to work such brutal hours that I became a sort of machine, almost incapable of feeling or expressing emotion, focused only on the task of survival. This is not good for any relationship. Inevitably, being a flawed man, I made other mistakes as well. But it was either long hours or bankruptcy—meaning the loss of everything we'd struggled for, including a decent start in life for our sons. Annie understood how much was at risk, and gave me the time and peace

of mind I needed to focus. If she hadn't, I don't think we would have made it.

She also encouraged me to start taking yoga and make some lifestyle changes, which I did, finding ways to stay centered and grateful within the insanity that marked every day. I damned well made it a mission to stay healthy, not just for my family, but also because I wasn't going to allow an unjust distribution of wealth shut us down. That would be caving to the pampered rich whose lobbyists run the country for their interests instead of everyone's. I refused to do that, as I'm sure you have. After all, I wanted to do my part in helping to correct the whole bloody mess, and couldn't if we failed.

Succeeding is a form of protest; using your prosperity to help effect positive change is another. To me, that is one of the best definitions of success.

CHAPTER 8

GETTING INTO THE GALLERIES

All right, let's assume you're ready to approach a gallery. You've exhibited in juried shows, restaurants, and artists' coalitions, you've found your audience and are confident of your work. With these things behind you, you're ready to begin the process of approaching the galleries. I'll coach you a bit so that you do this right, do it well, and stand a better chance of acceptance.

As we begin, please bear in mind that as an artist you are self-employed, and thus in some ways an entrepreneur. If you handle the business details of your career professionally, you'll stand a greater chance of flourishing. If you handle them amateurishly, you'll stand a greater chance of failing. I wish I could tell you that to create great art alone is enough, but unfortunately it is not. Dali, Giacometti and Frankenthaler handled the business aspects of their careers very well, or had others do it for them. Had they flubbed the business aspects, they probably would have never gained much notice until after death—an all-too-common occurrence that I find needless.

So, with a well filled-out resume in hand, let's proceed.

REJECTION / PERSEVERANCE

Before we go on to the galleries, you should know that your work may be rejected several times initially, and that finding the right gallery will not necessarily be easy. Therefore allow me to share some of my experience about rejection: learn to anticipate it, then determine to persevere beyond it, no matter what.

Perseverance is the quality that enables you to handle rejection after rejection, then more rejection, then further rejection, then maybe a few more years of rejection, and still snap back. I'm not saying that those rejections shouldn't depress or anger you, or make you want to abandon the whole bloody business. On occasion they will. On occasion they'll flat out piss you off. But you'll have to persevere nonetheless—that is if you want to succeed.

You're the one creating the work. You're the one who has to believe in yourself. You're the one who has to know whether your work is any good. If you do know this, and are certain of your destiny, then no amount of rejection should matter. Sure, you may punch some holes in a few walls before it's all over, but after the dust has settled and you've mended your knuckles, go back out and make the approach again, and again and again, and again, until you achieve your goals.

Please don't give in to despair. Listen to your inner voice, the one that has assured you about your place in the world since the day you began to create. Voices like that rarely lie—which isn't to say that we don't on occasion misinterpret them. Listen to the reassurance it gives you. When you're at your loneliest and most depressed you may find that voice a comfort, especially after it proves to have been right about your talent all along.

As you listen, and as you prepare to send your work out once more, try to employ resiliency, combined with stubbornness, mellowed with humor, strengthened with discipline, bound with humility. And hell, enjoy yourself. You're alive, you're free to create, your work is maturing. If you learn to take the rejections well, you'll gain strength from them. In time, this can develop one formidable artist. Decide that it will, and that the day is coming when the galleries will be happy to work with you. People respond well to confidence—which of course should not be confused with arrogance.

Determine that the rejections will help build these things up in you; they can if you take them that way. They can also destroy you. Don't let them. In the end, the only person who has the power to do that is you, to paraphrase Eleanor Roosevelt. That's a tough one to remember and a tougher one to practice, but from everything I've seen, I believe it to be mostly true.

CHOOSING THE RIGHT GALLERY

I advise that you start with galleries located in a major city or resort near you. Visit them and browse. Don't mention you're an artist. Don't mention anything. Just walk around and get a feel for the place. Is the gallery well laid out and well lighted, or is it dim, dusty and reeking of disorganization? Does it exude contentment and confidence or despair and ineptitude? Most importantly, are the director and staff snobs or are they considerate and helpful? If the former, I advise caution.

Snobbishness, like many negative traits, is rooted in insecurity. If the staff is this way with you, chances are they're this way with clients, which will only lead to lost sales. I have to admit though, some snobs do make excellent art dealers, they're just a pain in the ass to work with. In the end it's a personal call. If you feel you can work with these folks, go ahead—just watch your step as you do. Snobbery, by my experience, is often an indicator of a lack of integrity, not to mention a lack of enlightenment.

Once you find a group of galleries that impress you, you'll need to assess if they're a fit for your work. You can do this by taking in the inventory. If they only carry landscapes, it's doubtful they'll be a good fit for abstraction. Ditto the reverse. But some galleries, like mine, carry both abstracted and representational art. These businesses are open to a wide variety of work, and can have a broad range of clientele. If your work is a stretch for a particular space, no worries. It could stretch them in a good direction, provided they're passionate about it. So, stir their passions.

After you decide which galleries you're interested in, drop by and make an appointment to see the director—portfolio or laptop in hand. Why this way? Because requesting an appointment in person works better than making a call or sending an email, since it's harder

for someone to refuse you if you're standing in front of them. The reason you ask for an appointment is because that shows respect for the director's time.

I rarely view an artist's work without an appointment, or without that artist going through the submission process. Once they do, and assuming the work is a fit, I'm happy to sit down with them. What my staff and I cannot do is review the portfolio of every artist who walks in hoping for this—and many do, simply because they were never taught how to properly approach galleries. If we did make this a practice, we couldn't effectively run our business, promote our artists, or have time with our families. You'll find that most galleries operate the same way, and have no choice but to.

Even so, the reason you want a portfolio or laptop at hand is because the staff member might be willing to take a look. You want to be ready for this opportunity should it arise, with a couple of originals waiting in your car. But I wouldn't count on things unfolding this way. Instead, just inquire what the submission process is. Most galleries accept submissions via email, where they'll ask you to forward a link to your website, or to send them several images. For this reason, it's essential that you have a comprehensive website before approaching the galleries, as that will make you seem established.

If you do an email submission, try to make sure it goes to the staff member who reviews submissions, and not to the general email address—where it may well wind up in the trash. Keep the cover letter brief, mentioning the major points of your career in the first paragraph, with relevant links where appropriate. Also be sure to address the gallery or staff member in your salutation; never use a generic salutation.

If you mail hard copy, which I feel makes the greatest impression even in this digital age, again keep the cover letter brief. You also want it on quality letterhead with a business card enclosed. All these things can be laid out so they reflect your work and individuality. In fact I advise that you make them look unique yet professional. Why? You're making the impression that you handle your career well, no matter how broke you might be. These little steps will assure the gallery that you'll carry your end of the business agreement. Naturally you must include a disc of your work. Make sure your web address

is printed on all relevant materials, since you want the staff going to your website and getting blown away by how cool it looks. To ensure this happens, you can always send an email with a link to your site a few days after submitting.

Call the gallery a week after you submitted, whichever form you submitted in. The first gallery rejects you? Try a second, third, and fourth if necessary. No matter how many rejections you get, you must persist. If you've got the talent and have paid the dues, you'll find the right gallery—but only if you persist.

When finally you get an appointment to meet with the director, take a moment to enjoy that fact, since it's probably been a long journey. Dress in a way that suits you—whether in a t-shirt and jeans or business attire—as long as you give the impression that you're successful. If that success is primarily expressed in the mastery of your medium, fine. Take five-to-ten of your best pieces. Make sure your presentation is neat, organized and professional—with quality frames on your paintings if frames are needed, or refined bases on your sculpture if bases are needed.

In my gallery, when an artist walks in the door for an appointment, I expect her to be prepared. Sure I'm primarily looking at the work, but I'm also looking at the artist, gauging whether she'll be responsible in her obligations as well as a pleasure to work with. If I see real possibility in the work, we'll help organize her career. But if she strikes me as unreliable and undisciplined, I'll politely decline. I just don't have time to personally manage my artists, no matter how talented they might be. Most dealers don't. I do make some exceptions in the case of artists where I feel I'm supposed to help guide them, whether we make any money off their work or not. Otherwise, if I want to have a life away from the gallery at all, I have no choice but to avoid this.

Equally important is the manner in which the dealer treats you. Does she show you respect? Is she considerate? Is she polite? She may be busy, she may be in debt up to her arse, but you deserve respect for the years of sacrifice you've paid out. Bear that in mind; it's something to be proud of, since the achievement isn't common.

Of course you should also return the respect. Most directors are very busy, operating on a thin profit margin, if they're making a profit

at all. It's difficult, vexing work to run a gallery and often thankless. Just be glad you don't have to do it. If a gallery takes you on, they have to convince the public that you're worth investing in. This can take months or years. And while they invest their time and resources in you, initially losing money in the effort, they still have to meet payroll each month, pay their debts, taxes, artists, utilities, rent, office expenses, unexpected expenses, and hopefully take home a little dough. This is no mean feat. That's why when you meet the director, it's important that you be aware of the reality she grapples with every day.

So when that first meeting occurs, respect should be shown on both sides. Later, if you work together, that will have to be married to earned trust. You both will need to achieve this if you're to have a good working relationship. As you're talking with the director, keep this in mind. This two-way street will be one of the most important you'll travel in your career. It involves all the give-and-take of any successful relationship, and begins with mutual consideration.

I know, because I've blown this on occasion, not always showing the consideration that I should have. Such is human nature when you're irritated or flat pissed off. Naturally if an apology was due, I made one. Other times the artists were at fault. But overall in this kind of situation, we both normally made mistakes that damaged the relationship. If it was repairable, we repaired it. If not, we separated and moved on. Whichever course was taken, I've always tried to walk that line in a constructive and honorable way.

In the same vein, many actors have had lifelong relationships with their agents, as have writers and musicians, and those relationships have sometimes brought forth history-making careers. Just as many, though, have had terrible relationships, marked by screaming matches, fistfights, lawsuits, and the constant changing of agents. A gallery is an agent of sorts. Try to get off on the right foot—unless drama is your bent. And hey if it is, that's ok. The art world's always been full of conflict, which does make for some pretty good stories. I personally just don't like conducting business that way.

BUSINESS

As I've already mentioned, a gallery is a business and must function as one if it is to succeed. DreamWorks is a business, as are

Random House and Columbia Records. No film studio, publisher, or record company can prosper if it doesn't operate on sound business principals; nor can its artists. The same applies to galleries. Not only do the galleries have to understand aesthetics, but they also must run in the black, undertaking the necessary discipline to ensure this happens. If they don't, they'll go under, and possibly take with them any monies that might be owed to you.

I've known of galleries from Vancouver to Miami where the owners put on a great front, operated lavish spaces, drove expensive cars, wore chic clothes, had packed openings, and constantly maintained a pretense of wealth. Unfortunately there were few red dots at the openings and no fall-back plan. In each instance those galleries went under, owing their artists anywhere from $100,000 to $250,000 as they sank beneath the waves. This is not the kind of "business" you want to be represented by, where everything is just a façade.

Far safer to be carried by a gallery that is soundly established, pays on time, and doesn't confuse success with shallow notions of riches and notoriety. If this means they drive used cars and wear clothes from Macy's, fine. They probably know more about business than the pretenders ever will.

COMING TO AN AGREEMENT / GALLERY PERCENTAGES

This should be a straightforward arrangement, wherein the director agrees to take your work, you consign perhaps six pieces to her, and she prints out and signs a consignment sheet for you. My consignment sheets generally read as follows:

––––

To Whom It May Concern:

This is to confirm that Donna Quackenbush, artist, has consigned to Leopold Gallery the following oil paintings:

"Sur Le Pont," Oil on Canvas, 36" x 48", $4,700
"Ornamental Wind," Oil on Canvas, 36" x 44", $4,200
"Remain in Light," Oil on Canvas, 28" x 36", $3,200
"Petra," Oil on Canvas, 28" x 36", $3,200

These works are consigned for as long as the artist is content with Leopold Gallery's business practices and sales performance. The pieces listed will be insured for their appraised worth against loss or damage for any reason whatever by Leopold Gallery. Leopold Gallery is to receive a commission of 50% of gross on any sales that are made of these works, or from any insurance claim involving same. Leopold Gallery pledges to pay Donna Quackenbush within 30 days of any sales that are made.

With sufficiency acknowledged, I sign my name to the above in good faith.

Paul Dorrell, President
Donna Quackenbush, Artist

Note that the sheet lists the title, size and price of each work. It also lists the commission charged, and the fact that insuring the pieces is my responsibility. This should always be the gallery's responsibility, no matter how broke they might be.

At the time of this writing, I charge varying commissions on works in varying media, listed as follows:

Paintings and Photos:	50%
Blown Glass:	40%
Metal Sculpture:	40%
Ceramic:	40%
Fiber:	40%
Bronze Sculpture:	33%

In most galleries, it's standard to charge painters and photographers a fifty percent commission. If the prices are high enough, both you and the gallery will make a sufficient profit. If your frames are inordinately expensive, perhaps the gallery will split the cost of these with you, but don't count on it. Galleries have enough overhead to

deal with; better to figure the cost of the frame into the price of the painting and make your profit after. Even better to find an inexpensive source for frames, whether you make them yourself, or order them from framing companies online.

Why do I only charge forty percent for glass, metal, ceramic, etc? Because expenses for these artists are far greater than for painters. I feel it would be unfair to charge them the same commission. Some galleries agree with this, some do not. Many charge a straight fifty percent to all their artists, regardless of medium. I wish I could do this, as it would be more profitable, but in good conscience I simply cannot.

My reasons for charging thirty-three percent on bronzes are, again, based on the artist's expenses, owing to the fact that casting fees are considerable. It also has to do with pricing, since a common formula for determining the retail price of a bronze is to multiply casting fees by three. Thus if a bronze costs $1,000 to cast, I sell it for $3,000, retaining $1,000, with $2,000 going to the artist. If a stone base is used, that expense is added in.

Again, many galleries charge fifty percent on bronzes just as they do paintings. If they do, that's their business. All I can say is it isn't our policy.

YOU'RE IN A GALLERY: NOW WHAT?

First, it's best if you don't expect miracles. Give the dealer time to work the market and find out which of your styles sells best. If she makes suggestions regarding how to make your art more salable, listen to her—assuming she knows her business. If she's urging a subtle change or possible new direction, see if it works, as long as you find the change inspiring. Sometimes objective feedback from a competent professional will help you make a leap in your work that both inspires you, and sells well. How cool is that? You don't compromise on your standards, and yet sales increase.

This does not mean, however, that the shallower aspects of the market should dictate how you work, since if it does, you'll wind up creating art that lacks passion and soul—which I don't doubt you already realize. Unfortunately I've seen artists swayed by well-intentioned but uninformed suggestions, which got them off the track of

their instincts and into a series of aesthetic dead-ends. In the end, only the artist can know what she wants or needs to create. Just try to always stay true to the essence of that vision.

PASSION

By this I don't mean yours but the gallery's, since it's critical that the staff feel a genuine fascination for what you do. Why? Because collectors will sense their passion and become infected with it. Conversely if the staff is indifferent to your work, this too will be sensed by clients, who will respond accordingly. The next thing you know, you'll become one of those non-selling artists whose pieces are ignored, then begin collecting dust, then are moved to the storage racks in the basement.

There is also the possibility that, no matter how passionate the staff is, your work simply won't sell. It could be you're in the wrong gallery, the wrong region, or that no one has an answer for this all too common occurrence. Nobody can really predict the art market, just as no one can really predict that other market based at the corner of Wall Street and Broad. Even so, the combination of a gallery's energy, and your mastery, will normally bring good results. If, after all good efforts, the work still doesn't sell, always be willing to try another gallery—just try to part on good terms.

EXCLUSIVITY

Any gallery that represents you should be given exclusive representation of your work in their city. If you live in their city, this also means no more selling out of the studio. Does that seem unfair? It's not, especially if they're to devote money and time to promoting your work. Besides, in the long run you'll benefit more by having an established dealer handle the sales and promotion. What you don't want to do is profit from their efforts if clients try to bypass them and buy directly from you; that is definitely a bad idea.

If no galleries in your area rep you, naturally you can sell out of your studio. Some artists are adept at this, and enjoy doing it. In general though, I find that most don't want to be bothered; they'd rather just create and leave sales up to the galleries. I feel the same about my books.

GETTING PAID

Let's be optimistic. Let's assume the gallery's going to sell a truckload of your work. As they do, you'll require payment. This shouldn't be a problem, but sometimes is. It's best then to discuss the payment process with your dealer in advance, so you'll know what to expect.

Anytime a piece sells, you should be informed within roughly two weeks of the date of the sale. A check should be forthcoming within thirty days of the sale. If a gallery ever takes longer than thirty days to pay, something is wrong. Either there's a problem with the book-keeping, or they're broke, or dishonest. We've certainly been guilty of the first two issues, but never the third. In fact, in hard times we sometimes had to pay on a sixty-day basis instead of thirty, but only with those artists who were doing well by their day jobs and were cool with it. The others we always did our best to pay on time.

Whatever the problem, get to the bottom of it. Be polite but firm, and find out when you will get paid. Try not to lose your cool. If the gallery is run by an honest, hardworking director, you'll want to stay on good terms. She may be experiencing a condition of temporary impoverishment, but may wind up working wonders for your career later. If you trust her, let her take the necessary time to pay you— even if it extends to ninety days, and especially if you have a day job to cover the gap. Your patience may benefit you both.

Example: When my gallery first opened, our sales couldn't keep pace with expenses. So I had to make an unpleasant choice: pay all my artists on time and be forced to close, or pay my bills and stay open. I chose the latter, then informed my artists. All of them were upset, understandably. Still none of them wanted to be in my position, appreciated the difficulties I faced each day, and knew that without the risks I was taking, they would likely remain obscure Mid-western artists. None of them wanted that or wanted to see me close. We all knew we were onto something, and that we'd have to stick together to see it through. So I formulated a payment plan, wherein I paid everyone off within six months. I stayed in business and everyone's career benefited, including mine. None of this would have happened if we hadn't trusted each other.

I've had to do this more than once in protecting our capital, and several times paid interest on the amounts owed. Because most of my artists had day jobs, knew how hard I worked, and that I always paid in the end, most were gracious about the delay. They understood that we were in business together, and wanted me to keep moving things forward. That was very kind, since if they hadn't, I would not be writing this book. In return, I busted my butt for them to the limits of my endurance—sometimes to the point where my staff wondered if it was good for my health. It wasn't, but what the hell; we all gotta die of something.

Different example: One of my painters was once represented by a fashionable couple in Aspen. This couple lived lavishly, did their desperate best to socialize with all the people on the A-List, and did so on credit. The gallery closed six months after they opened. The painter was never notified, never paid for any of the works that sold, and never got back the paintings that didn't. Of course he'd had a bad feeling about the dealers from the beginning, but was so excited to be in an Aspen gallery that he overruled his instincts.

If you don't trust a gallery you're in, if they've owed you money for more than ninety days, and if the director seems so twisted that she'd defecate a corkscrew upon eating a nail, you'd better pull your work and cut your losses. You can take legal action later—although the only person likely to benefit from that will be the lawyer. Normally it's sufficient to just harass the dealer until she pays, threatening to have a local journalist write a story if she doesn't.

The best thing, though, is to avoid this conflict in the first place. One way to do that is to ask for the contact information of the gallery's leading artists. Any honest dealer will supply this, and will in turn be praised by her artists. If she doesn't supply it, don't sign.

Just as importantly, get a sense of the owner. Is she obsessed with appearances? Does she reek of insincerity? Does she place greater value on money than relationships? And does she have beady little eyes? If these things hold true, then the dealer likely has an integrity problem. There is nothing wrong with being focused on making a profit—lord knows we are—but the art, and the people you work with, must come first. If these things are taken care of, along with marketing and sales, normally everyone will profit.

YOUR FIRST ONE-WOMAN / ONE-MAN SHOW

This is a big event for you, and should be treated as such. You've waited years, maybe decades, for this night. After all your hard work, this is an enormous step for your career and your sense of accomplishment.

Preparing for the show is the gallery's job; preparing the art is yours. The manner in which you split expenses can work in any number of ways. In my place, I pay for the wine, the printing of the invitations, and the mailing of them. I always pay for the expenses, since I consider the event a celebration of the artist's talents, and I wouldn't want anybody paying for the wine at their own celebration.

I do not cater my openings lavishly. I used to, when I felt I had to impress my clients with smoked salmon and bits of tenderloin on garlic bread. Then I realized everyone was doing more drinking and eating than looking and buying. Too much drinking, in fact—once I had to dismiss a drunk for feeling up the women. After that I dropped the food and began supplying just enough wine to cover the evening. In that way everyone indulged less, and the focus swung back toward the art.

The trick of getting clients into the gallery is achieved through a combination of mailings, Internet marketing, networking, and on occasion, ads.

An impressive postcard by itself can bring a good turnout, depending on the viability of the mailing list. We mail the cards three weeks before the opening, since if they're mailed too soon, people tend to forget about the event, and if mailed too late—well, it's too late. We always order a thousand extra cards, so that we'll have an abundance to hand out for the next year.

Internet marketing is an art form in itself, involving e-postcards, website promotion, social networking, and innovative thinking that enhances your web presence. I'm not going to delve into that here, since it's a complicated subject that other people have written entire books on, and which you would do well to research. Please just be advised that it's important to maintain a strong Web presence, both for your site and the galleries that rep you, so that all these sites

are easily found when people carry out an Internet search. I'll get into this more comprehensively later, when I discuss websites and related issues.

As for magazine ads, if we run one, we split the cost evenly with the artist we're promoting. While I may run small ads in local magazines, it's the national publications I run the largest ads in, since it's the national market I'm always after. These ads place the artist's work before hundreds of thousands of collectors, and increase the likelihood that I'll sell the piece advertised. They also get the attention of editors.

Before the ad runs, I always order several issues of the magazine and a thousand copies of the ad itself. Then, as with postcards, I can hand out the ad to prospects. This communicates to clients that the artist's work appeared in a national mag. Never mind that the image appeared by means of an advertisement, what the client will remember is *where* it appeared, which tends to make a lasting impression.

Does all this seem like a game? Sure. Like many things in life, it is. You can fight it and get frustrated, or accept it, have a little fun with it, and prosper along the way. I've tried both approaches, and long ago decided which of the two I prefer.

Pollock never really did learn this, but Magritte and Steichen learned it quite well. So did Vincent van Gogh's sister-in-law, Johanna van Gogh-Bonger, who played a key role in the growth of his posthumous fame. Of course she had an exceptional story to work with—self-taught genius, painted for only a decade, quite limited body of work. With dignity yet savvy, she used that story to advantage. Had she not worked so hard promoting Vincent, I wonder if his reputation would have reached such stratospheric heights. It's a pity that she and her husband, Theo—who was not only Vincent's brother but also his dealer—couldn't do the same for Vincent while he was alive. But let's face it, the public wasn't any more ready for van Gogh than he was for the public.

It seems to have been his fate to suffer in obscurity, the harshness of which compounded his instability, affected his art, and finally effected his end, when he shot himself in that field outside Auvers-sur-Oise and stumbled back to Dr. Gachet's house. He died in a

little room there two days later—broken, mad and alone except for Theo's love, who, distraught and out of his mind with grief, died six months later.

My point? None of you has to endure the absolute obscurity that van Gogh did. Art collecting has never been more common in the history of the world, nor has acquisition ever been so simple for clients. This doesn't mean that finding your niche will necessarily be easy, but it will be far easier than it was for the many generations of artists who came before us, and certainly easier than for that troubled soul from Zundert.

THE CRITICS

Sooner or later as you do a series of shows, a critic is bound to cover one of them. As with literary critics, theater critics, and every other kind of critic, you may be flattered by what they write, you may be offended, you may be perplexed. Whatever the case, don't worry. The critics are just doing their job while keeping discussion of the arts alive. The fact that they covered your opening is what counts. Most collectors will forget what was written about it, good or bad, and decide for themselves anyway.

I've encountered many fair-minded critics over the years who understood how to write an informed article and intelligently give their views. I've also encountered those who were composed mostly of vitriol and pettiness. These critics often have curious prejudices—meaning everything that doesn't fit within the confines of those prejudices is panned. This attitude makes me wonder how complete the educations of these people are, and whether concepts of open-mindedness are altogether alien to them.

Just because an artist paints in the manner of Turner, and does it well, doesn't make her shallow because Turner did it so long ago. Similarly, just because an artist creates an installation out of crushed beer cans and broken glass doesn't mean she is without talent because of the lack of craft. Still I encounter these condemning attitudes constantly, and am always disappointed by the narrowness they reflect.

You'll encounter this too, especially by self-appointed, amateur online critics, whose only mission in some cases is to attack every-

thing they come across. Ignore and stay above the crap. In the long run, the critics will never have as much impact on your career as you, your galleries and collectors will. Sure, some can exert tremendous influence, but it's a toss of the coin as to how substantial that will be. I advise you not to count on it one way or the other. Count on yourself. There's greater satisfaction in that, and far greater worth.

GALLERIES IN OTHER CITIES

Since your first gallery will likely be in your own region, it's important that you next establish yourself with galleries in other regions. This isn't really all that difficult, but it will require time, travel, and a little research.

Because my artists and I are based in the Midwest, I long ago decided that if we were to succeed on a national level, it was essential that I help get them accepted by successful galleries elsewhere. Those other galleries had more influence than I did at the time, and I wanted to capitalize on that, reasoning that if one of my artists did well in Santa Fe or San Francisco, she would experience increased sales and stature at home.

If this is of interest, start by researching the galleries of a city that appeal to you online. Make a list of the galleries that seem a fit, then call and ask about their submission guidelines, or ask the director of the gallery you're currently with to do this for you. If the staff sound like snobs, don't worry, a lot of gallery folk sound like snobs on the phone. Most of them don't mean to, it's just that they're weary of being approached by unprepared artists. Prove to them you're prepared, and that snobbish veil will lift.

Once you've compiled your list of galleries, you'll likely hope that you'll be able to achieve acceptance via email, snail mail, and the phone. Unfortunately in most cases this simply won't happen. Instead you'll probably have to go to the city you've chosen and investigate. There really is no other way to assess the galleries of interest. Take plenty of inventory with you, since your goal is to place work while there. Also get receipts for all your expenses, since this is a business trip and you'll be able write it off. Finally, have fun while you're at it, since any road trip should be an adventure.

Once you've arrived and have found the galleries, follow the same steps for approaching them that I laid out earlier. Since you're only going to be in town a brief while, it's essential that you get a staff member to view your originals if possible. Normally a major gallery will only do this by appointment, so try to secure that appointment before hitting town. Where this isn't possible, show up with portfolio in hand and ask for an appointment. However you do it, you must show your originals to a handful of galleries before you leave. They may love your work, they may detest it, but you must try to achieve this.

Even if you do achieve it, it's unlikely that anyone will accept your work the first time out. Nonetheless, try to establish rapport with whatever staff member you meet. If they respond favorably, but tell you that they won't be looking for new work until next year, fine. Go home and send them occasional updates until the next year. At that time, try to make another appointment, and start the process all over again.

Also, be sure to have the director of the gallery you're already with write you a letter of endorsement, praising the salability of your work, your professionalism, and dedication. If necessary, have her write about your charm and effervescence—whatever it takes to place the work. Make copies of the letter and place it in the presentation folder that you should leave with each gallery, since if they're impressed with it they'll keep it on file.

Certain galleries will refuse to make an appointment with you, and will only view your work on the basis of a mailed submission. It's best to anticipate this, because it will occur. When it does, get the card of the person to whom you're supposed to write, and send her a presentation folder. Include a stamped, self-addressed envelope if you want the materials returned.

I've helped several of my artists get placed in other cities, but only when I felt that other directors would listen more closely to me than to the artists. I always told those directors that I didn't want any transactions to go through me, but only wanted to introduce them to work that I felt had great potential. When it was required, I traveled to the city in question—Chicago, Miami, Carmel... Each of my artists was relieved to have me do this, and agreed to pay me five percent

of all sales resulting from the new gallery. In most cases this worked out well for everyone. In some cases the galleries we chose didn't succeed for the artist, but that's one of the risks you take.

However you do it, placing work with galleries in other cities is an important move. Make it a priority. Once this is done, list it on your resume, in the bio section of your website, and ask your local gallery to announce the fact to their clients. I assure you this will have an impact.

YOUR RELATIONSHIP WITH YOUR DEALERS

Hopefully these will be long-lasting alliances built on mutual respect and sound business practices. You don't need to socialize together, you don't need to be friends, but you do need to be on friendly terms. If any of these relationships are tense and abrasive, those are the ones that will probably fail. But if you earn one another's trust, that will likely lead to higher levels of success for both parties. I hope so. You've earned as much. So has any honest dealer who might choose to rep you.

CHAPTER 9

CLIENTS, RICH AND OTHERWISE

As your career continues to move forward, you will inevitably deal with a variety of clients. When you do, please remember this: the wealthy collector, the moderately wealthy collector, and the struggling collector all have one thing in common—they love connecting with the passion of your art.

For collectors who are well off, this can reinvigorate them after all the years of dull, repetitive, mind-numbing work many of them had to do in acquiring their wealth. Now they're at a stage where they may want to share that wealth with others, including artists. Normally that heralds the beginning of an impassioned life of giving back to their community, and collecting. These people are often quite generous, reaping the rewards of their hard work while enjoying the life of plenty that can sometimes be achieved in this strange, wonderful, overwrought land.

Then there are those whose growth may have been compromised by the money chase, creating an imbalance that is reflected by their harsh acquisitiveness and selfish tendencies. This may make them depressed, half-alive, and generally unaware,

consumed by the misery of avarice. Their fixation with money may have screwed up their marriage, their kids, their lives, leaving them outside the feast of life, with them now trying, through art, to reach for greater meaning. Great, welcome them in.

There are yet others who care nothing about a life of meaning, and are just insatiable consumers who can never have enough *stuff*—paintings and sculpture included. Fine, as long as the checks don't bounce.

Whatever their individual natures, the rich do have a place in our system, and while it might not be as important as many of them think, it's still significant. Their corporations and firms create scores of jobs, many of them passionately support the arts, and when of the visionary sort, they do things for the underprivileged that go beyond generosity. Regardless of what types of people they are, kind or greedy, we never judge them, never envy them, and never allow ourselves to be intimidated by them.

Be cool when dealing with the rich, be confident, but also be kind. Like anyone, they're only looking for acceptance. Some of these folks will pay you full price; most will want to negotiate. Fine. Negotiating is a game. Allow yourself to be amused by it while you still get what you deserve. If a client offers you an absurdly low price for a piece, politely decline. They'll respect that, and will probably be back later. But if they become disrespectful, show them the door. On occasion it feels good to do this to those who so rarely have it done to them. It will be good for you, and possibly even good for them.

Then there are still other clients—teachers, physicians, men and women who own small businesses, architects, housewives, househusbands, lawyers, bankers, brokers, priests, rabbis, and a whole range of people who are potentially interested in what you do.

Some of these folks may know nothing about art. Wonderful. This gives you an opportunity to teach them. Anyone can respond to art. It's your job, and that of your dealer, to help the uninitiated learn. The art world should not, in my opinion, be a coded society where only those with the proper attire and hip phrases of the moment are allowed entry. That sort of elitism only limits collectorship, when the point should be to broaden it.

It may be that certain clients can barely afford your work. Great. Allow them to make payments. For some it might be their first acquisition and the first in a series of steps where they open that window to the creative soul. Art can help do that.

Other clients may be leading lives that are already full, with a lifestyle that is virtually a work of art itself. Cool. Then buying your work will only complement what is already impassioned.

Treat all these clients well, regardless of their monetary status. They'll appreciate that, and will express this by sending friends who will also buy. Their circle of prosperity is one you may enjoy being a part of. All you have to do is develop the relationship.

Finally, when a client buys a piece, it is cause for rejoicing—and I mean for everyone. A sale should never be seen as a one-sided victory for the artist or gallery, where perhaps a client paid excessively for a work that will never maintain its value. Unfortunately I've seen this happen. People who view each monetary achievement in one-sided terms tend to lead one-sided lives. You may want to avoid galleries whose owners function under this particular view.

HOW DO YOU LAND A COMMISSION ON YOUR OWN?

The simplest sort of commission occurs when a client falls in love with one of your works, but it's already sold. Do you let them go away disappointed? We don't. Instead, we offer to have the artist execute the same piece in a different size, be it painting or sculpture. This practice dates back to the time of Rembrandt, whose better-known paintings were often executed in three different sizes: study, enlargement, and monumental scale. The pieces are never exactly alike anyway. While they might capture the same mood or scene, there are always slight differences.

Most of our artists love this practice, but a few don't care for it, since the idea of doing the same piece twice bores them, even if in different sizes. But for those who practice it, they always strive to make the second piece as impassioned as the first, so that it radiates its own particular fire.

If this approach leads to your first commission, make sure the details are spelled out in a letter of agreement. This should discuss

size, price, date of completion, and the fact that you guarantee the client's satisfaction. I mean you already know you're going to do good work; the guarantee just clarifies this while winning the client's confidence.

OTHER TYPES OF COMMISSIONS

Let's assume you meet an executive, restaurateur, or politician who wants to commission a large work. If it's your first commission, please pay attention to what I'm about to cover. It details a set of circumstances that are far more common than not.

In the beginning with commissions, most emerging artists virtually have to give away their work in order to place it, since until you're established, it's hard to get the price you're worth. I'm not saying you should give it away, only that you'll face some challenges in this respect until your reputation is established. It's no different for emerging musicians, like the Rolling Stones when they started out, initially performing for almost nothing just to get a gig.

Example: Arlie Regier's first large commission, prior to joining my gallery, involved a huge work in stainless steel for a city park. He was approached by a local politician about it, and was so thrilled to be placing a substantial piece, that he set the price rather low. This often happens when emerging artists don't have professional representation, since they tend to underestimate the totality of their expenses, while also hoping the exposure will offset the low price and change their fortunes, not realizing it rarely does. By the time Arlie finished with the hundreds of hours of cutting, welding, grinding and polishing, he regretted giving the city such an insane deal. Worse, no sales resulted after the big dedication. Why? Nothing was promoted.

If the installation isn't promoted—which requires real forethought and effort—it will have little impact on your career. I'd love to tell you that the crowd who shows up on dedication day will automatically start buying your work the day after, but that's rarely the case. This is why you must have a thorough understanding of what your real costs will be, why you must get the highest price you can, and why someone needs to promote the fact of the commission both while it is taking place and after it has been completed.

How do you promote a commission? By posting it on your website, notifying friends and clients in an email blast, posting it on your social network site, adding another line to your resume, and getting the press to cover. When the piece is finished, you'll also want to create a postcard or photographic one-sheet that shows the finished work. You can use this to hand out to prospects, while also converting it to a PDF for emailing purposes. And so forth...

Just use your creative sense about how you can announce the significance of this achievement without overdoing it. The possibilities are many. If you're not sure of what steps to take, sit down with some promotion-savvy friends and brainstorm. Taking those steps will help you land future commissions, with you gradually increasing the price as time goes by.

Arlie? Because he made the sacrifices involved in finishing that first commission, it gave me an installation to promote him with once he joined us. Building from that, I was able to place his smaller works with more clients, win him larger commissions, and convince galleries around the country to carry his work. This led to many breaks, including a piece in the Museum of Fine Arts, Boston. Hence that first, underpriced commission wasn't a wasted effort—but it might have been had we not promoted it.

What happens if, say, a restaurateur approaches you about doing a series of paintings for his restaurant but he can't pay full price? Have him pay as much as he can, then barter for the balance. You can also do this with car dealers, dentists, accountants, contractors, and just about any trade you can imagine. How would I know? Because we've done it all.

Of course what you really want is to be well paid for your commissions—with money, not meals. Sure you want this. Everybody wants this. But it takes time to achieve. So if an opportunity for bartering arises, you might consider it. As long as you strike a good deal, it's fine. In fact you may want to make a list of people you know who like your work, yet never felt able to buy it. If they provide a service you value, and that you have to pay for anyway, this could be a simple way to start placing works and expanding your client list. Our dentist's rather large collection reflects how well this has worked for

us—and my family has had some damned expensive dental issues. Now if I just could have found a way to do this with the universities.

LETTER OF AGREEMENT

When you secure a commission, you should draw up a letter of agreement before you proceed with any work and before any money changes hands. This is essential, as it spells out the terms for everyone involved, and normally prevents misunderstandings from occurring later. I've provided a sample letter below, based on one we recently used with a patron who was sponsoring a sculpture for a major city.

Gloria Swanson
461 Ocean Boulevard
City of the Angels, CA 90210

Dear Gloria:
This is to establish terms between Matt Kirby, Artist, Gloria Swanson, Client, and Leopold Gallery, Art Advisor, in the creation of a monumental sculpture for City of the Angels.

Title: *Pierced Sky*

Design: A sculpture in stainless steel, mild steel, and cast glass, created to conform to the original design, as submitted by Artist and approved by Client.

Dimensions: 16' high, 5' wide, 14' deep.

Gross Weight: Approximately 3,000 lbs.

Finish: The mild steel aspects will be powder-coated in a black, mat finish. The stainless steel and cast glass require no special finish.

Commission Amount: $95,000, which includes delivery and installation.

Mounting Method: The method of mounting will be approved by a certified structural engineer, as will the stability of the sculpture, which will be fabricated in such a way as to warrant that the

steel will not develop metal fatigue from wind, gravity, or natural lateral forces for the duration of its placement. Exceptions will be made in the events of vandalism, accidental damage, extreme weather, or Acts of God. All aspects of fabrication and installation will be approved by Art Advisor and Client.

Installation: Artist will supervise installation, in concert with Art Advisor.

Client Approval: Artist warrants that overall design, installation method, and metal quality are subject to approval by Client and Art Advisor.

Client Monitoring: Client will be kept informed of progress via digital photography, periodically submitted by Art Advisor, as well as by studio visits.

Deadline: Work will be completed and installed by November 3, 2012

Copyright: Artist retains copyright, but will grant Client usage in non-salable printed materials and internet promotions, as long as Artist is given credit in each instance.

Terms: $47,500 down payment; $23,750 when work is half way completed; balance upon installation and satisfaction of client.

With sufficiency acknowledged, I sign my name to the above.

Sincerely,

Paul Dorrell, Director
Gloria Swanson, Client

A lawyer didn't draw this up, I did, although I advised my client to have her lawyer approve it. As for my part, I trust my business sense in landing commissions, negotiating them, and working out the details. Hence I rarely involve lawyers in formalizing agreements, since that tends to delay matters, drives up costs, and can inspire mistrust. But when I do need a lawyer for complex contracts, I hire

one who operates on the same basis of mutual fairness that I do. It's up to you whether you choose to involve an attorney. If you don't, just make sure that someone with a keen business mind proofs the agreement, looking for weaknesses or missing details.

Regarding the commission for the sculpture described above, we didn't get the first price we presented, so I had to negotiate to a slightly lower price—which I'd anticipated, so started with a higher price than I thought we would get anyway. The price we did get in the end was satisfactory. By the time the installation was complete, the client was ecstatic, the press coverage good, and the success of that work led to other commissions—but again, only because we promoted the sculptor, good old Matt Kirby.

COMMISSIONED PAINTINGS THROUGH GALLERIES

If you're a painter and are comfortable with large-scale work, galleries that represent you will hopefully begin securing commissions—a task that will be made easier if you've already handled a few on your own. Some of these commissions may be large, others modest in size. I've handled scores of them, some for as much as $50,000, others for as little as $1,700.

If the commission is for a moderately large painting like a 30" x 40", it will normally require a study. The study will be small, say 9" x 12", and should conform in scale to the dimensions of the larger work. It should also be a fairly accurate reference as to how the larger painting will look. The large work will be better defined and possibly more inspired, but the study will provide the client and you with a map of how you're going to get there. We typically include it in the price of the commission. We always invite our clients to the artist's studio as a commission nears completion. They love that process, and in this way nobody gets any surprises. Normally the client is stunned by the piece, and offers few, if any, suggestions. If they do offer criticism, which it is my job to interpret and keep a handle on, we listen. While I never allow a work to be dictated by a client, I do pay attention to their wishes, and several times have found their requests worth acting on. After all they're paying for the piece, so they should be as passionate about the finished work as the artist is. As long as the artist is cool with the requests, it's just good business.

How long have artists and clients been having disputes about commissioned works? Oh about 3,000 years, whether you're talking about Egyptian artists, Greek artists, or Vermeer and Sargent. There's nothing new about it, or about the occasional lawsuit when things get nasty. I'm just trying to help you grasp the fundamentals before you begin, and get things off on a smooth start as you embark on this journey—which really should be a fun one.

As for my portion of commissioned paintings, I take between thirty-three percent and fifty percent, depending on the nature of the job and how much work the artist has to do. If there's any uncertainty about my fee, the artist and I always establish this at the outset, writing down the terms if necessary, even if only in the form of an email. As with clients, you don't want any misunderstandings with the gallery owner either.

COMMISSIONED SCULPTURE

Except for a few basic differences, sculpture commissions are similar to those for large paintings. Primary among those differences is price. Sculpture almost always costs more than paintings, owing to the higher cost of materials and normally the greater amount of labor that is required. Thus, as I mentioned earlier, you must have a clear grasp of your expenses before setting your price. Go over the costs carefully, trying hard to consider all the things you may not have anticipated, then add twenty percent. The client will likely try to negotiate anyway, and because most sculptors underestimate their expenses in the beginning, it's best to be prepared.

Regardless of your medium, you should execute a maquette to flesh out your design and inform your client of how the finished work will look. This may be difficult if you work with found objects or blown glass, in which case you can always illustrate. Even so, your clients need to know how the finished work will appear before they'll put down the big money. But if you're in that rare situation where they're so enamored of your talent they don't give a damn what you create, as long as they can own it, cool. It does happen.

If you're working in bronze, you'll have to sculpt a clay maquette, but don't cast it unless the expense for this is covered in the contract. Whenever I land my bronze sculptors a large commission,

we always provide the client with a cast version of the maquette, but only because the casting fee is figured into our costs. In other words, our clients pay for the casting of a maquette. We don't, and neither should you.

With most other materials—wood, fiber, steel, ceramic—create the maquette so that it is close to the large piece in terms of proportion, design and detail. Of course it will never have the power of the large work, which will probably evolve as you go up with it. No matter, just explain this simple reality of sculpting to the client. If they're impressed with your other installations, they'll follow your lead.

My percentage on these larger commissions depends on the medium, and on the artist's expenses. On big bronze commissions, like the D-Day Memorial, I make twenty percent of gross. On large projects in stainless steel and other media, I tend to make thirty-three percent.

PUBLIC CALLS FOR ARTISTS

Virtually all cities, regardless of size, periodically send out Calls for Artists—especially since most states mandate that one percent of the construction cost for a public building be spent on art. States themselves also send out calls, as do counties, universities, corporations, hospitals, etc. The call might be for one work or several, whether in front of a library, at an airport, or for the interior of a university building. The commission could be for sculptors, painters, photographers, video artists, or what you will. The committees that structure these commissions often do not dictate the medium, but simply send out the call and respond to what they receive. In other words they try to remain open-minded as they look to artists to introduce them to a visionary approach. Budgets can run in the hundreds of thousands of dollars.

Commissions of this nature provide exceptional opportunities for moving your career along, making good dough, and having a great time doing it. If you've already completed pieces in public and private spaces, you're qualified to submit. But of course in order to do that, you have to know about the calls. How do you become informed? Get on the email list of the local arts commissions, both

civic and state. Many of these announce public commissions—whether in your region or elsewhere. If they don't send out these email blasts, see if a relevant page on their website is regularly updated. You can also pay a fee to any public art network in order to stay informed, or check the websites of various arts commissions around the country.

Preparation is essential, since you don't want to be scrambling around one day before deadline trying to throw together a presentation. Instead, simply determine that commissions of this sort are a goal, and that you're going to land a number of them. Then assemble a presentation folder in advance and have it reviewed by tough critics who will honestly tell you whether it's brilliant or dull. Keep refining until you have it right. With these materials at the ready, you can make adjustments for the specific requirements of each call.

Here's a basic list of what you'll need in the packet:
- Resume
- Bio
- A contact list of professionals who have worked with you.
- Professional photos of past installations.
- A disc that shows a stunning PowerPoint of past installations.
- A large postcard or simple brochure that highlights your work.
- Any press you may have landed over the years.
- Three brief letters of recommendation from people you've worked with
- Business card
- Bribe money (optional)

If the call requests that you submit a design, naturally you'll have to, but I frown on that practice—meaning when panels ask artists to design for free. A more respectful approach is to send out a call, review the submissions, then select artists who are a possible fit, paying each an honorarium for a design. In that way everyone's treated with respect.

When I manage a public call, I dig the rush of getting all those submissions in and learning about the artists. Then when we select three finalists and pay an honorarium to each to design a concept, I dig even more learning about what they want to install. Many of them

will research their subject well, and come up with a work that is in some way relevant to the organization or project. Others will simply submit a cool design that stands alone. Both approaches are valid, although clients do love it when some relevant meaning is inherent in a piece.

When the commission is awarded, I often work with the artist to help them keep costs down, assuming my assistance is desired. Why? Because in their excitement, the less-experienced artists usually give the client more than they paid for, losing money as a result. When I oversee a commission, I consider it my job to work with both client and artist, taking care of their interests, and if necessary, helping the artist make a reasonable profit. Far better to come out well and spend the money on a trip abroad, a fast bike, or a cause one believes in than to lose money for no reason.

Once you land the commission, you'll be working with a committee, which can be a dream or a nightmare, depending on how you handle it. In the case of a dream, you'll make friends and your reputation will be spread. In the case of a nightmare, you'll make enemies and venom will be spread. How do you avoid the latter? Maintain your sense of humor, try not to take offense at ill-informed suggestions, and be easy to work with. Take things gradually in the first meetings, let the committee get accustomed to you, and earn their trust. In the end you'll still create your design, will avoid the *Art by Committee* scenario, and have a commission under your belt. But if your tendency, like Gutzon Borglum's, is to make enemies of every committee, that's fine, just be aware that it comes at a stiff price.

As with all commissions, you'll need a letter of intent, will have to work from a maquette or study, submit photos as the work progresses, and so on. You'll also want to invite the committee to your studio to view the work as it progresses, and when it's finished. Those instances should be relaxed and celebratory. Have some wine on hand, crank up the music, then sit back and enjoy yourself while everyone walks around the piece in amazement. Their oohing and ahhing will be a great reward; the dedication an even better one.

But what if all the commissions you submit for only result in rejections? Just keep submitting, expanding your resume with other projects as you do. The competition for these commissions is often

immense, but that doesn't mean you won't qualify; it should only make you more intent on the goal. Like writers, try to constantly keep a submission in the mail. In that way, you always have another response to look forward to. If you've done good work, and make a stunning presentation each time, the odds will be in your favor in the long run.

COPYRIGHT

By law, you own copyright on every work of art you create, regardless of whether you register the copyright or sign the piece. While registering copyright of the artwork offers certain benefits, it isn't necessary in order to own a copyright of the work. Generally, the copyright remains the right of the artist unless and until there has been a transfer of that right, or if the work was a work for hire or was specially commissioned.

Therefore, I advise you to never allow a client to reproduce one of your works without written permission. Especially, don't allow a corporation to reproduce one of your images for sale without negotiating a royalty deal. Only you, the artist, own the copyright, and only you can grant permission to copy or reproduce the image. If you haven't signed away the copyright, and if a client reproduces a work without your permission, they may be in violation of copyright law. If this occurs, tell them to cease all usage until an agreement has been worked out. If they won't cooperate, sic a lawyer on 'em.

Copyright violation occurs all the time, but rarely because of greed. More often it's because of ignorance on the part of the perpetrator. Most collectors assume that when they buy a piece, they can use the image in whatever way they want. I've worked with a lot of corporations. In every case their legal departments were misinformed about the extent of their rights, and those of artists, so they simply made false assumptions in favor of the company. Big surprise, eh?

One way to prevent these misunderstandings is by making sure that a copyright clause is in the content of every contract, and on every certificate of authenticity. This is one of our practices, since every original we sell is accompanied by a certificate. Ours read as follows:

— ∞∞ — ∞∞ — ∞∞ —

Client Name
Address
Date

CERTIFICATE OF AUTHENTICITY

Title: Bloodshot
Artist: Derrick Briedenthal
Medium: Oil on Panel
Dimensions: 36 X 36

This is to affirm that the painting you purchased is an original work. Listed above are the details of the work as well as its current market value. This document may be considered my appraisal of the piece, and can be used for insurance purposes.

In accordance with copyright law, copyright is exclusively owned by the artist, hence no reproductions or photographs of the work may be produced without consent of the artist. Further, proper attribution must be given to the artist for reproductions of any kind in every instance. All such permission can be obtained through Leopold Gallery.

Thank you so much for your purchase.

Sincerely,

Paul Dorrell
Director

— ∞∞ — ∞∞ — ∞∞ —

You can also use a copyright clause on a bill of sale. However you do it, I advise you to never sell a work without defining these terms in the paperwork. If you don't, uninformed collectors may

misuse your copyright, which, whether they intend it or not, essentially dismisses your worth to society. It is our responsibility to help inspire appropriate respect for that. I mean, have you ever seen a corporation give away copyright? No, and neither should you.

WHEN SHOULD YOU ENCOURAGE CLIENTS TO UTILIZE YOUR COPYRIGHT?

You can always be a real brick and grant a client usage of your artwork in connection with the client's website or in printed materials. If you decide to allow clients to use your artwork in this way, gain the counsel of a copyright lawyer, put the permission in writing, and require that the use includes your name somewhere near the image, along with the title of the work, along with a link to your website. One reason you may wish to allow this is for the promotional and potential economic benefit. If the client has a website that gets a lot of traffic, and they post your work on it, this could prove a boon to you, especially if they link to your site. Many corporations are happy to do this.

So when you're negotiating a commission, you might want to consider this as a way of further enticing the client. It gains you free promotion, and educates your clients about copyright law—a pretty good thing all around.

WORKING WITH INTERIOR DESIGNERS

I've had scores of interior designers filter through my gallery over the years, and have made presentations to hundreds. Out of all these, there are a couple of dozen I work with. I'd enjoy working with more, but the others seem indifferent to original art, or get caught up in trying to match paintings with the color of the walls, which means they'll often go for a factory-made reproduction over an original. To me a painting is a window into another world, and you don't match a window to anything. This doesn't make these designers inferior; many of them are fantastic people. All it means is that they need more experience with original art and artists.

Then there are those designers who, being frankly shallow, are indifferent to how difficult the artist's life is. As a reflection of this, I've sometimes had designers borrow paintings to show their clients,

then fail to return the work. Worse, a decorator once asked one of my sculptors to design a piece for a foyer, then changed his mind without bothering to tell us. This was partly my fault, as I failed to get an agreement up front—which I never allowed to happen again. Nor did I chew the dude out, but was tempted to.

Despite all this, I still make presentations to the local chapter of the American Society of Interior Designers, and the International Interior Design Association. I dig these people, and know that as time passes increasingly more of them will work with us. As for those golden individuals who work with us now, do they understand art? Quite well. Do we pay them a commission? You bet. Are they a pleasure to work with? Always. I can't urge you enough to develop similar relationships with designers in your area.

WORKING WITH ARCHITECTS

My experience with architects has been different from that of designers. After all, it was architects who hired me for the National D-Day Memorial, for a monumental project in the Capitol Building in DC, a convention center in Kansas City, the University Of Kansas Hospital, etc. But when you consider all the hundreds of mailings I've sent to architectural firms, and the dozens of presentations I've made, the return seems rather small.

There's a reason for this. Architects *are* artists; their projects are their art. Consequently if there's an art budget, they often leave art selection up to the client, as they feel their part of the job is done. Even so, most architecture firms have a design team who love to select art when the client asks them to. These people can be very helpful in assisting you with placing your work. As with interior designers, make sure you get to know them, and that your galleries do the same. How? Buy the architect lunch, give them a presentation folder, do a PowerPoint, tell a joke or two, and develop a relationship. Even if they're not involved in selecting art on a given project, they may pass your name on to clients who would be interested in your work.

Another approach is to mail out presentation folders—just make sure each mailing is addressed to a decision-maker. Do your follow-

up a week later. If you can't reach the party by phone, try to get their email address. If you do get it, please keep the email brief, emailing only once unless a relationship develops. You don't want to be perceived as a pest, but rather as someone the architect would benefit from working with.

Handle these details professionally, or have your dealer do it for you. You'll find that one good architectural contact can, over time, bring you more work than you can handle—an enviable dilemma by any standard.

CONTRACTORS AND DEVELOPERS

This group is made up, for the most part, of those individuals who are forever expanding our suburban sprawl with massive and often unimaginative developments. By my experience, at some point one of these guys (and they usually are guys) will decide they need a sculpture parked at the entrance to *Foxtrot,* or *Heaven's Gate,* or whatever they call the place. Once this vision occurs, he might call me and say, "Son, I hear you're a fine hand at turning out sculptures. I'd like to get us one. Would you mind coming out to the site so's we can discuss it?" Even though it's often a waste of time, I always ride my bike out to the site so's we can discuss it.

I arrive, and the dude drives me around in his Humvee or Lexus (If he has two, are they called *Lexi*?). We look the place over, and he asks me for a price on an appropriate sculpture. I quote him something near to what his car cost, he falls silent, drives me back to my bike, and says he'll call later. I never hear from him again.

A year later I'll pass by the entrance and see a cast concrete Cupid there, or a pair of concrete deer, or just a pile of boulders. Or maybe he found some amateur artist whose talent hadn't flourished yet, paid him a starvation wage, and wound up getting what he paid for—without knowing the difference.

If you encounter this breed, whatever type of business they're in, be leery. Some are honest, some are hopeless, but many seem to approach buying art with the same attitude that they employ when buying cars, only with less respect. Still a commission is always worthwhile if the client is reasonable and the money right.

A clearly worded letter of agreement will handle these people. If at the time of delivery they claim the work isn't what they expected, and don't want to pay the balance—a scenario that is normally avoided through client consultation—then you retain the piece and refund their money. You can always sell it elsewhere. It is far better to do this than to be taken advantage of.

Conversely, there are scores of other types of developers who labor hard to rebuild the urban cores of our cities, create developments that are green and innovative, with neighborhoods that are designed to accommodate bikes and pedestrians. These folks often possess an appreciation of art, treat artists with respect, and pay them accordingly—just as they do their lawyers and dentists. I know those guys are out there, because I've worked with them. They don't seem to be in the majority yet, but given time they might be.

CHAPTER 10

CORPORATE CLIENTS

As a dealer, I've been fortunate enough to work with dozens of corporations who hired me to design complex art programs for their buildings, and who in the process demonstrated terrific respect for artists. Does this mean we carry and install corporate art? Most certainly not.

Corporate art in the 70s and 80s tended to be a bland type of abstraction or landscape in print form, commercial in nature, often in dull tones. It had nothing to do with the regional culture in which a given corporation was based, and did nothing to benefit the arts there. If anything the practice of buying this stuff harmed the arts in the regions of the corporations that bought it, since it was normally acquired from a reproduction warehouse in a different part of the country, brought no investment to artists of the area, and primarily benefited the consultant who selected and framed it. Sadly this is still taking place.

When we're hired by a corporate client, whether in San Francisco or Kansas City, we utilize our artists where appropriate, sure. But we also set out to discover exceptional talent in the

region where each client is based. As we create a collection that is relevant to that corporation, the employees begin taking pride in the process. In fact we make a point of involving them. Soon they and their employer are participating in the arts in a way they may not have before—which benefits the artists and cultural growth of the area.

I especially enjoy selecting works that relate to each client. We did this in the case of H&R Block, and Brent Collins's bronze *Pax Mundi*, which is composed of a non-intersecting Möbius strip that describes the shape of a sphere (see photo section). The design is influenced by mathematical theory. Block is a math-driven corporation. The relevance of the sculpture speaks for itself and we don't need to belabor the point, though the staff at Block do love telling the story.

With each corporation, my job is to deliver the fire and passion that only fine art can bring. When done well, this will bear a positive impact on everyone involved, both employees and artists. The art is a sound investment that will appreciate over time, bring the firm accolades, inspire staff, and more deeply connect it to the community—at least the way we go about it.

You and your dealers can use a similar approach. When done well, this will help artists and galleries in your area gain commissions they might not have otherwise, executing work at new levels of mastery that may have previously seemed beyond reach because the opportunity, and funding, didn't exist.

Corporations are, or can be, a huge part of the current renaissance. The Italian Renaissance would never have advanced so dramatically without families like the Medicis. The American Regional Renaissance will not continue advancing without corporate involvement and investment. Sure it's great when you can get an affluent family to back a movement, but not every region hosts individuals of such wealth and inclination. Each region does, however, host sizeable firms. Involving them can work just as well, as long as you retain creative freedom.

CORPORATE CULTURE: THE GOOD, THE BAD, AND THE CORRUPT

I've worked with many corporations that were so open, innovative and humane they shattered all my notions of corporate evil. They paid their employees well, provided great benefits, and encouraged creativity. This vibe emanated from the top down, where the executives were open-minded and made sacrifices on behalf of their people, voluntarily accepting reasonable rather than excessive pay so that revenue could be invested back into the company, and so their employees could realize job security.

I've also worked with corporations who were so petty and small-minded that all my notions of corporate evil were confirmed. They paid their employees squat, provided minimal benefits, and stunted creativity through the oppressive regimes they'd devised. As for their execs voluntarily accepting reasonable rather than excessive pay, and protecting the job security of their employees, forget it. Those executives' primary concern was their own compensation, that of the board, and that of the shareholders—no matter what it cost their workforce, and it cost them plenty.

Just as great leadership starts at the top and trickles down, so does misery. It's my experience that these less humane firms are run by executives who are obsessed with themselves, their possessions, and money. They reflect how the majority of the wealth in most countries is still concentrated in the hands of the few. All countries have historically struggled against this, but lately America has been struggling and losing. How?

In 2008, a U.S. Government Accountability Office study found that fifty-seven percent of U.S. companies paid no federal income tax for at least one year between 1998 and 2005. It also found that twenty-five percent of U.S. corporations with more than $250 million in assets or $50 million in sales paid no federal income tax for at least one year in that same period.

In the 1940s, corporations shouldered about fifty percent of the tax burden; now it's closer to fifteen percent. Yet small businesses like mine are hammered with disproportionate taxation that in the early years threatened to shut us down. A lot of this disparity can be laid at the doors of the corporations that have devised complex tax

shelters, which their lobbyists got passed into law through the buy-
ing of congressional influence, allowing those corporations to shirk
their responsibilities while the rest of us footed the bill.

Also in the 1940s, the average executive earned roughly ten
times that of a skilled worker. Currently in many firms they'll earn
200 to 300 times as much, which could not be better exemplified
than by the billions of dollars in bonuses that are annually paid out in
the financial services industry, whether on Wall Street or elsewhere.
Do those people actually earn their bonuses? They've argued that
they do, but I find the claim suspect when the perks are financed
by people like you and me, as they were in 2008, when the Federal
government bailed out over 900 corporations, including Goldman
Sachs, AIG, and Bank of America. Those companies were all broke,
yet their executives had the cheek to collect their taxpayer-funded
bonuses—even as many taxpayers were losing their jobs, pensions,
and homes.

Consider this a moment, and the lives of excess that money goes
to support—the luxury cars, multiple houses, planes, boats, ward-
robes, and piles of stuff. I mean, it's not like the money is going to
rebuild our crumbling infrastructure, improve educational standards,
or help curb the cycle of poverty. It's merely going to feed the in-
satiable demands of a very small group who, by manipulating the
system that made their wealth possible, have abused their privileges
and in the process prevented the rest of us from attaining a general
sort of prosperity that, through honest labor, should be our due.

This issue is addressed below in an article by Robert Frank, an
internationally lauded professor of economics at Cornell. The article
appeared in the *New York Times* as I was completing this book.

> During the three decades after World War II, incomes in
> the United States rose rapidly and at about the same rate—
> almost 3% a year—for people at all income levels. America
> had an economically vibrant middle class. Roads and bridg-
> es were well maintained, and impressive new infrastructure
> was being built. People were optimistic.
>
> By contrast, during the last three decades the economy
> has grown much more slowly, and our infrastructure has fall-

en into grave disrepair. Most troubling, all significant income growth has been concentrated at the top of the scale. The share of total income going to the top 1 percent of earners, which stood at 8.9% in 1976, rose to 23.5% by 2007, but during the same period, the average inflation-adjusted hourly wage declined by more than 7%.

If such a high proportion of revenue is being paid to executives at the top, how many jobs within their corporations have been eliminated to help finance this, forcing one worker to perform two jobs instead of one to satisfy those execs, and their shareholders? How many families have been negatively impacted because both parents had to work brutal hours as a result? Millions. This kind of avarice undermines democracy, since it places inordinate power in the hands of an unenlightened few.

Executives of this sort even protect each other's income, meaning that when one becomes CEO of a major corporation, but performs poorly and is forced to resign, that resignation is often accompanied by an enormous severance package—approved by a board of other executives. Among my clients are two nationally recognized figures who were in circumstances such as this. They were forced to walk after performing poorly, and both did so with severance packages of over forty million each. How is anyone worth that kind of money? And why would any exec be handed a reward when they fail, instead of being forced to hit the streets and earn their keep like the rest of us?

Paralleling this problem is the issue of individual income tax among the super-rich, which Warren Buffet, CEO of Berkshire Hathaway, addressed in a piece he wrote for the *New York Times*:

> ...while most Americans struggle to make ends meet, we mega-rich continue to get our extraordinary tax breaks... Last year my federal tax bill was $6,938,744. That sounds like a lot of money. But what I paid was only 17.4% of my taxable income...
>
> The mega-rich pay income taxes at a rate of 15 percent on most of their earnings but pay practically nothing in pay-

roll taxes. It's a different story for the middle class: typically, they fall into the 15% and 25% income tax brackets, and then are hit with heavy payroll taxes to boot.

My friends and I have been coddled long enough by a billionaire-friendly Congress. It's time for our government to get serious about shared sacrifice.

I've dealt with executives in this class. Many are great leaders like Buffet, using their wealth to make a real difference in the world. Many others are not, having become just as self-serving and destructive as the Robber Barons of the 19th century. F.D.R. faced down people such as this while combating the Great Depression, a mess he inherited and which he summed up with his usual eloquence: "We have always known that heedless self-interest was bad morals; we now know that it is bad economics."

The demonstrators in New York know the same thing. I joined them for a day at Zuccotti Park, bought an edition of *The Occupied Wall Street Journal*, and went to one of their meetings at 61 Wall Street. Attended by a combination of intellectuals and stoners, the meeting lacked leadership, an agenda, and clearly defined goals. But everyone knew something was rotten, veiled by layers of complex financial devices like derivatives, collateralized debt obligations, credit default swaps, and similar practices that enriched insiders while devastating millions of others. They also knew that their future had been sold downstream. What nobody knew was if they could get it back.

Can all this be laid at the door of corporate evil? Of course not. Many entities played a role: lobbyists, members of Congress, and the corporate interests who fought for deregulation of Wall Street in the first place. It took years to create the mess, and will take just as many to correct it. What pisses me off, though, is that many of the culprits knew these practices would harm basically everyone who wasn't an insider. What pisses me off even more is that so few of them are doing time for what amounted to criminal activity.

When I negotiate with executives of this sort, I sometimes think how few of them could shoulder the load that artists do and maintain these things: humor, dignity, a face of optimism no matter how

many times slapped by rejection, a heart of generosity when broke, the ability to return to your calling each day with passion despite no paycheck, and the humility to remain grateful for all you've been given. Most of them would crack under the strain, especially the part about no check. But you never betray this when you're at the table. You just negotiate the deal and try not to judge, even as they rape the system that made them so rich, even as their lobbyists help create policies that may bankrupt your business and family yet not their wealth.

I've seen how people of this ilk turn to me with dead eyes and try to get us to design something for free, so we'll be offered a contract. Then when the contract comes, the terms often have to be renegotiated so that my artists and I can pay our bills, send our kids to college, prepare for retirement (fat chance), support retired parents, and hopefully save a little dough. I love the renegotiation process. But if they can't be reasonable? I conclude the meeting and split. I don't put up with that crap, and neither should you.

As for the other type of corporations, run by executives who fill their firms with laughter, mutual respect and camaraderie, who value their employees and pay them accordingly, who value artists and pay what they're worth, and whose parties are a blast—those are the ones I prefer working with. The others? I work with them too; I just don't enjoy the process as much.

BURNING BRIDGES

As your career moves forward, you'll meet people who will fail to fulfill promises, ask for favors they never return, gossip when you achieve success, and in general behave like morons. Some of these people will be influential, others not. How do you treat them? Professionally, no matter how irritated you might get.

When I was in the midst of restructuring and expanding my gallery, taking risks that would bankrupt us if I failed, my banker stepped forward with a loan but also with some words of wisdom. He knew I was entering new territory, especially for a novelist struggling to learn the ways of business, and took me to lunch one day to discuss it. His words were simple:

"You're going to a higher level now. This means you'll be working with more people than before. And while most of them will probably be great, you'll also encounter plenty of pettiness and rejection. When you do, Paul, just remember one thing: don't take it personally."

My banker is a man of understatement. He didn't explain all that he meant by this, believing I would either figure it out or not.

He was sure right about the pettiness. As we expanded, I encountered many influential prospects who had adopted greed and narrowness as their standard, and who only knew how to use people—including me.

But I also met many fine clients who bought a lot of art, paid us well, gladly returned favors, introduced us to new clients, and behaved honorably. These people vastly outnumbered the small-minded, though it didn't always seem that way.

The instances of pettiness more than once caused me to rage at the night sky when we were broke. But most of the time I stayed cool, and remembered what my banker had said. If I took everything personally, I'd go berserk, so I resolved to control my emotions, which is especially important when it comes to getting rejected, since any new gallery or consultant will be rejected most of the time.

It was like I repeatedly went racing up to a drawbridge that I desperately needed to cross, only to have it yanked up at the last minute because I didn't yet belong to the right club. This can drive you nuts when it happens year after year, especially since as artists we put so much passion into everything we create. The temptation is to get off the horse and beat the crap out of the bridge operator, but then we'd be the ones behaving like morons.

You can burn these bridges if you want, cause scenes, and have shouting matches. Some people can't seem to help doing that, never realizing that they may have misconstrued things, made false assumptions, or imagined slights where none were intended. More often than not this is at the root of misunderstandings.

My approach? I never intentionally burn a bridge, though I may cease to cross certain ones. If anyone wants to do the burning, I let it be the other party. I just move on, sending no negative vibe, uttering no gossip, and creating new successes. If later the bridge-burner

wants to reconsider, I'll leave the door open. You never know when someone you're fed up with this year will turn out to be a great ally the next, and you'll realize that you misread the situation. I don't disallow that option unless the person in question is so twisted they're not worth working with. If I decide this is the case, I also acknowledge that they're likely doing the best they can with what they were given, and let it go.

I have to maintain a civilized way of doing business. If I don't, my artists and family will suffer. In the beginning this went against the grain of my passion and ego, especially in dealing with petty individuals of primitive outlook. Well the passion was good but the ego was not. I needed to adjust it and eventually learned to.

In all relationships it is obviously best to build bridges. This applies to individuals as well as nations. Maybe if we improve at it as individuals, nations will too. I mean Gore Vidal and Normal Mailer buried the hatchet, and if those two could, anyone can. So if you can work by this method, your career will surely go further. But if you can't, what the hell—let her rip.

NETWORKING

You'll never advance your career as well on your own as when connected with influential individuals and organizations. You don't like socializing with them? In the beginning I didn't either, considering myself too hip and literary to bother. How absurd.

It was at this time that I learned about Ben Franklin's Junto, which was a kind of social group made up of Philadelphia intellectuals and businessmen. Their purpose was to debate moral, political and philosophical issues, exchange knowledge of business affairs, and help advance one another's careers—while also drinking plenty of wine.

Franklin, a genius by any standard, inspired me to get off my butt. I joined the chamber of commerce, got several speaking gigs, then became involved with inner-city high schools. Whether your reaching out is based in business or volunteerism, you inevitably meet people with similar passions who will introduce you to yet others, and so the circle grows. This can bring you respect in both the art and business communities, which usually leads to more clients,

which can help you to help others who may not have had your opportunities. Very cool how that works, eh?

Many people in business would like to be more involved in the art world, it's just that in their overworked realm, they rarely have time. Your reaching out to a business group will make this easy for them. You don't have to compromise on your work. Let it remain what it is—no matter how *out there* it might be. *Out there* is good.

Whatever you do, please don't stay in the studio bemoaning your lack of contacts. Become proactive and join an organization of interest. Great things can result if you make use of the acquaintances you strike up. Those people may help advance your career in surprising ways, with you returning the favor. To me, that always beats the path of the Lone Ranger.

FINANCING

If it hadn't been for creative financing in my gallery, I'd have closed the first year. Sure, some of that financing involved credit cards and bank loans, which isn't creative at all, just desperate. But as I grew more experienced, I devised ways of maintaining cash flow without going too deeply into debt.

As artists we often dream of finding a backer who will pay our debts, give us buckets of money, and bring clients aplenty. In some instances these people have actually existed, as in the case of Tchaikovsky's relationship with Nadezhda Filaretovna von Meck, a patroness who financed his career so he could focus on composition. She believed in him so completely that few strings were attached to the arrangement. In fact they never formally met, carrying on their close but platonic relationship via letters—1,200 of them. After thirteen years though she had to shut it down, since she was facing bankruptcy.

Now this is a great example of the wealthy supporting the arts, even to their own detriment. It's also uncommon. Oh plenty of flush people support the arts, but they typically do this by writing a check to the symphony, a local art center, or ballet company. Rarely do they act as willing backers for an individual artist or gallery.

Why? People who are financially successful take a dim view of investing in anything that doesn't guarantee a reasonable return. So

when an artist or gallery approaches them with a request for funds, if that isn't accompanied by an airtight business plan detailing how the financier will be compensated, it will be dismissed.

The problem is, if you ask for a loan you'll naturally have to repay it with interest. If it comes to this, you may as well go to a bank. Further, you don't want to repay the loan with money, you want to repay it with art. Most banks won't be interested in that, but certain collectors will.

How do you go about this? Here are some steps:

1. Don't approach a patron unless you can prove that your career is in the ascendancy, and that collectors value it, even if just a few.
2. Before you approach a patron, draw up a document that states what each party's obligations are and have it approved by a lawyer.
3. Don't ask for a loan. Ask for an investment in your career, meaning that if the patron agrees to invest a specific sum, this will serve as a down payment on art which you'll then create for them, giving them a discount that you normally don't give to others, while warranting that they'll be more than satisfied with the result.
4. Don't ask for a large sum from one person, but smaller sums from several individuals, such as $1,000 to $10,000 each. But if you know people who will write bigger checks, great.
5. Determine what each investor will get for their money. For instance, if they invest $10,000, then you can let them acquire works at twenty percent off. Thus for the $10,000, they'll get roughly $12,500 worth of art. This works well with people who are on the fence about buying, since they usually find this kind of opportunity attractive.
6. Begin creating studies or models of the works that you'll execute for their home or business, exceeding their expectations each time. As that process matures, following the natural course of your passion, those patrons will become some of your best promoters—willingly.

This can be a great way of advancing your career with little risk to yourself and your investors. You can even relaunch the program with a new group each year until you're on solid ground. Just be careful who you dance with, as you never want to involve people who have a reputation for abrasiveness or dishonesty. That simply isn't necessary, as the world is full of kind people who love the arts and enjoy helping artists succeed. All you have to do is find them, then prove you're a worthwhile investment.

A major step toward proving that is to draw up a solid business/career plan that defines your vision and goals. In fact, this should be done at the same time you draw up the sample agreement, and presented along with it. Any potential investor will appreciate the forethought of that. Again, when it comes time to sign the investors, you must have a lawyer approve each agreement if the wording is changed from the original, so that you don't find yourself compromised should one of the relationships sour.

We used this program during our various periods of financial difficulty, offering incentives and opportunities that our clients fell in love with. They took pride in our growth, and in the impact they were having on regional culture. Without them, I'm not sure our ultimate success would have been possible.

MENTORS

I've always sought out mentors in the arts and business who were older than I, had experience in areas that were foreign to me, were honest about my shortcomings, and generous with their counsel. You may want to tap a group of people who can also do this for you. Once they become involved, they'll inspire you to reach for higher goals than you likely would on your own. You don't need to be friends with these people, or socialize with them beyond the occasional lunch. But you should meet with them on a regular basis, make note of how they advise you, and take action on the things that make sense—especially those that might be difficult to achieve.

What do you give them in return? That's the beautiful thing about a mentor—the best ones expect nothing, and are content just to help you succeed. But if you feel like giving them a cool work of art, it will no doubt be appreciated.

CHARITY ART AUCTIONS

All right, it's late in the evening, you're exhausted after working your day job, and now you're working your real job–your art. You're not making much money at it yet. In fact you may be broke, with your credit cards maxed out and the debt rising. But at least you have your passion and the freedom to pursue it. So you're pursuing it when the phone rings. Some well-meaning dilettante wants you to donate a work to their School Auction, Public Television Auction, or some other kind of auction. They promise you great exposure, enhanced collectorship, and career advancement if you participate. Should you? No. At least not without establishing the following rules:

1. You set the minimum bid, meaning that if the piece would sell for $1,000 in a gallery, it must sell for about the same at auction. If your price isn't met, it doesn't sell.
2. You require that the sponsors of the charity pay you a percentage of the sale price to cover your expenses—unless you don't need that, in which case, donate away.
3. You make certain the event is established and well-attended before consenting, and that your contact information and website will be distributed.

Look, these people mean well. What they don't understand is how much damage they can unintentionally do to artists' careers, and to the art market in general. How? In most of these auctions they virtually give away the work, making you and all other artists look like you don't deserve the prices that you normally get. The exposure you receive under these conditions is insignificant and counter-productive. Or as one of my painters puts it: "Man, I've known artists who have died of exposure."

Once you establish the ground rules, these people will respond accordingly. They'll also begin to better appreciate the realities of your life, the sacrifices you have to make, and the difficulties you juggle. Artists are among the last people to ask for a charitable donation in terms of money, although they're often generous with their time and work. After all, it's important to help any organization that is in turn helping others with their own difficulties, whether in the Third

World or the U.S. But if the sponsors can't abide by the above-listed guidelines, I advise you don't participate–just be nice as you decline.

In my gallery, the word went out long ago that our rules are as I've listed, hence the only calls I get for auctions are those where these rules are applied. I enjoy working on those events, because I know everyone will benefit. Otherwise I save my donations, both in terms of time and money, for teenage artists from low-income families. But this gig of well-intentioned socialites demeaning artists out of indifference or pure naiveté is something I ain't got much use for.

Finally, if you do donate, be sure to document the amount of the donation as a tax write-off. In some cases, you're only allowed to write off the material expenses of a piece, which is absurd but better than nothing. In other instances, you're allowed to write off the market value, which is better. Just don't inflate the value. Otherwise you might wind up getting a call from the IRS. Either way consult a CPA on what you can and cannot write off, just to ensure that you stay within the bounds of the law.

TAX WRITE-OFFS AND RELATED ISSUES

As I mentioned at the outset, you're an entrepreneur of sorts. And any successful entrepreneur understands how to write off all possible expenses. The IRS, who I've dealt with on occasion, is actually a reasonable institution that allows the self-employed to write off more expenses than most people realize. If you become adept at understanding the rules, you can reduce your tax bill by thousands and put that money to better use—like your kids or your next trip abroad.

Here is some basic structure:

- File your art career as a business, likely a Sole Proprietorship. There won't be any need to file as an LLC until you have employees.
- Open a separate banking account for your career once it begins to generate revenue—even if only a few thousand dollars per year. All revenue from your career should be deposited in this account.
- Keep receipts for every expense that relates to your business, such as gasoline, art supplies, phone bills, heating bills, business lunches, etc. This includes expenses for any type of education

or travel relevant to your career, especially travel to art fairs and exhibitions.

- Keep track of all mileage that relates to your art, then deduct the appropriate amount per mile that the government will allow.
- If you build a studio, whether in your backyard or bedroom, all expenses relating to the creation of that studio can serve as a write-off.
- Put all expenses on a debit card, which will make them simpler to track. Of course you can use a checkbook if you prefer. But please, try to avoid using credit cards—those legalized loan sharks!
- Make sure an accountant advises you on how to go about this process, and keeps you within the guidelines of tax laws as they evolve, since they do change periodically.

Does logging all this stuff sound a bore? Sure it does. I can't stand doing it either, so I have a bookkeeper do it for me. But in our early days I forced myself to undertake this, which saved us a lot of dough—after I lost plenty by failing to do it. So grit your teeth and set aside an hour each week to organize your receipts and write-offs. You'll find it isn't that hard, and is worth the effort. But if you simply can't make yourself do it, just be aware that over time you'll wind up giving tens of thousands of dollars to the government that they don't even expect. Man, that would pay for a lot of trips to Italy.

CHAPTER 11

WEBSITES

I didn't bother setting one of these up in the early '90s, when the Web was less a part of our culture. But by the late '90s I was obligated to do it. By then most galleries had a bloody website, so we had to have a bloody website too. It's the same with artists, since if you're serious about your career, having a website has become essential.

Our own site has proven greatly beneficial, and inspires more sales each year. Even so I find that art buying tends to be a first-hand sort of thing, where the client must normally see the work before making a decision. But a site can serve as a useful tool in introducing prospects to your work, or to the galleries you're in. The tough part is getting those clients to find you within the informational black hole that is the Web.

It's usually easier for a gallery to be found than individual artists, since they'll have a brick-and-mortar space with foot traffic, will make sure their Web address is printed on everything they hand out, will advertise their site, place it with a wide variety of search engines, and in general promote themselves like any

business. This will drive up their Web presence. Artists are less likely to promote their sites so extensively, though they tend to benefit if they do.

If you're already with a gallery, make sure they include your work on their site. In fact this is now a standard practice, since most galleries will devote an entire page to each of their artists.

As for your own site, setting it up can vary in cost from several hundred to several thousand dollars, depending on how you go about it. You can work with an independent developer or pay for an online service and utilize their template, customizing it to suit you. Several online art societies and magazines also offer website development. Just remember that a sophisticated design which is easy to navigate, and easy to update, is essential.

After setting up the site, you'll want to register with a large number of search engines. If you're a painter, you can be listed under Artists, Painters, Abstract Painters, Conceptual Painters, Landscape Painters, or whatever fits. While you're at it, try to be mindful of the keywords that people might use that would lead them to your site, since these items will be indexed by search engines and used to rank it. Most search engines also have the ability to search for images, so it's important to title and tag your images appropriately. Also list your web address on all printed materials, and make sure a link to your site is embedded in the signature portion of every email you send out. If you create a page for links, then link to any galleries that represent you and to any arts organizations you're a member of. Practices such as these will make it easier for prospective collectors to find you. If you don't make that effort, the site will serve little purpose, in which case you may as well scrap it.

Another thing to keep in mind is that as technologies evolve, some devices may not be compatible with certain web technologies. An excellent example of this is the Apple iPad and Adobe Flash. Flash has been a mainstay of website animation for years but is not compatible with the Apple iPad. This may change by the time you read this book but the lesson learned is: make sure you're aware of the capabilities of your desired audience and design your website to fit those general capabilities.

A well laid-out website will probably not make you a rock star overnight, but it will provide one more piece in the puzzle that is your

career, and that you'll have to consistently work toward assembling, and sometimes even reassembling, if all your years of sacrifice are to pay off.

SOCIAL MEDIA

Once this was simply a way to keep up with friends. But now social media has become a useful tool for any artist who wants exposure on the Internet. There are a variety of options. Select the ones you prefer and establish a presence on each. Sites like Facebook and Google Plus not only offer personal pages but fan pages and group pages as well. Setting up a fan page is easy and allows you to potentially connect with a community millions strong. It also allows you to share events, shows, and other relevant information with your fan base.

If sharing information or keeping up-to-date with others in your milieu is important to you, then Twitter facilitates this to a considerable degree, at least at the time of this writing. This form of microblogging allows you to reach out to your fans with minimal effort while boosting interest in your work. You don't have fans yet? Just keep working on it. They tend to follow people with talent.

If you start a blog, this can also drive traffic to your site and help develop interest in your work. Unlike tweets, blogs tend to be more in-depth and article-based. That allows you to discuss any aspect of your work in depth or provide commentary on galleries, shows and controversies.

Of course the end goal is to develop exposure to your work, so it's important to link all of the tools you use to your website and vice versa. Quite often people will find a blog, Facebook page, or Google Plus page before they'll find your website, so make sure the user has an obvious pathway from your website to your Facebook page or blog and back again.

All these little steps might seem tedious (they are to me), but they do add up, and will become increasingly relevant as technologies evolve. That said, some people do have a tendency to get sucked into the vortex of social networking, somehow believing that if they're active enough on the Internet, this will provide a major boost to their career. My opinion is that it's just a minor aspect of your career, and what really counts is the work, how active you are with galleries, and especially with collectors.

As for the whole social network phenomenon, I consider it an overrated technology that devours too much of our time, encourages narcissism, and separates us more than it brings us together. Oh sure it has its uses in business; we have a Facebook page, update it regularly, and have found it to be worthwhile in certain respects. Even more importantly, in my opinion, is its use as a tool for social activism. Look at how effectively it was utilized to help organize the Egyptian Revolution of 2011. That isn't just admirable; it helped change the course of history.

But because Facebook was developed by Mark Zuckerberg when he was in college—no matter that he's an adult now and runs it with other adults—its structure is essentially an extension of college culture and, as such, can sometimes play like a manic popularity contest. Therefore many people get depressed if they don't get a large number of friends and fans, or if others don't respond with multiple comments and likes to each posting. This is especially, and needlessly, hard on teenagers. Please don't fall victim to that nonsense. Just use the social networks where they apply, use them with savvy, then forget them and go back to creating great work, an enduring career, and living a full life. In the end, that's what it's really all about.

E-MAILING IMAGES

Like social networks, email too has become imbedded in our society. But also like social networks, we've become so hooked on this technology that in many instances we've forgotten about that old-fashioned device, the phone. I personally prefer to talk with a client or artist rather than shoot a hundred emails back and forth. To me that keeps the relationship grounded and real. In addition, misunderstandings easily occur through email, which often comes off as curt or rude when nothing of the kind is intended. Like social networks, I feel that this gizmo also separates us more than it binds us together. Besides, an actual conversation allows me tell stories, crack jokes, and indulge in my love of cussing. Doing this in email just ain't the same.

But whether I like it or not, this technology has become essential to my business as it is also essential to your career, since we both must often send images to clients, galleries and prospects. If you

attach images for viewing or mid-quality printing, don't attach too many, and make sure they're of relatively low resolution. In that way they'll download quickly. If the images are of high resolution they may be blocked by your Internet service provider, take a long time to download, or be sent to the trash folder.

Of course if you're sending images for high-quality printing, this does require high resolution. You'll have to decide whether you'll send them as a jpg, tif, or pdf. For really large images you'll have to utilize an FTP site (file transfer protocol), or a web service designed to email large files, which is common in graphic design and publishing. All this is pretty basic stuff, but for those of you who are novices in these areas, I urge you to familiarize yourself with these techniques, whether through a handbook or class, since this technology is likely here to stay. Few people went back to hand-writing texts after the invention of the Gutenberg press, which was modern technology for the Renaissance. The application of the Web is no different.

As for texting, I utilize this when it's convenient or effective, but again I'd rather converse. My sons? Those wisenheimers use it all the time.

Then we have cyber-bullying, blog gossip, and cyber stalking. The whole business makes me a bit nauseous, since some people tend to say cruel and bizarre things online that they never would in person. I'm not sure if this has been good for civilization, but for good or ill, it's with us now, so we'll have to make the best of it.

While the Internet has made the conducting of business more efficient, it's also sped up our culture to an absurd degree, where we expect results much too quickly, placing stresses on one another that we'd be better off without. To me this seems to have contributed to as many problems as it's resolved. I suppose there's little we can do about that except treat it sanely, and decline to participate now and then.

UTILIZING REPRODUCTIONS IN MAGAZINES AND AS PRINTS

One of the most basic ways of utilizing reproductions relates to magazine covers—art magazines, interior design magazines, lawn and garden magazines, and so on. Many of these welcome the opportunity to reproduce a work of art on their covers, be it 2-D or 3-D. If they haven't done it before, all you have to do is suggest it.

The Kansas Medical Society has made a practice of this, as has the Missouri Medical Society, and both have reproduced images by my artists. I've arranged the same with other publications, both major and minor. I never charge a copyright fee though, since I feel that promotion of the artist is what's most important.

Reproductions can also be used for websites, corporate brochures, restaurant menus, and any other application you can think of.

Example: It was this sort of reproduction that launched Maxfield Parrish's career, when a candy manufacturer out of Cleveland asked to reproduce one of his paintings on their boxes. Parrish agreed to a modest fee, the boxes were distributed by the thousands, and within a year he was signing a contract to distribute reproductions of his best originals. This led to an increased demand for his originals, also increasing his prices, giving him the leisure to paint as he wanted.

If you're a painter, reproductions of originals can be a career-enhancing move. It can also be a flop, depending on how it's managed. How do you go about it?

Start with the strongest possible painting, then have it professionally photographed for reproduction by a studio that specializes in this type of work. After the shot is complete, you have to choose a reproduction process. The choices generally are: offset color prints on archival paper (glorified posters), Giclee prints on archival paper (extremely glorified posters), or just posters. I've dealt in the first two options. Over time, the wholesaling of these works can pay well, but the main reason I did this was to make my painters better known and sell more of their originals.

If I cover the cost of production, I pay the artist twenty percent of gross sales. If the artist covers the cost of production, then I keep fifty percent of each framed piece they consign to me after I sell it.

Then there are fine art prints—etchings, lithographs, and engravings, which I value far above color reproductions. For the artist skilled in these processes, this is a refined way to showcase your talents without charging the higher fees that paintings command. It's more difficult to market this sort of work than reproductions, since these tend to be more expensive and don't use much, if any, color. But then they're not made for the mass market. These prints are

works of art unto themselves for sophisticated collectors, which is a smaller market.

Reproductions aren't for everyone, but if you feel you can carve out a niche, go ahead. I advise you to start gradually though, working in small editions, investing as little as possible, printing only what you need—which is one of the advantages of the Giclee process. It's better to test the market this way than to invest heavily in several hundred prints and find out that no matter how stunning they might be, you can't even give them away. This happens more often than not; you don't want to be one of the people it happens to.

GRANTS

This is tricky, highly politicized ground for me to cover, but I wouldn't consider the book complete without it. The mystery of grants, who is awarded them, and why, is something most of us in the arts simply can't explain. And while many successful artists I know did apply for grants when they were younger—with a handful actually being awarded one—the vast majority don't go to the effort once they begin to succeed.

Most artists do not qualify for the major grants until they've established themselves as exhibiting artists. Inevitably, many of those who are awarded grants end up earning the scorn of the reactionary portion of our society, who tend to question art that is provocative or outrageous, despite how society can benefit from being provoked, since that leads to the questioning of authority—essential in any democracy. The most obvious example of this is our government's reversal of its policies during the Vietnam War, from active engagement to withdrawal. Though it did take many years, much sacrifice, and even more violence to achieve that, it would have taken longer had artists not been involved—musicians, writers, illustrators, painters, and so forth.

This group of "radicals" helped convince society that the war was a tragic mistake, and to question the authorities who were perpetuating it, especially all the corporations who were making a profit from it. At first only a small portion of society agreed with this view, but the numbers rapidly grew until a majority demanded that the war be stopped. Those beautiful, provocative nonconformists were there at the beginning, as they were at the end.

Of course the act of provocation inevitably gives rise to extreme reactions among authorities, which can lead to misunderstandings and harsh repercussions. A classic example of this is the Robert Mapplethorpe case, and how it affected the National Endowment for the Arts, which was peripherally involved in the blowup. If you're not familiar with the controversy, which was preceded by another one involving Andres Serrano, it went like this:

In 1987, the Southeastern Center for Contemporary Art, in Winston-Salem, North Carolina, received a $75,000 grant from the NEA to support a program of theirs that was called Awards in the Visual Arts. The NEA grant was matched by $75,000 from the Equitable Foundation and the Rockefeller Foundation. These grants enabled the SECCA jury to select ten artists, whose works were showcased in a traveling exhibition.

Among those pieces was a photograph by Serrano titled *Piss Christ*, which showed a crucifix submerged in a glass container of yellowish liquid—purportedly the artist's urine. This infuriated a wide range of people, both liberal and conservative, many of whom soon put the NEA in their crosshairs, despite the fact that the NEA was not involved in the selection process.

A year later, in 1988, the University of Pennsylvania's Institute of Contemporary Art received an NEA grant of $30,000 for a retrospective of Robert Mapplethorpe's photography. The exhibition, titled *The Perfect Moment*, opened at the ICA in Philadelphia. The photos were superbly done studies of light and shadow where the subject happened to be graphic nudity, much of it homoerotic. Coming on the heels of *Piss Christ*, this was too much for those who already despised the NEA—which was also uninvolved in the selection of Mapplethorpe's work. The only thing it did was provide funding to the ICA, which spent it as they saw fit. But that indirect link was all the enemies of the NEA needed. They saw it as an elitist organization that despised traditional approaches to art, and traditionalists in general, so mounted an attack that was intended to make drastic changes. It did.

Jacob Neusner, a scholar of Judaism and a much-lauded historian, served on the National Council on the Arts at the time, the art advisory body for the NEA. He later wrote about the controversy in an article for *National Review*, a segment of which I've posted below.

Now I don't consider *National Review* a well-rounded platform for discussion of the arts. Even so, I do find Mr. Neusner's article illuminating and fairly even-handed, even all these years later, despite his obvious leaning toward conformist interpretations of art.

Two years after Serrano, our side has lost the struggle to preserve the NEA as an agency in the service of the entire American people. The NEA is held captive by a staff that regards with contempt conservatives, Republicans, taxpayers, the middle class, and pretty much everybody else outside its own circle of the avant garde.

But what is at stake is not the agency. What now is at stake is the good name of the arts. Congressman (Pat) Williams came to the Council last summer with Congressman (Ralph) Regula and warned us: "You are making the arts, not the Endowment for the Arts, into the laughing stock. You are giving the arts a bad name."

What an epitaph!

Do I think we should maintain a national endowment for the arts? Yes, I do. But not this one.

This was big news for over a decade and still resonates for good reasons. It illuminates both the weaknesses and the strengths within the grant system.

Do established artists, as Mapplethorpe was in 1988, really need project grants? In some cases, sure, since being established doesn't necessarily mean you're flush. But in other instances, where the artists are already well off, grants are given anyway. Why? Primarily to honor the artist, though it might perhaps be wiser to bestow the honor in the form of a medal and a shindig, and save the money for struggling, unrecognized artists of comparable talent.

NEA grants have changed considerably since the Serrano/Mapplethorpe affair. For example, the NEA no longer awards grants to individual artists, except in the case of literature. Its Visual Artist Fellowship Program ended in 1996, when Congress altered their legislation. At this time, NEA grants in the visual arts only go to nonprofit organizations that arrange exhibitions, commission work, host residencies, and provide studio space for artists.

The Mapplethorpe exhibit received this kind of grant; it didn't go directly to the artist, although an earlier grant did. Of course his work benefited enormously from the exhibit and resulting firestorm (although he didn't, since he died in 1989). Depending on where your allegiances fall, that was either a great thing or a disaster. Either way, this controversy was very hard on the NEA, which is unfortunate, considering how small the grant was in comparison to the scope of a very worthwhile institution. But such are the risks in mixing govern-ment monies, and therefore politicians, with art.

As for the fellowship system itself, it seems to me that many grant organizations primarily assist artists whose work relates to the aes-thetic of the avant-garde, or that has a certain shock value. Artists who are more craft-oriented or tradition-based are often ignored. That's bold, but after awhile it becomes predictable. Of course some people maintain that if you don't understand shock art, you're intel-lectually lacking. I simply can't buy that. The world is daily exposed to shocks that are far more disturbing than anything we can create in attempting to awaken the indifferent and dozing portion of our popu-lace—although we remain obligated to go on doing just that.

I frankly don't care if the NEA supports organizations that fund pieces like *Piss Christ*. Given the long-overdue revelations of sexual abuse within the Catholic Church, an artist may have valid reasons for creating work of this nature. To me, this is no more shocking than the Sensation exhibit at the Brooklyn Museum was, where Marc Quinn executed a self-portrait with eight pints of his own blood, and Chris Ofili incorporated a clump of elephant dung into his portrait of the Virgin Mary. Is this sort of work new? Not entirely; the Dada-ists went there in the 1910s and 1920s, shocking anyone who they felt needed to be shocked—and many people did, especially those who had blindly instigated the firestorm of World War I, which laid the foundation for the next World War, as many artists recognized it would. Among those radicals was Duchamp with his Readymades, like the urinal he signed and attached to a wall, titling it *Fountain*. Man, did that outrage the conformists. Good.

Whether one likes this kind of art or not, one of the most impor-tant aspects of avant-garde work is that it can cause us to expand our perceptions and question certain beliefs, especially those that

might eventually prove misguided—such as the racist beliefs that were so dominant prior to the successes of the Civil Rights Movement. That, in turn, can give rise to a general expansion of open-mindedness in the individual, which I've witnessed with corporations and private collectors alike. To me, that's invaluable.

There will always be a need for nonconformist art, which necessarily challenges narrow-minded beliefs and helps give birth to new movements. Still I feel we've gone to many of those extremes already, in fact had to go there in response to the blatant injustices that are invariably maintained by people in power. Perhaps now, though, it's time we moved back a tad in the other direction, supporting with equal zeal artists who work in a more tradition-based fashion as well as those who are outright renegades.

State-sponsored grants are just as tough to get as the federal variety, and just as hard to figure as to why certain artists receive them and why others are passed over. I've been told by artists who have received both federal and state grants that it's a terribly political process, where inside connections will take you farther than the substance of your work. I'm sure there are instances where this is true, and I'm equally sure there are just as many where it's false. But that's life in this world—it's been political since the beginning, and will remain political until the end.

Despite all this, I consider it good practice to submit for grants. It will teach you the importance of quality photography, resume development, and presentation. Be warned though, the competition is so great that the chances of being awarded one are slim. This doesn't mean you shouldn't apply; I'm just trying to apprise you of the odds—rather like getting a literary novel published.

Applications for most grants can be obtained through civic and state art commissions, as well as the NEA, all of which have comprehensive websites.

My take on all this? Individual grants disturb me somehow. I fear that if I were awarded a large one, I might become dependent on the grant instead of my discipline. Of course I know that grants are meant to help buy the artist time in developing his work—a wonderful thing. Gauguin gained this kind of windfall when the French government paid passage for his first trip to Tahiti, allowing him to create an entire body of work that the world wouldn't appreciate until after

his death. Still in some ways I view grants for the individual artist as a well intended, but sometimes misguided, attempt to soften the harshness of the artist's life. The intent is noble, but it's somewhat akin to interfering with someone's fate, when that fate is something they need to go through.

The artist's life is supposed to be harsh to a certain degree. If it isn't, what will inspire you to reach higher than your immediate grasp? If conditions are made too easy, will you still create your best work? In instances where the grant system has been abused—subsidizing a drug habit, a drinking habit, or just the perpetuation of mediocrity—this has sometimes been the case. In instances where the grant system came riding to the rescue just in time, awarding desperately needed funds to deserving artists, it culminated in glorious results. Like most things, there is an upside and a downside to it.

As for myself, if I were awarded a grant tomorrow, would I turn the money down? Better yet, would I have the guts to hand it over to some struggling artist who needed it more badly than I? If I were flush, yes. If I were broke, no. I'm as human as anyone else.

COMPROMISE, AND ONE EXAMPLE OF IT

To me, one the best examples of compromise is cradled in the story of the Vietnam War Memorial. The design—with its angled granite walls, endless list of names, and the installation like a wound in the earth—is simple yet moving. Maya Lin's concept, submitted when she was only twenty-one, has proven timeless. I've been to the wall several times, have watched veterans weep, have wept myself.

One of my brothers served in Vietnam, was wounded there, shipped back to the states insane, and finally died twenty years later as one more casualty of that awful war. In a sense his name belongs on the wall too. Maybe that's one reason I like visiting it.

When the memorial was dedicated in 1982, it inspired a level of emotion and healing that most war memorials simply don't. It still does. As long as Vietnam veterans are with us, it always will. But at the time of its dedication, many vets felt something was missing because there was no figurative representation of them. As with the Iwo Jima Memorial, countless Civil War memorials, and most other memorials, these guys wanted bronze figures at the site. They made this known, and there started a bitter debate.

Some critics argued that the placement of such figures would disturb the integrity of the memorial, and amount to stooping to sentimentality. I understand the argument, but found it then, and find it still, the height of arrogance. Did any of those critics fight in the war? Did any of them lose an arm or a leg or the ability to walk? Did any of them soil their pants under fire, scream for their mothers when wounded, or watch others scream as they died? I suspect few did. On that basis they had no business interfering with the veterans' wishes.

The men and women who do the fighting in our wars often have no choice but to serve, and are rarely interested in contemporary art. The vets wanted figures in bronze at the Vietnam Memorial, and finally when Frederic Hart was commissioned to execute them, that's what they got.

The solution was to situate the figures some hundred yards from the memorial, with the three grunts having just finished a patrol, likely to soon go out on another, and from that one, perhaps not return. A black man, a white man, and one who might be Hispanic. This was a brilliant compromise. The bronze didn't interfere with the design of the memorial, and satisfied the visual needs of the men who served in combat.

For my part, I've always felt that the figures were a little too idealized, that they don't look drained enough, and that the emotional price they were paying doesn't show on their faces. None of them has that haunting *thousand-yard stare*. This doesn't detract from the effect the bronze has on visitors though, since many people are moved by them.

There can be compromise between the traditional world and the contemporary. Nobody really needs to feud over which is superior. History, with the benefit of hindsight, makes those assessments for us, and all our squabbling will make little difference. Many of these arguments might be worth pursuing, but never as an affront to sacrifice, suffering, or dignity.

A stonewalled failure to learn compromise will only bring more frustration than achievement, but if you're so-inclined, it doesn't hurt to try living without it for a while. Doing so can teach valuable lessons. It certainly did for me.

Then there are people like Frank Lloyd Wright, who almost never compromised about anything. To a degree, this worked for Wright, being a genius, but whether it was worth the trouble it caused him—and it caused him plenty—is something I don't know. I do know it wouldn't be worth it for me, but then I'm not a genius.

SELF-DOUBT

Every living artist I've ever worked with, and every deceased artist I've ever studied, shared one simple trait—each has gone through varying levels of self-doubt that made them question the worth of their talent. No one that I know of has ever been exempt from this. For some, like the poet Sylvia Plath, their spells of doubt were mind-numbing, paralyzing, and in the end, beyond their control. For others, like Picasso, those spells were nothing more than a minor dip on their emotional graph.

However severe or mild your bouts might be, I bring this up to assure you that they are common, and that after you weather each bout, your confidence and perceptions will likely grow—that is if you're willing to go through the introspection and pain which often accompany that.

I feel that spells of self-doubt occur so that we will reassess our direction. For some, these spells can destroy them if they don't keep their emotions in check. But for most artists, the spells serve as a tool for reevaluating their work, and deciding whether they want to continue in the same vein. I consider the process necessary, and in many ways unavoidable.

Sure, you're supposed to enjoy the gift of creation. But if it doesn't, on occasion, make you howl with self-deprecation, if you don't sometimes wonder whether everything you've done up until now is pure crap, or whether you even have any talent, then something's wrong. You're supposed to feel these things. They keep you on the edge of your passions, inspiration, and drive.

However you take it, please don't believe that self-doubt is limited to you. We all share it, we all struggle with it, we all struggle to overcome it. Let it serve you, while you try to stay in control of it. Like so many powerful emotions, this one too contributes to the energies of creation.

How do you break free? You can discuss it with friends, you can whisper about it at night with your lover, you can reread this passage, but really there's only one way I know of to break out, and that is through demanding more of yourself, then going on to fulfill those seemingly impossible goals. That is what you're here to execute, no matter what it takes. Besides, the thing it gives back is normally richer than the thing it takes away.

EXPANDING CAREER

As you and your work evolve, always be willing to follow any path that excites you, demands a higher level of discipline, or maybe just a higher level of being. Try to avoid falling into ruts of complacency, apathy or habit.

At the same time, if you discover a style that works well and keeps you inspired, there's nothing wrong in staying with it. You don't have to reinvent your work every five or ten years to maintain your sense of integrity. You paid a heavy price in establishing your style and have earned the right to reap from it all you can, just as Wayne Thiebaud did first with his paintings of cakes, then with his scenes of San Francisco. Is he really known for anything beyond these two styles? No, nor does he need to be.

Similarly, how many haystacks did Monet paint and how many paintings of the same stack did he do? Dozens. Did this harm his career? To the contrary, it advanced it. Sure, some critics of the time derided him for this practice, and others may deride you. They may say you've betrayed your talent, or some artistic truth, or whatever. Let them. They're not the ones doing the work, they're only doing the talking.

Yet there does come a time in most artists' careers when they must reassess where they're going. A change, or paradigm shift, normally follows. If your intuition is on target, your talent psyched, and your passions aroused, the change will probably be good. But even if none of these elements are aligned, you'll still have to attempt it now and then. Doing so will help keep you from growing bored, since if you grow bored with your work, it will likely bore others.

Example: Arlie Regier had been sculpting in scrap steel for twenty years when I met him, a process influenced by the legendary Richard

Stankiewicz, under whom he studied. Arlie had created hundreds of pieces, whether painted or rusting, and had placed every one. Then he grew tired of this medium and began experimenting with stainless steel scrap, especially pieces tossed out by manufacturers. I took one look at the new work, told him to forget painted steel and concentrate on the stainless. His intuition proved correct, and the new work brought him hundreds of collectors that he otherwise wouldn't have won. This challenged him and his son Dave to take their sculpting to a higher level, which eventually landed them gigs like placing work in a Warner Brothers' film, commissions with firms like H&R Block, and participation in a group exhibition at the Museum of Fine Arts, Boston.

Not every change can be met with such success, but I've yet to meet the artist who doesn't undertake this challenge at least once in his life, and benefit from the struggle. You'll know when the time is right for you, and when it's not.

MUSEUMS: GAINING THEIR ACCEPTANCE

Eventually, if your work has received sufficient notice, you and your dealers should consider placing it in museums. There's no point starting with the larger museums, since they likely won't give you the time of day until you're a phenomenon, so you might start with some of the smaller ones in your region.

As for when to approach a museum, it will likely have to take place after you've achieved several substantial successes—unless you have a rich aunt on the board. You'll have to be fairly established and mature in your career before most museums will consider your work. Once you're at this point then pursue them ardently, just be sure to have one of your dealers do it for you. There's nothing wrong with having a rep promote your work, but it's considered bad form for an artist to do it himself.

What is the goal? To place a piece in the permanent collection. If this can't be achieved yet, then an exhibition or retrospective would be great.

If a museum does become interested in acquiring a work, try to avoid donating it. If they value your art, they'll raise the money or ask a patron to step forward. You can let them have the piece at

a wholesale price however, since it's better to place the work and make minimal profit than to not place it at all. But if you must donate, fill out the necessary paperwork for writing off the maximum allowed on your tax return.

Should you achieve this, as with all other significant achievements, announce it in the papers, post it on your website, add the line to your resume, and have your dealers announce it to all their clients. Finally, if you get enough of the smaller museums to carry your work, it will be time for the larger ones to be approached, but probably not until after you're dead. That's usually when they show the most interest. So let your heirs cash the check, or better yet, establish a fund for an orphanage in Uganda.

SNOBBERY: ANOTHER WORD FOR 'WASTED INTELLIGENCE'

I suppose I could be a snob in writing about snobs and thus try to out-snob them, but there's no winning that game and anyway it's undignified. Compassion, I find, is the best way to deal with these people. Remember, they too are just trying to fit in; unfortunately snobbery is the only thing they've found that works. Except it doesn't work. It only leads to misery and isolation and a great deal of depression.

I can't think of any group that has done more damage to the arts, made the artist's life more difficult, and the arts less accessible than snobs. Their elitism drives away potential clients for you, intimidates people who lack their education yet might buy art, and discourages those in the working class from participating. Snobs make all these people feel unwelcome, saving their attentions for those few they deem worthy. This attitude has held back the arts for centuries. Well it's time for a revolution. Just as love of wine exploded across America in the '70s, we need a similar explosion in the arts now. In fact we're already going through it.

Every time you encounter one of these people, try to remember that inside each is a child who was scorned on the playground, in the classroom, or perhaps at home. Inside each is a frightened person who is still trying to learn the song of life, except all they have is the words, not yet the music. That said, which do you think snobbery

is rooted in—insecurity or confidence? Notice how the question an-
swers itself.

To scorn people who are not well versed in the arts is a poor use
of intelligence. What it amounts to is bullying.

Example: If a working-class woman is a single mother who
missed college, whose days are filled with long hours and adver-
sity, yet who is aware of her ignorance and wants to alter it, does
that make her inferior to the upper-class esthete? If she comes to a
gallery for escape, should she be treated with respect if she asks a
naïve question, or disdain? Ditto the manual laborer, the hairdresser,
and the uninformed businessman. All these people should be made
to feel welcome, but often an elitist doesn't understand this basic
truth.

The snob will talk down to them, laugh at them after they've left,
and go home thinking they scored a minor victory, when all they re-
ally did was deepen their own misery, and discourage yet another
person from becoming involved. But the snob doesn't stop there.
They will snipe at you, they will most certainly snipe at me—in fact
already have—and they constantly snipe at each other.

Who do they help with this attitude? No one. Who do they hurt?
Apart from artists and the art market in general, primarily them-
selves, although they often don't realize it until late in life. What good
do they do? Very little, except if you respect their opinion that may
cause you to strive harder than you would otherwise. After all, in a
backward way they do help us to maintain high standards. That isn't
all bad, though I'm not sure it outweighs the boatload of negativity
they otherwise bring to the table.

Don't let the snobs discourage you in pursuing the thing you
were born for. They've always had a place in the arts, and always
will. Remember, the only reason they behave as they do is because
they're intimidated by life; they just chose an unfortunate manner
of coping. Any well-educated person can be a snob, but it takes
strength to live with compassion, treating each person with the dig-
nity they are due.

If snobbery isn't one of your problems, cool. If the art world is
primarily a place of play for you, just keep playing. The best work

comes from that sort of freedom. Good work can also come from elitism, but what a way to live. Life's tough enough without making enemies at every turn.

EXPANDING LIFE

As your work goes, so will your life. One will be a reflection of the other, although not necessarily in any particular order. The better your work gets, the more fulfilled you'll likely be. That notwithstanding, I've known plenty of artists whose work was brilliant, but who remained depressed and neurotic just the same. I've also known many whose work was just average, yet who were among the most contented people I've ever met. Why? I have no simple answer really, just observations.

If I observe any consistency in contentment among artists, and people in general, it's that those who take themselves the least seriously tend to enjoy life the most. They might take their work dead seriously, but somehow keep from maintaining too lofty a view of the person creating it. That allows them to have fun, and having fun is essential to the enjoyment of life. It's a childlike quality, sure, but certain childlike qualities are good to hang onto. This, to me, is one of them. But don't take my word for it. Take Bertrand Russell's, the English philosopher:

> The decay of art in our time is not only due to the fact that the social function of the artist is not as important as in former days, it is due to the fact that spontaneous delight is no longer felt as something which it is important to be able to enjoy…. As men grew more industrialized and regimented the kind of delight that is common in children becomes impossible to adults, because they are always thinking of the next thing, and cannot let themselves be absorbed in the moment. This habit of thinking of the 'next thing' is more fatal to any kind of aesthetic excellence than any other habit of mind…

But Frank Lloyd Wright said it more succinctly on the occasion of his eightieth birthday: "…a creative life is a young one…. What makes you think that eighty is old? The purpose of the universe is

play. The artists know that, and they know that play and art cre-
ation are different names for the same thing."

Another thing I've noticed is that the most contented artists tend
to be among the least selfish. They went through all the selfish stuff
years ago, wearied of its lack of grace, and discovered that giving
to others brings unparalleled rewards. In this way they don't be-
come too self-absorbed, remain grateful for what they have, for what
they've achieved, and what they can do for their part of the world—
not a bad approach to both your work and life.

Whatever difficult things you experience, whatever the tragedy or
sense of inadequacy, please try to remember that you're not alone.
Most of us have been there, and most of us will be there again. Harsh
experiences on the road to self-awareness are common, if not nec-
essary. Without them you'll never adequately shape your character
or your art. Without them, you'll never really grow as tough as you
need to. It's kind of like that Chumbawumba song from the '90s:

> I get knocked down
> But I get up again
> You're never going to keep me down.
> I get knocked down
> But I get up again
> You're never going to keep me down.

Man, I sang that one a lot the night the gallery burned.

If you can take solace in nothing else, take solace in the com-
monness of our experience. Then get up, dust yourself off, and
move on. Ultimately you have no choice, just as all the artists who
have preceded us through the centuries didn't. Cool. That tena-
cious crowd is pretty good company to be in.

CHAPTER 12

SUCCESS

Success, as I'm sure you know, can only be defined by the person achieving it. By my experience it has less to do with monetary achievement than personal accomplishment, inner growth, and artistic mastery.

I've known artists whose work was spectacular, who were financially set, and had earned critical acclaim, yet whose inner life, family life and emotional life were horrible wrecks—mostly because of their own actions. This to me was hardly a measure of success. Even so, nearly all of these artists considered themselves successful, as did the public.

I've known others whose work was equally spectacular, who had achieved only moderate prosperity, with little acclaim, and yet were fulfilled in all areas of their lives. These people, too, considered themselves successful. So did their collectors. So did I.

Myself? I tend to break success up into different categories. I've always felt successful as a father, normally as a husband, and for years now as a man, despite some of my more enduring

depressions and setbacks. As a writer I never considered myself successful until a book was published, praised, and had begun to sell—regardless of how well written I was told the unpublished ones were. Equally, as an art dealer I never felt successful until we had succeeded aesthetically as well as financially, despite the fact that during the early years, everyone who knew of my gallery seemed to consider it a success.

As for you, you'll obviously know your own measure of success when you achieve it, depending on how you define this. Over the years that definition may change, depending on the nature of your experiences, disasters, and victories. Most of the successful artists I know try to learn from each disaster and are grateful for each victory. They try to make the end result of each change positive, rooting it in their artistic integrity, balancing it with common sense. You don't possess that last trait? Sometimes I don't either. So when I'm lacking it in a particular situation, I seek the counsel of people who have buckets of that trait, and who care enough to share it with me. Eventually some of it may rub off. And if it doesn't? What the hell, we're artists; sometimes the constant employment of common sense is just too boring.

FAILURE

What happens if you "fail" and have to join the business world, or some world similar to it? The truth is, you haven't failed. All those years of struggle, adversity and wrestling with the muse have brought, in return, these years of growth and a mature outlook. Without the struggle you wouldn't have the growth. Besides, the working world isn't all that bad. You could do worse. You could be living in Somalia or Myanmar and have no prosperous world to join at all, only deprivation and hardship.

If you're compelled to join the working world, just pick an employer who is sane and who treats her employees sanely. You'll still have your work and, if you're like most artists, nothing will keep you from it. You may have to burn more midnight oil, you may lose sleep, lose weight, lose a bit of your sanity, but the struggle may bring out more insight and even better work. Follow your inner voice in this process. It will likely take you where you need to go. That may not

be where you want to go, but usually where we need to go is the more important of the two destinations—though it's often the more difficult of the two as well.

Joining the world of the full-time employed is not necessarily a surrender; it is taking time out to face what you need to—in your work, yourself, and your life. If you have it in you, you'll still bring out your best work no matter what.

Take yourself a little bit seriously—no one else will—but not too seriously. Learn to laugh at your mistakes and admit your weaknesses. There is strength in the one and humility in the other, and both, in doses, are a necessary part of the process. At least, those things have always stood me in good stead.

Oh, and one other thing—never give up, never give up, never give up. Don't betray your talents by destroying them, or turning on them, or walking away and saying it can't be done. You don't have that privilege, nor usually even that choice. I know; I tried it once and madness was nearly the result. I won't try it again.

Now please put this blasted book down and get back to work. And whatever you do, don't admit to anyone how hard it is. Don't even admit this to yourself. It's supposed to be hard. Only mediocrity is easy, and you're too good for that.

THE END

My dear brother, if I were not broke and crazy with this blasted painting, what a dealer I'd make...
 —Vincent van Gogh, in a letter to Theo.

SELECTED BIBLIOGRAPHY

Complete Letters of Vincent van Gogh, Little Brown,
New York, 1958

Philip Callow, *Vincent van Gogh, A Life*, Ivan R. Dee, Inc.,
Chicago, 1990

F. Scott Fitzgerald, *Tender is the Night*, Charles Scribner's Sons,
1933

Meryle Secrest, *Frank Lloyd Wright*, Alfred A. Knopf, New York, 1992

Sue Davidson Lowe, *Stieglitz, A Memoir/Biography,* Farrar
Straus Giroux, New York, 1983

Jacqueline Bograd Weld, *Peggy, The Wayward Guggenheim*, E.P.
Dutton, New York, 1986

Gordon Parks, *Voices in the Mirror, An Autobiography*, Doubleday,
New York, 1990

Friedrich Nietzsche, *Beyond Good and Evil*, Oxford University
Press, Oxford, England, 1998 (translation by Marion Faber,
1998)

Anne Stevenson, *Bitter Fame, A Life of Sylvia Plath*, Houghton
Mifflin, Boston, 1989

David Sweetman, *Paul Gauguin, A Life*, Simon and Schuster, New
York, 1995

U.S. Government Accountability Office, *Comparison of the Reported
Tax Liabilities of Foreign—and U.S.—Controlled Corpora-
tions*, 1998-2005; 2008.

Mark Bauerlein and Ellen Grantham, *National Endowment for the
Arts, A History*, 1965-2008, National Endowment for the
Arts, Washington, DC, 2008.

Jacob Neusner, "The end of the N.E.A," *National Review,* New York,
May 13, 1991.

Robert H. Frank, "Income Inequality: Too Big to Ignore," *New York
Times*, October 16, 2010

Warren Buffet, "Stop Coddling the Super-Rich," *New York Times*,
August 14, 2011

Paul Dorrell founded Leopold Gallery in 1991. His clients include Warner Brothers, the Kansas City Chiefs, H&R Block, the Kauffman Foundation, and thousands of private collectors. Reared in Kansas City and educated at the University of Kansas, he has spent years roaming North America by motorcycle. Paul has lived in Alaska, Los Angeles, New York, and Italy, but makes his home in Kansas City. He has written for numerous art magazines, and spoken at venues such as the Rhode Island School of Design and the Art Students League of New York.

To learn more about his work, go to leopoldgallery.com
To learn more about the book, go to livingtheartistslife.com